immaterial

architecture

Architecture is expected to be solid, stable and reassuring – physically, socially and psychologically. Bound to each other, the architectural and the material are considered inseparable. But Jonathan Hill, architect and architectural historian, argues that the immaterial is as important to architecture as the material and has as long a history.

Immaterial Architecture explores the sometimes conflicting forces that draw architecture towards either the material or the immaterial. The book discusses the pressures on architecture and the architectural profession to respectively be solid matter and solid practice, and considers concepts that align architecture with the immaterial, such as the superiority of ideas over matter, command of drawing, and design of spaces and surfaces.

Focusing on immaterial architecture as the perceived absence of matter more than the actual absence of matter, Hill devises new means to explore the creativity of the user and the architect. Users decide whether architecture is immaterial, but architects, and any other architectural producers, create material conditions in which that decision can be made. In conclusion, *Immaterial Architecture* advocates an architecture that fuses the immaterial and the material, and considers its consequences, challenging preconceptions about architecture, its practice, purpose, matter and use.

Jonathan Hill is Professor of Architecture and Visual Theory and Director of the MPhil/PhD by Architectural Design programme at the Bartlett School of Architecture, University College London. He is the author of *The Illegal Architect* (1998) and *Actions of Architecture* (2003) and editor of *Occupying Architecture* (1998) and *Architecture – the Subject is Matter* (2001) among others. Galleries where he has had solo exhibitions include the Haus der Architektur, Graz, and Architektur-Galerie am Weissenhof, Stuttgart.

Also available

Actions of Architecture
by Jonathan Hill

Architecture – the Subject is Matter
Edited by Jonathan Hill

Occupying Architecture
Edited by Jonathan Hill

For further information and to order from our online catalogue visit our website at www.routledge.com/builtenvironment

IMMATERIAL

ARCHITECTURE

Jonathan Hill

 Routledge
Taylor & Francis Group

LONDON AND NEW YORK

First published 2006 by Routledge

2 Park Square, Milton Park, Abingdon, Oxon, OX14 4RN

Simultaneously published in the USA and Canada by Routledge

270 Madison Ave, New York, NY 10016

Routledge is an imprint of the Taylor & Francis Group, an informa business

© 2006 Jonathan Hill

Typeset in News Gothic by

Keystroke, Jacaranda Lodge, Wolverhampton

Printed and bound in Great Britain by

TJ International Ltd, Padstow, Cornwall

British Library Cataloguing in Publication Data

A catalogue record for this book is available from the British Library

Library of Congress Cataloging in Publication Data

Hill, Jonathan, 1958–

 Immaterial architecture / Jonathan Hill.–1st ed.

 p. cm.

 Includes bibliographical references and index.

 ISBN 0–415–36323–3 (hb : alk. paper) – ISBN 0–415–36324–1 (pb :

alk. paper) 1. Architecture–Philosophy. 2. Immaterialism (Philosophy)

3. Building materials. I. Title.

 NA2500.H545 2006

 720′.1–dc22 2005023528

ISBN10: 0–415–36323–3 (hbk)

ISBN10: 0–415–36324–1 (pbk)

ISBN10: 0–203–01361–1 (ebk)

ISBN13: 978–0–415–36323–5 (hbk)

ISBN13: 978–0–415–36324–2 (pbk)

ISBN13: 978–0–203–01361–8 (ebk)

CONTENTS

contents

FIGURES

COLOUR SECTION

1 HOUSE AND HOME

figures

2 HUNTING THE SHADOW

INDEX OF IMMATERIAL ARCHITECTURES

figures

ACKNOWLEDGEMENTS

This book developed from my teaching and research at the Bartlett School of Architecture, University College London. I want especially to thank Ganit Mayslits, Francesca Hughes, Lesley Lokko and Elizabeth Dow, my teaching partners in Diploma Unit 12, whose ideas and advice have been stimulating and generous. My colleagues in the MPhil/PhD by Architectural Design programme have offered criticism and encouragement, especially Dr Penelope Haralambidou, Dr Yeoryia Manolopoulou, Dr Jane Rendell and Professor Philip Tabor. Also at the Bartlett, Abi Abdolwahabi, Professor Iain Borden, Professor Adrian Forty, Professor Christine Hawley, Simon Herron, Susanne Isa and Bob Sheil have been constructive and supportive. Dialogue with an exceptional group of Diploma and PhD students has influenced considerably the character of this book. From the Diploma I wish to thank Pooja Asher, Anton Ambrose, Matthew Butcher, Mark Damien, Charlie de Bono, Max Dewdney, Laura Dewe Mathews, Misa Furigori Gonzalez, Louise Heaps, Lina Lahiri, Chee Kit Lai, Lucy Leonard, James Patterson, Juliet Quintero, Kirstie Robinson, Tobiah Samuel, Rupert Scott, Ruth Silver, Paul Thomas, Nick Tidball, Tim Wray, Olga Wukonig and Elena Zabeli. And from the PhD, Ana Paola Araújo, Nick Callicott, Chadi Chamoun, Marjan Colletti, Ersi Ioannidou, Jan Kattein, Rosalie Kim, Tae Young Kim, Igor Marjanovic, Neil Wenman and Stefan White.

Professor Jean-Baptiste Joly, Director of Akademie Schloss Solitude in Stuttgart, offered an environment in which I could first develop ideas relevant to this book. While I was at Stuttgart, Reinhard Piper suggested a visit to the rococo Amalienburg hunting lodge outside Munich, which clarified my interest in immaterial architecture.

I very much appreciate the suggestions and support of many friends and colleagues. They include Xiaochun Ai; Morag Bain; Carolyn Butterworth, University of Sheffield; Barbara-Ann Campbell-Lange, Royal College of Art; Professor Nat Chard, University of Manitoba; Catherine Charles-Wilson; Emma Cheatle; Dr Mark Dorrian, University of Edinburgh; Professor Anthony Dunne, Royal College of Art; Paul Fineberg; Professor Murray Fraser, University of Westminster; Kaye Geipel, *Bauwelt*; Alex Gino; Jason Griffiths; Dr Katja Grillner, Royal Institute of Technology, Stockholm; Catherine Harrington; Paul Hodgson; Udi Kassif; Toni Kauppila; Bekir Kaya; Constance Lau, University of Nottingham; Mark Lumley; Henning Meisner; Ben Nicholson, Illinois Institute of Technology; Jean Oh; Ulrike Passe; Kay Preston: Fiona Raby; Rahesh Ram; Neil Rawson; Ingalill and Roland Wahlroos-Ritter, SCI-Arc; Catsou Roberts; Ro Spankie, Oxford Brookes University; Kay Ngee Tan; Bradley Starkey, University of Nottingham; Yen Yen Teh; Professor Jeremy Till, University of Sheffield; Professor Leon van Schaik, Royal Melbourne Institute of Technology; Dr Victoria Watson,

acknowledgements

University of Westminster; Professor Eyal Weizman, Goldsmiths College; Julian Williams; and Bobby Wong, National University of Singapore.

A number of individuals and organizations have kindly supplied images for this book: Alvar Aalto Museum; Matthew Butcher; Nat Chard; Leon Chew; Christo and Jeanne-Claude; Conway Library, Courtauld Institute of Art; C. Cottrell-Dormer; DIA Art Foundation and John Cliett; The National Gallery of Ireland, Dublin; Dunne + Raby; Adrian Forty; Simon Haycock; Tanis Hinchcliffe; Andrew Holmes and Mark Fisher; Lina Lahiri; Lisson Gallery and Hans Haacke; Yeoryia Manolopoulou; Igor Marjanovic; Zoë Quick; Juliet Quintero; Harry Shunk; Ruth Silver; Collection Lila and Gilbert Silverman, Detroit, Michigan; sixteen* makers; Philip Steadman; Bernard Tschumi Architects; Victoria Watson; Michael Webb and Archigram Archive; Peter Wilson, Bolles + Wilson; Worcester College, Oxford; and Elke Zinnecker. The Bartlett Architectural Research Fund provided financial support.

Immaterial Architecture is the fourth book of mine to be published by Routledge, and I am especially grateful to Caroline Mallinder for her continuing commitment, support and intelligence. At Keystroke, I appreciate the efforts of Rose James, Maggie Lindsey-Jones, Sarah Pearsall and Emma Wood.

Finally, my special thanks go to Emma Jones for her generous and thoughtful advice and for sharing a love of gardens and much else.

ILLLUSTRATIONS

introduction

immaterial/material

introduction

The view from my first home extended across fields for three miles to the north. In the distance was a row of electricity pylons. Against the familiar grey sky the grey pylons were invisible. Very occasionally, when light chanced on steel, the pylons would briefly flicker and then disappear. Physically unchanging, the pylons were as seasonal as the fields.

For many an architect or writer, ideas and concerns evolve over time, from project to project. Strategies, forms and materials that first appear in one design develop and mutate in another. Characters, narratives and events that first appear in one book grow and change in another. In *Actions of Architecture: Architects and Creative Users* I write:

> *The word architecture has a number of meanings. For example, it is a subject, practice, and a certain type of object and space, typically the building and the city . . . I consider each of these definitions but focus on another: architecture is a certain type of object and space used. Within the term 'use' I include the full range of ways in which buildings and cities are experienced, such as habit, distraction and appropriation.*[1]

1 Hill, *Actions of Architecture*, p. 2.

Architecture is expected to be solid, stable and reassuring – physically, socially and psychologically. Bound to each other, the architectural and the material are considered inseparable. But *Immaterial Architecture* states that the immaterial is as important to architecture as the material and has as long a history. Two chapters, a conclusion and an index follow this introduction. The chapters respectively explore the sometimes conflicting forces that pull architecture towards either the material or the immaterial. Although one chapter follows the other, they are best understood in parallel rather than in sequence because the forces they describe are often present at the same time. Consequently, the two chapters cover similar historical periods and offer contrasting interpretations of some of the same buildings.

The first chapter considers the material stability and solidity of architecture through an analysis of two homes – one of architecture, the other of architects – identifying the safety they offer and the threats they face. 'Chapter 1: House and Home' discusses the coupling of material stability to social stability, and considers the resultant pressures on architecture and the architectural profession to be respectively solid matter and solid practice.

The second chapter traces the origins of the architect, as the term is understood today, to the Italian Renaissance, when drawing was first associated with ideas and essential to architectural practice. Dependent on the concept that ideas are immaterial and superior to matter, the command of drawing underpins the status of architectural design as intellectual and artistic labour. In conclusion, 'Chapter 2: Hunting the

Shadow' relates the command of drawing to other concepts that draw architecture towards the immaterial, such as space and surface.

There are many ways to understand immaterial architecture. As an idea, a formless phenomenon, a technological development towards lightness, a *tabula rasa* of a capitalist economy, a gradual loss of architecture's moral weight and certitude or a programmatic focus on actions rather than forms. I recognize each of these models but concentrate on another. Focusing on immaterial architecture as the perceived absence of matter more than the actual absence of matter,[2] I devise new means to explore old concerns: the creativity of the architect and the user. The user decides whether architecture is immaterial. But the architect, or any other architectural producer, creates material conditions in which that decision can be made.

In the conclusion and index, *Immaterial Architecture* advocates an architecture that fuses the immaterial and the material, and considers its consequences, challenging preconceptions about architecture, its practice, purpose, matter and use. 'Conclusion: Immaterial–Material' weaves the two together, so that they are in conjunction not opposition. 'Index of Immaterial Architectures' discusses over thirty architectures – buildings, spaces and artworks – in which the material is perceived as immaterial.[3]

[2] In this book I mostly use the familiar architectural understanding of matter as material rather than matter as energy, which is discussed in 'Chapter 2: Hunting the Shadow'.

[3] However it was conceived, each is discussed as architecture.

house and home

THE HOME OF ARCHITECTURE

The Home of the Home

1 Rykwert, p. 105.

2 Vitruvius, pp. 38–39.

3 In *Immaterial Architecture* book titles are given in English even if a book was first published in another language.

4 Laugier.

A recurring theme in architectural discourse states that the house is the origin and archetype of architecture, the manifestation of its important attributes. The most noted example is the primitive hut, for which the Roman architect Vitruvius is 'the source of all the later speculation'.[1] According to Vitruvius the first shelter was a frame of timber branches finished in mud.[2] But a more familiar and idyllic image of the primitive hut appears in the frontispiece to Marc-Antoine Laugier's *An Essay on Architecture*,[3] 1753, depicting four tree-trunks supporting a pediment of branches.[4]

Marc-Antoine Laugier, *Essai sur l'Architecture*, 1753. Frontispiece. Courtesy of the Conway Library, Courtauld Institute of Art, London.

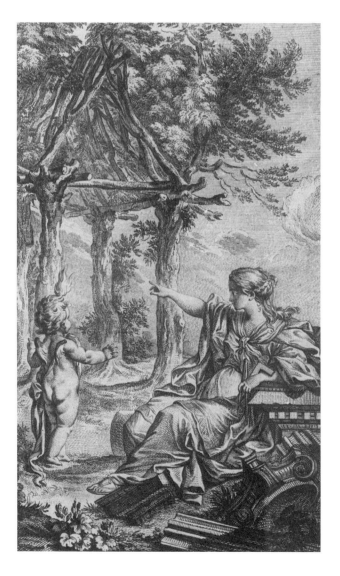

Extending Simon Schama's thesis in *The Embarrassment of Riches*, Philip Tabor concludes, however, that seventeenth-century Netherlands is crucial to the development of ideas and images relevant to the contemporary home:

> As far as the idea of home is concerned, the home of the home is the Netherlands. This idea's crystallisation might be dated to the first three-quarters of the seventeenth century, when the Dutch Netherlands amassed an unprecedented and unrivalled accumulation of capital, and emptied their purses into domestic space.[5]

Seventeenth-century Dutch society promoted a significant transformation in domestic architecture from public to private. A home unfamiliar to us today, the medieval house was public in that it accommodated numerous functions of business and domestic life and numerous people – family, relatives, employees, servants and guests – in shared spaces.[6] Even sleeping was a communal activity, with many people sharing a bed and many beds sharing a room. Later, in the fifteenth and sixteenth centuries, the Italian Renaissance palazzo was occupied as a permeable matrix of rooms. Each room had no specific use and as many as four doors,[7] an arrangement suitable to a society 'in which gregariousness is habitual'.[8] Robin Evans concludes that 'Such was the typical arrangement of household space in Europe until challenged in the seventeenth century.'[9] Increasingly, the matrix of rooms common in 'hovel and mansion' was believed to have two features that 'rendered them unfit as moral dwellings'.[10] First, they offered little privacy as people could roam from one space to another without being easily monitored.[11] Second, they encouraged overcrowding and close contact between occupants.[12]

Increasingly, spaces and functions were segregated. By the middle of the seventeenth century 'the subdivision of the house into day and night uses, and into formal and informal areas, had begun', writes Witold Rybczynski.[13] The corridor plan, and privacy in the home, reached fruition in the nineteenth century. However, Raffaella Sarti notes that the Netherlands 'developed architectural elements similar to "modern" corridors very early', as was the case in England where they were introduced in the seventeenth century.[14] The corridor enables a room to have a single use and a single entrance, defending privacy and discouraging entry to anyone without a specific purpose.

With its emphasis on cosy comfort and the accumulation of personal possessions, the contemporary home is aesthetically similar to one in seventeenth-century Netherlands. Other similarities are the number of people accommodated, the value given to privacy, and the separation of domestic and working life. A Dutch seventeenth-century town house was smaller and had fewer occupants – four or five – than houses

5 Tabor, p. 218.

6 Riley, p. 11.

7 Even the lavatories might provide routes through the house, as in Andrea Palladio's design for the Palazzo Antonini, Udine, 1556. See Evans, 'Figures, Doors and Passages', p. 63.

8 Evans, 'Figures, Doors and Passages', p. 88. Evans notes that a house represents and produces domesticity, and is indicative of a way of life at the time of its construction. The matrix of rooms allows alternative, and potentially private, routes between rooms. Privacy could also be achieved by monitoring entry to a sequence of antechambers, which suggests either that Evans overstates somewhat the gregariousness of sixteenth-century society or that, like all building arrangements, a house can be occupied in unintended ways.

9 Evans, 'Figures, Doors and Passages', p. 88.

10 Evans, 'Rookeries and Model Dwellings', p. 101.

11 Evans, 'Rookeries and Model Dwellings', p. 102.

12 Evans, 'Rookeries and Model Dwellings', p. 104.

13 Rybczynski, p. 56.

14 Sarti, p. 269.

15 Rybczynski, p. 59.

16 Zumthor, pp. 45–46.

in other countries, where as many as twenty-five people per house was possible.[15] Employees and apprentices lodged elsewhere. As self-reliance was valued, servants were rare and the subject of taxation charged to the employer.[16] Occupied by a family and synonymous with family life, the Dutch seventeenth-century house was separate and private. According to Schama:

17 Schama, p. 391.

> The well-kept home was the place where the soiling world subjected to tireless exercises in moral as well as physical ablution . . . That threshold, moreover, need not be literal. Very many, if not most, businesses and trades were still carried on within the physical precincts of the house, but the division between living and working space in middle-class households was nonetheless clearly demarcated and jealously guarded.[17]

Towards the end of the seventeenth century work was fully removed from the house. This remained the model in future centuries and was further enforced by the industrial revolution, which increased large-scale factory production and reduced the small-scale craft manufacture that had once occurred alongside domestic life. Today, the house is once again a place of work, in part due to the proliferation of electronic communications. But the desire to separate working and living remains apparent. In seventeenth-century Dutch society, the house became private and personal, and a home familiar to us today.

Managing the Home

18 Evans, 'Figures, Doors and Passages', p. 75

> There was a commonplace analogy in seventeenth-century literature that compared a man's soul to a privy chamber, but it is hard to tell now which became private first, the room or the soul. Certainly, their histories are entwined.[18]

Home is the one place that is considered to be truly personal. Home always belongs to someone. It is supposedly the most secure and stable of environments, a vessel for the identity of its occupant(s), a container for, and mirror of, the self. Associated with all that is solidly comforting, the home is synonymous with the material.

However, the concept of home is also a response to the excluded, unknown and unpredictable. Home must appear solid and stable because social norms and personal identity are shifting and slippery. It is a metaphor for a threatened society and a threatened individual. The safety of the home is also the sign of its opposite, a certain nervousness, a fear of the tangible or intangible dangers outside and inside. The purpose of the home is to keep the inside inside and the outside outside.

Traditionally, threats from outside come in a number of guises, notably inclement weather and undesirable people. Both are associated with the formless, fluid, unstable and unpredictable. Banister Fletcher writes that 'Architecture . . . must have had a simple origin in the primitive efforts of mankind to provide protection against inclement weather, wild beasts and human enemies.'[19]

19 Fletcher, p. 1.

A defining purpose of the home is to provide shelter from the weather. In contrast to the unpredictable weather outside, the home provides a controlled climate inside. Attempting to control the relationship between the two environments, the home introduces desirable external conditions, such as daylight, while creating and retaining comfortable internal conditions, such as warmth in winter. For psychological as well as physical comfort, the threshold between inside and outside must be clear. A threat to the home is considered a threat to the self. Discussing the projection of such fears onto the home, Mark Cousins writes:

> people . . . ask nothing of the house in architectural terms, except that it be sealed
> away absolutely successfully from any natural process . . . There is no reason why the
> window cannot be fixed the next day, or the next week. But it simply follows from
> the degree of psychic investment which people have made in respect of the building's
> integrity, that it must be fixed at four in the morning.[20]

20 Cousins, 'The First House', p. 37.

Unwanted people may pose an equal external threat to the home. Schama writes that in seventeenth-century Netherlands 'Criminals, beggars, vagabonds, men without occupation or abode then, were by definition outsiders against whom the community had to defend itself.'[21] For an outsider to pretend to be an insider was a crime. But there were two types of outsider. Insiders' outsiders, such as licensed tradespeople and street musicians, were allowed to inhabit the public domain but not the private one.[22]

21 Schama, p. 587.

22 Schama, pp. 57–572.

David Sibley notes that 'Nature has a long historical association with the other.'[23] Sometimes the threat of the outside merges with the threat of the outsider, as occurred in seventeenth-century Netherlands due to its precarious geography and struggle for nationhood. For the United Provinces of the Netherlands, founded only in 1609, threats from the outside and outsider merged in the flood tide, the most disturbing natural force in the Dutch landscape. However, the sea was the source of the Netherlands' growing prosperity as a trading nation and the flood tide was understood as both destructive and a means of moral redemption:

23 Sibley, Geographies of Exclusion, p. 26.

> The flood tides not only functioned in historical chronicle as a metaphor for the ebb
> and flow of national fortunes; they virtually took on the role of an historical actor

24 Schama, p. 38.

– sometimes destroyer, sometimes, as in 1574, deliverer. And if the two processes of resistance – against absolutism and the ocean – were linked together, so were those of national and territorial reclamation.[24]

In a culture that both enjoyed wealth and felt guilty about it, the flood tide eased the moral ambiguity of commercial success and initiated a period of rebuilding compatible with a society driven by market forces.[25]

25 Schama, pp. 47–49.

Seeking comfort in the moral force of a sweep of water, Dutch cities were noted as the cleanest in Europe. In conjunction with the social cleansing of outsiders, physical cleansing extended outwards from the surfaces of the home to the pavement.[26] According to Schama:

26 Sarti, p. 111.

'Home' existed in the Dutch mentality in a kind of dialectical polarity with 'world,' in particular the street, which brought the mire of the world, literally, to its doorstep. The obligation to wash the pavement in front of the house, then, was not just a legal civic duty, that is to say, a public obligation, it was also a way to protect the threshold of the inner sanctum.[27]

27 Schama, p. 389.

In seventeenth-century Netherlands a static and reassuring interior was juxtaposed to a fluid and menacing exterior, personified by the flood tide and vagrant,[28] each considered to be a physical threat and a metaphor for all that was disturbing. As today, home was equated with the material, the exterior world with the immaterial. The threat of external factors was psychological and social as much as physical. Consequently, the interior world, heavily portrayed in paintings of the time, acquired particular value and poignancy. In contrast to the public medieval house, in which furniture was mobile and minimal, personal possessions proliferated in the private and more static Dutch seventeenth-century interior.[29] Schama writes that 'Even in less grandiose households, there was nothing plain or simple about taste in domestic possessions. If anything, Dutch sensibilities, from the *early* part of the seventeenth century, veered towards profuseness, elaboration and intricate detail.'[30] The fascination with the interior, and the denial of the exterior, was obsessive, as Tabor acknowledges:

28 A nation with a territorial claim on the Netherlands was a further representation of a menacing exterior, but less visible and everyday.

29 Rybczynski, p. 40.

30 Schama, p. 304.

the Netherlands, much of which lies below sea-level, have a perilously elastic envelope separating the homeland from sea, a condition which has impressed into the individual Dutch soul a paranoiac anxiety to defend an inhabited interior (the self) from a menacing exterior . . . This paranoia, if such it was, was distilled into cultural form by the stupendous pictures of domestic interiors of the time: one thinks especially of Pieter

de Hooch and Johannes Vermeer. It is certainly astonishing how interior these interiors are . . . drawing us into their intimacy and security.[31]

31 Tabor, p. 219.

High and narrow, the principal façade of a Dutch seventeenth-century house carried no structural load; its large windows allowed light to permeate the interior. However, Rybczynski notes that 'The light coming through these windows was controlled by shutters, and by a new device – curtain windows – which also provided privacy from the street.'[32] Appropriate to a sea-trading nation engaged in land

32 Rybczynski, p. 57.

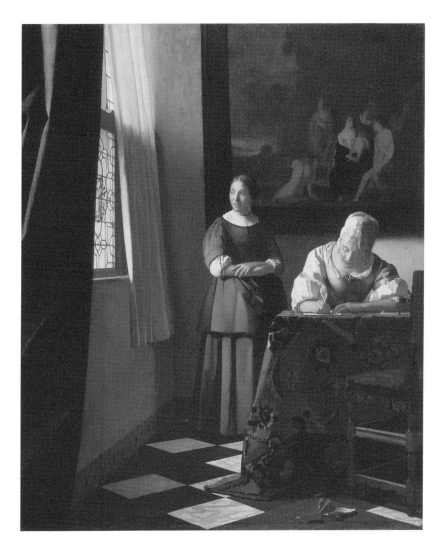

Johannes Vermeer, *Lady Writing a Letter, with her Maid, c.* 1670. Courtesy of the National Gallery of Ireland, Dublin.

33 Andrews, *Landscape in Western Art*, pp. 82–93.

34 A number of Vermeer's paintings depict wall maps and small landscape paintings.

35 Steadman, p. 65.

36 Steadman, p. 66. The three paintings are *Woman Holding a Balance, Lady Seated at the Virginals*, and *The Glass of Wine*.

37 Steadman, p. 100. Steadman notes 'the general consensus among art historians . . . that Vermeer seems likely to have used the camera obscura'. Steadman, p. 44.

38 Steadman, p. 165.

reclamation, landscape paintings and maps decorated seventeenth-century Dutch domestic interiors.[33] But many Dutch paintings of this period focus on the view inside rather than outside. In de Hooch's paintings the street is seen in the distance through a sequence of doors and windows. The majority of Vermeer's paintings depict a domestic interior occupied by three people or fewer.[34] Often a strong light falls across the interior but the exterior is rarely seen, and then obliquely. The typical Delft house depicted by Vermeer had four window lights, but only the lower two had solid shutters, obscuring the view to the street.[35] Philip Steadman writes that 'Vermeer makes repeated use of these shutters, together with curtains, to control the lighting in his interiors. In *Lady Writing a Letter, with her Maid* for example, one of the shutters on the visible window is closed. In three more pictures both shutters on this far window are closed.'[36] Steadman provides convincing evidence that Vermeer used the camera obscura as an aid to painting and that many of his paintings are paintings of his home:[37]

> And then he disposed these simple elements, in a few pictures, to say what he wanted – however elusively – about the subjects for which he cared: domestic routine, the love of men for women and fathers for daughters, the consolations of music, the worlds of science and scholarship, his own profession and its ambitions – all captured in his room within a room, his camera in a camera.[38]

Philip Steadman, Analytical drawing of Johannes Vermeer, *The Music Lesson, c.* 1662–1665. 'Diagonal lines in the pattern of floor tiles converge to a distance point D on the horizon line in *The Music Lesson*. A second distance point (not shown) is found on the horizon to the right of the picture.'[39] P is the central vanishing point. Courtesy of Philip Steadman, *Vermeer's Camera*, 2001.

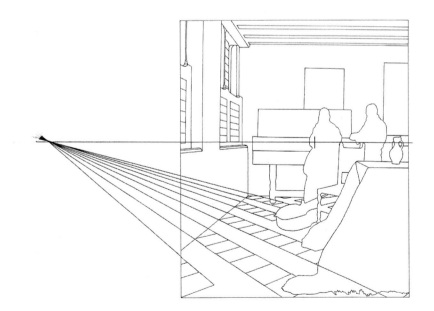

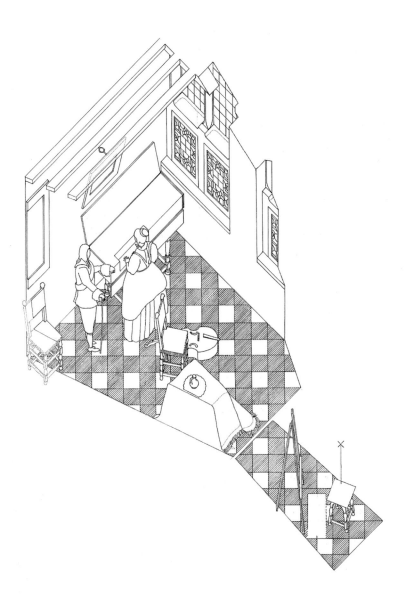

Philip Steadman, Analytical drawing of Johannes Vermeer, *The Music Lesson*, c. 1662–1665. 'Bird's-eye view of the space of *The Music Lesson*, including part of the room visible only in the mirror. The white rectangle between the stool and easel marks the position of the mysterious box.'[40] Courtesy of Philip Steadman, *Vermeer's Camera*, 2001.

Viewing one room from within another – the exterior filtered and edited – Vermeer typified the immersion in the personal and private that was characteristic of life in the Dutch seventeenth-century home. The popularity of such paintings today suggests that the inner world they depict remains just as relevant.

Claude Lévi-Strauss suggests in *The Way of Masks* that a mask transforms and omits as much as it represents.[41] He states that in the study of masks it is essential

39 Steadman, fig. 30, p. 76.

40 Steadman, fig. 40, p. 86.

41 Lévi-Strauss, *The Way of Masks*, p. 187.

to discover what is denied as much as what is revealed. Like the mask, the painting is an apparatus through which ideology is transmitted, transformed, concealed and produced. That the exterior is absent in many seventeenth-century Dutch paintings indicates the threat it posed as well as the fascination with home life.[42] The obsessive order of the interior suggests that disorder within was as disturbing as disorder without. Schama writes that 'In the moralist's canon, the polluters came in two guises: internal and external . . . But in some ways it was the threats from within that were more insidious, precisely for seeming so innocuous.'[43]

Sarti refers to 'the tendency to superimpose the concept of "family" on to that of "house"'.[44] But the contemporary meaning of the term 'family' – parents and children – is comparatively recent, as is its association with the home. Originally 'familia' in Latin referred to servants who worked for the same employer, and an implied hierarchy lingers in contemporary use of the term. Sarti writes that 'In English, the first records of it being used for all the people living under one roof or under the same householder date back to the mid-sixteenth century, while its use for parents and children . . . appeared a century later.'[45]

To domesticate is to tame. One purpose of the seventeenth-century Dutch home was to contain and order women, keeping them busy in their task as guardians of domestic life and its other 'unruly' elements, such as children. Domesticity and cleanliness go hand in hand. The term 'domestic' refers to a cleaner, familiarly a woman. Cleaning the interior, threshold and pavement was undertaken by women, whether family members or servants. Schama writes that 'Home was that morally purified and carefully patrolled terrain where license was governed by prudence, and the wayward habits of animals, children and footloose women were subdued into a state of harmony and grace.'[46] Not only women and children are ordered in and by the home, however. Home is a powerful concept society deploys to domesticate all its citizens in preparation for the public realm as well as the private one. In *The Origin of Table Manners*, Lévi-Strauss writes: 'Whereas we think of good manners as a way of protecting the internal purity of the subject against the external impurity of beings and things, in savage societies, they are a means of protecting the purity of beings and things against the impurity of the subject.'[47] The rules of good behaviour, such as those evident in the strong sense of civic and domestic duty in seventeenth-century Dutch society, are a contract between the public and private intended to protect us from ourselves as well as others.

42 As does the intensity of street cleaning.

43 Schama, p. 382.

44 Sarti, p. 38.

45 Sarti, p. 33.

46 Schama, p. 388.

47 Lévi-Strauss, *The Origin of Table Manners*, p. 504.

Man-made Weather

In the eighteenth century, weather continued to be defined by its opposition to architecture but was seen differently. The assumption that man and nature are subject to the same laws of reason led to increased confidence in empirical science and its wider application. Through the study of glaciers, plants, grape harvests and other natural phenomena, eighteenth- and nineteenth-century empirical science began to question the long-held assumption that climate was unchanging and divided according to zones. As Lucian Boia remarks: 'Man was becoming the dynamic factor through his ability to modify climate and to alter existing natural balances as he pursued his own projects.'[48] Since the eighteenth century, weather has been familiarly opposed to architecture but it can be manipulated or recreated as well as resisted. The focus of attention is the climate inside as well as outside.

With rudimentary drainage, open fires and candle lighting, the eighteenth-century house was no more successful as a climate modifier than one centuries before. By contrast, the emergence of new technologies such as gas lighting, the water closet and central heating ensured that the nineteenth-century house provided a more comfortable domestic environment.[49] In 1907, for the first time, the pioneer of air-conditioning Willis Havilland Carrier guaranteed the environmental conditions within a building.[50] The term 'air-conditioning' was devised not by Carrier but by a competitor, Stuart W. Cramer, in 1904. For many years, Carrier used a more poetic and appropriate term – man-made weather.[51] In *Towards a New Architecture*, 1927, Le Corbusier often mentions architectural solutions to environmental problems.[52] As early as 1915 he proposed a universal 'neutralising wall' to isolate inside from outside, its materials either transparent or solid as required.[53] Depending on the external climate, either hot or cold air was to circulate in the gap between a double membrane, maintaining the internal temperature at a constant $18°C$ wherever a building's location.[54]

Equating social transparency with visual transparency, the modernist house is a means to observe inside and outside and maintain their isolation when necessary. With reference to Le Corbusier, Beatriz Colomina writes that 'The house is a device to see the world, a mechanism for viewing. Shelter, separation from the outside, is provided by the window's ability to turn the threatening world into a reassuring picture.'[55] But one by Ludwig Mies van der Rohe is a better example of such a house. Fritz Neumeyer identifies Bauhaus teacher Siegfried Ebeling as an important influence on Mies. In *The Space as Membrane*, published in 1926,[56] Ebeling conceives space as an extension of the body, a protective membrane between interior and exterior similar to the bark of a tree.[57] Mies writes:

[48] Boia, p. 42.

[49] Farmer, pp. 52–53.

[50] Huguet Silk Mills, Wayland, NY. Banham, p. 275.

[51] Banham, p. 172.

[52] Le Corbusier, *Towards a New Architecture*.

[53] First devised for the Villa Schwob, La Chaux de Fonds, 1915; Banham, pp. 156–163.

[54] Le Corbusier quoted in Banham, p. 160. First published in *Précisions*, 1930.

[55] Colomina, *Privacy and Publicity*, p. 7.

[56] Published in German as *Der Raum Als Membran*.

[57] Neumeyer, p. 175.

58 Mies in Norberg-Schulz, 'A Talk with Mies van der Rohe', p. 339.

59 Since 1954, regular flooding undermines Mies' intention.

60 Giedion, *Befreites Wohnen*, p. 8; quoted and translated in Heynen, p. 36.

Ludwig Mies van der Rohe, Farnsworth House, Plano, Illinois, 1951. Photograph, Yeoryia Manolopoulou.

Nature, too, shall live its own life. We must beware not to disrupt it with the color of our houses and interior fittings. Yet we should not attempt to bring nature, houses, and human beings together into a higher unity. If you view nature through the glass walls of the Farnsworth House, it gains a more profound significance than if viewed from outside. That way more is said about nature – it becomes a part of a larger whole.[58]

At Mies' Farnsworth House, 1951, a one-room weekend house adjacent to the Fox River at Plano, Illinois, nature is separate and distinct, monitored as 'a part of a larger whole' if not 'a higher unity'.[59] Single occupancy and ownership of an expansive and carefully contrived portrayal of unsullied nature permit privacy.

In 1929 Sigfried Giedion, secretary to CIAM (Congrès Internationaux d'Architecture Moderne), wrote that 'Consequently, this open house also signifies a reflection of the contemporary mental condition: there are no longer separate affairs, all domains interpenetrate.'[60] Promoting universal space, transparency and mobility unhindered by numerous personal possessions, modernist architecture seems to undermine the

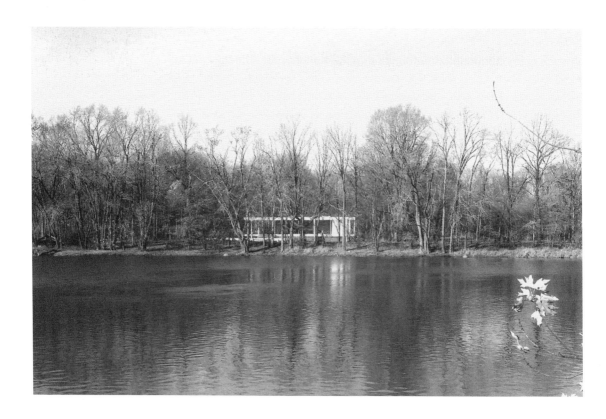

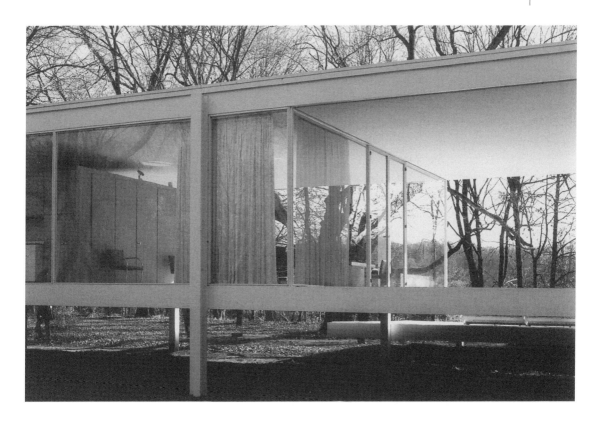

idea of the introverted and tangible home developed between the seventeenth and nineteenth centuries. But, in its attitude to nature, allegiance to functionalist theory, and preference for white walls, modernism responds to the desire for a private life devoid of unpredictable social interaction.

Functionalism was the dominant architectural theory of early twentieth-century modernism, and flavours many of its later interpretations. The prime concern of functionalist theory is the relationship between a form and the behaviour it accommodates. One of its principles is determinism, the idea that the actions of the user are predictable and every event has a cause. Functionalism was one of the most alarming aspects of the early modernist agenda because its adherents had confidence in a 'science' that cannot be validated scientifically and believed that the user is passive, consistent and has universal needs.

In 1928, based on research he conducted for a German housing agency, Alexander Klein proposed the Functional House for Frictionless Living, an application of the scientific management of labour to building design and use.[61] Considering the house a machine, Klein contrasted the complex intersection of everyday paths of

61 *The Principles of Scientific Management*, the conclusion of Frederick W. Taylor's studies since the 1880s, was first published in 1911. Through the expert analysis of labour, Taylorism calculates the optimal efficiency of each task in a production process. Le Corbusier was one early and influential advocate of Taylorism. See McLeod, p. 133.

movement through a typical nineteenth-century house to their separation in his own design, which he claimed was superior because it reduced the possibility of accidental encounters and, thus, social friction. Klein assumed that a one-to-one compatibility of a function and a space is possible and necessary.[62] As Henri Lefebvre writes, 'Functionalism stresses function to the point where, because each function has a specially assigned place within dominated space, the very possibility of multifunctionality is eliminated.'[63] The Functional House for Frictionless Living is emblematic of the rational, waste-free society proposed by many functionalists, according to which the archetypal user is a technician at work either in the factory or the home.[64] The user learns to operate a space the way the technician learns to operate a machine – correctly. Anthony Dunne recognizes the insidious user-friendliness that underpins the relationship of the user to the object in functionalism. Dunne refers to industrial products but his argument is of equal relevance to buildings, whether early twentieth-century or more recent:

> The enslavement is not, strictly speaking, to machines, nor to people who build and own them, but to the conceptual models, values and systems of thought the machines embody . . . For instance, camcorders have built-in features that encourage generic usage: a warning light flashes whenever there is a risk of 'spoiling' a picture, as if to remind the user that they are about to become creative and should immediately return to the norm.[65]

Le Corbusier's statements that a house is 'a machine for living in' and 'one can be proud of having a house as serviceable as a typewriter' are accurate descriptions of functionalist sensibilities in that the human is understood as a component of the machine.[66] The 'machine for living in' is a totalizing and all-pervading model for society as well as architecture. The desire for a society of scientific progress and functional purity is similar to the obsessive hand-washing in some individuals; each is a sign of anxiety but at differing scales. In Alvar Aalto's Paimio Tuberculosis Sanatorium, 1933, the surfaces of the white wash-basins are angled to silence running water as it falls into the basin below so that patients are undisturbed. But the silent flow of dirty water disappearing into drains can also be understood as a metaphor for the hidden cleansing of society through architecture.

Dirt shows up easily on a white surface. Often associated with the male western body, white may have a racist, sexist and moral dimension that associates colour with dirt.[67] As Mary Douglas notes in *Purity and Danger*, dirt is matter out of place.[68] Dirt is not intrinsic. Rather dirt is ascribed to something that is denied because it disturbs. Richard Weston writes:

[62] Function is the intended use of a space. Use, of which function is a particular understanding, is a richer and more flexible term.

[63] Lefebvre, p. 369.

[64] *Household Engineering: Scientific Management in the Home*, Christine Frederick's 1915 interpretation of Taylorism, informed early modernist architecture. For example, in 1927 Grete Schütte-Lihotzky used the scientific management of labour to design the mass-produced and standardized Frankfurt Kitchen for the city's social housing programme.

[65] Dunne, p. 30. In place of user-friendliness Dunne proposes 'user-unfriendliness, a form of gentle provocation'. Dunne, p. 14.

[66] Le Corbusier, *Towards a New Architecture*, pp. 10, 241.

[67] Mark Wigley describes the ambivalent psychosexual tensions of the white wall, at times masculine, feminine, naked body, male suit and feminine dress. Wigley, *White Walls, Designer Dresses*, pp. 278, 299, 316, 318 and 328.

[68] Douglas, p. 104.

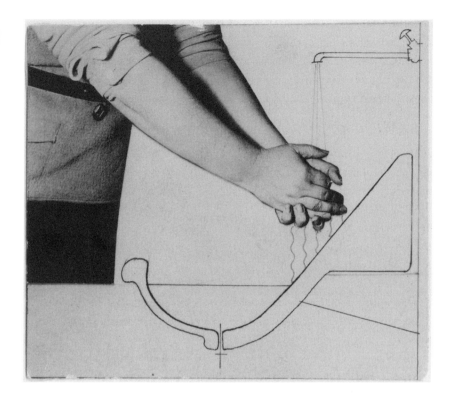

Alvar Aalto, Tuberculosis Sanatorium, Paimio, 1933. Drawing of a wash-basin. Courtesy of Alvar Aalto Museum/Photo Collection.

The prejudice against colour is longstanding. Plato condemned dyes as designed to deceive and a means by which women trick men, whilst later, in Rome, Pliny and Seneca argued that corrupting, florid colours were alien and came from the East. The ideal male body was seen as monochrome, whereas the female was unstable, prone to blushing and blanching.[69]

In the sixteenth century, a white garment was a mark of social position, indicating that the wearer could afford for clothes to be regularly washed and was unlikely to be engaged in manual labour.[70] As the shirt was washed rather than the body, dirt and sweat were merely placed out of sight. At the end of the eighteenth century, cleaning linen extended to cleaning the body. Mark Wigley writes that 'Bathing became the rule, a social statement. But still, the whole economy of hygiene remains fundamentally visual rather than sensual.'[71] The white modernist wall continues this tradition. Notably, in 'A Coat of Whitewash: The Law of Ripolin', Le Corbusier argues that whitewash is morally superior to other finishes.[72] Associated with moral rectitude, the modernist white wall looks clean and requires regular cleaning to stay white. It is presented as symbolically and literally clean. And if the modernist white wall is

69 Weston, p. 56.

70 Vigarello, p. 227.

71 Wigley, *White Walls, Designer Dresses*, p. 5.

72 'A Coat of Whitewash: The Law of Ripolin' is a chapter in *The Decorative Art of Today*, which accompanied the construction of Le Corbusier's Pavillon de L'Esprit Nouveau at the 1925 Exposition Internationale des Arts Décoratifs et Industriels Modernes in Paris. Ripolin is the name of a paint company familiar at that time.

73 The prevalence of the thin layer
of paint in modernist architecture is
discussed with relevance to the paper
drawing surface and Gottfried Semper
in 'Chapter 2: Hunting the Shadow'.

74 Moholy-Nagy, p. 59.

75 Eisenman, 'Post-Functionalism'
and 'The End of the Classical'.

76 Eisenman, 'Afterword', p. 110.

77 Benjamin, 'Paris, Capital of the
Nineteenth Century', p. 155.

78 Heynen, p. 118.

79 Benjamin, quoted in
Heynen, p. 114.

understood as masculine, cleaning and managing domestic life are likely to be associated with women once again, as in the seventeenth-century Dutch home.[73]

Early modernist architects designed private houses as well as mass housing, and the spaces they promoted shared some of the concerns of previous domestic architectures. But they habitually denounced domesticity, characterizing it as bourgeois. Although private rather than public, the early modernist house was rarely designed as a home, as László Moholy-Nagy's criticism of people 'who look for the essence of architecture in the meaning of the conception of shelter' indicates.[74] Discomfort with comfort is a recurring theme among contemporary architects, even those who question modernism.[75] Commenting on his design for House VI, Cornwall, Connecticut, built in 1976, Peter Eisenman writes: 'In its original incarnation it certainly questioned the idea of inhabiting, or habitation, as habit. There was nothing about the occupation of the house that was habitual . . . In short, nothing about the house's function conformed to the existing typology of country house.'[76]

Largely a supporter of modernism, Walter Benjamin was less dismissive of domesticity, writing that 'To live is to leave traces . . . In the interior these are emphasized.'[77] Hilde Heynen notes that Benjamin wanted to 'understand modernity and dwelling as things that are not in opposition to each other'.[78] Benjamin tried to reconcile the need to 'leave traces' with the rush of contemporary life but ultimately gave the latter greater emphasis: 'For it is the hallmark of this epoch that dwelling in the old sense of the word, where security had priority, has had its day.'[79]

No less than the Dutch seventeenth-century house but by different means, the modernist house establishes precise boundaries inside and outside. However, the lack of popular support for modernism in some countries is no doubt related to modernists' ambivalence to domesticity. Increasingly the term 'minimalism' is used in place of modernism to avoid the latter's negative connotations. But minimalism succinctly indicates modernism's continuing unease with a home abundant in possessions, memories and traces.

Electromagnetic Weather

80 Tabor, pp. 221–222.

81 *An Interpretation of Dutch Culture
in the Golden Age* is the subtitle of
The Embarrassment of Riches.

Tabor notes that 'The parallel between the seventeenth-century experience and our own is obvious . . . in the advanced economies, a huge and quite sudden enlargement of personal access to information.'[80] For Dutch culture, the seventeenth century was a golden age of expanding prosperity powered by the nation's success as a sea-borne trading nation.[81] A deluge of exotic objects and ideas poured into the Dutch domestic interior from distant travels, engendering both delight and disturbance. Delight because

of the pleasures of consumption and new-found status and independence. Disturbance because the exterior world was evermore present, the interior world evermore vulnerable, and the threshold between the two evermore permeable. In the Dutch psyche, a deluge of information could easily recall a deluge of water.

Contemporary telecommunications alter our concept of home so that it is associated not just with a place but with devices and their capabilities. One of my friends was comfortable without a physical home for a while because her mobile and computer provided familiarity, ready access to a community of friends, and thresholds that she could open and close. But how secure are these new thresholds? Information flows into the contemporary home with greater ease than before. The last fifty years have seen a bombardment of information borne not on ships but on televisions and computers. Dutch seventeenth-century paintings rarely focus on the windows of a home. But a painting is a window, and so are the television and the computer. A window surveys; it also composes and edits. Looking out through a window in a wall, the viewer is aware of his or her separation from the world outside, while also feeling immersed within it to some degree. Being both here and there is an experience engendered by all windows, whether glazed, painted or pixelated. Of all the windows experienced today, the computer is the most enveloping, in part because it is viewed alone, unlike the television.[82]

[82] The painting is also viewed alone.

As here and there merge, the boundaries between the home and the street, and between the self and others, breach and blur. Referring to Joshua Meyrowitz's research into American domestic life, Tabor remarks that the impact of electronic media on social behaviour has broken 'former barriers between community and privacy, subservience and authority, male and female, childhood and adulthood, leisure and work, and so on'.[83] Increased awareness of the world outside the home, neigh-bourhood and nation is positive, as are some of the shifts in social behaviour Meyrowitz identifies. But a further consequence is social and psychic unease that strains relations between individuals and groups because boundaries are less effective.

[83] Tabor, p. 222; Meyrowitz.

As surveillance and communication technologies advance, government agencies and business corporations know more and more about our personal habits and transactions, and private life is the focus of public attention. But, inversely, as the private becomes ever more public, the desire for a protective home life increases, fuelled by the very media that undermine it. On the television and computer, in newspapers and magazines, images that promote the virtues of the home as a bastion against external disorder and public gaze are 'never-ending invitations to consume further the privatization of the family'.[84] While one vicious circle engenders public consumption of private life, another fuels personal consumption. Dependent on the myth that a mass-produced commodity is somehow individual and can transform and

[84] Sibley, *Geographies of Exclusion*, p. 78.

define an individual, a capitalist economy generates ever-expanding cycles of consumption that cultivate rather than resolve feelings of personal inadequacy. Increasing desire for the safety of the home is a result, ensuring that the home seems evermore fragile.

The Dutch seventeenth-century home is based on the separation of inside and outside and informed by awareness of the difficulty of that task, which is further increased now that communication technologies expand and civic duty, so important in seventeenth-century Netherlands, diminishes. Today, even more than in the seventeenth century, people feel under threat from what they find inside and outside their homes, what they find at the threshold between the two, and what they imagine to be there.

Threats to the home arrive by new means and old. Physical barriers – such as doors and walls – are less likely to keep the outside outside and the inside inside. While means to exclude weather increase, electromagnetic weather flows in and out of the home via the phone, television, radio and computer, extending the permeability of architecture identified by Benjamin in the early twentieth century. Unlike natural or man-made weather, electromagnetic weather is generated inside as well as outside the home. Anthony Dunne and Fiona Raby write that 'electromagnetic weather, oblivious to damp proof membranes, effortlessly passes through, saturating everything'.[85]

85 Dunne and Raby, 'Notopia', p. 102.

In 1988 Toyo Ito judged the annual Shinkenchiku competition organized by *Japan Architect*. As the competition theme he chose 'Comfort in the Metropolis', which a previous judge, Peter Cook, had set ten years earlier. Ito wanted the competitors to consider whether the city, and the possibilities for living within it, had been transformed in the years between the two competitions. One of Ito's most famous projects is the Tower of Winds, 1986, an elliptical tower concealing the ventilation shaft to an underground shopping complex in the centre of a Yokohama traffic interchange. The Tower of Winds has no conventional function. In response to the speed and frequency of traffic and other movements, photosensors transform its appearance from solid to opaque or translucent. The Tower of Winds celebrates the ephemeral flow of information, which for Ito has become the subject of architecture, and to which architecture is subject. The competition winner, Peter Wilson, placed his entry, the Ninja House, on the outer edge of the interchange that encircles the Tower of Winds, but turned his building away from Ito's. For Wilson, comfort in the metropolis exists in 'electronic shadows', moments of psychological and physical privacy from the flow of information: 'The subject of the project is the physicality of architecture and the ephemerality of the contemporary city; the evaporation of distance and matter through electronic technology.'[86] A defensive exterior ensures that no electronic communication enters or leaves the Ninja House. While the Tower of Winds refers to the eastern architectural

86 Wilson, p. 37.

tradition in which porous boundaries are defined by actions and rituals rather than materials,[87] the Ninja House is solidly within the western architectural tradition in which boundaries are rigid and materials robust.[88]

The Ninja House suggests a re-interpretation of the inward seventeenth-century Dutch home. The flood tide was weather's principal threat to the Dutch home. For the Ninja House the threat of natural weather is less evident than the invasive flow of electromagnetic weather. Unlike the flood tide, a flood of electromagnetic information does not necessarily suggest redemption, although a contemporary obsession – televisual celebrity – is often presented as such.[89]

Identifying and naming the worst excesses of the electromagnetic landscape, Dunne and Raby write that 'The rapid expansion of uses for the electromagnetic spectrum has resulted in a new form of pollution, or electrosmog.'[90] Consequently, they argue that the 'challenge today is not to create electronic space, but electronic-free space'.[91] Ten years after the Ninja House they proposed a project with similar concerns: a Faraday Chair, an enclosed day bed that counters the flow of electronic information. The physicist Michael Faraday invented the Faraday Cage in 1836 to shield a room from external electrical fields. Faraday indicated that the charge of a charged conductor – in his experiment a room coated in metal foil and earthed – is dispersed across the exterior and does not enter the interior. The Faraday Cage is most often used to protect electronic equipment from electrostatic discharges, such as a lightning strike. Dunne, however, proposes its wider application: 'I realised that today all space is electronic, and that the challenge to designers is to create an "empty" space, a space that has not existed for most of the century due to the explosion of uses for the electromagnetic spectrum.'[92]

The Ninja House and Faraday Chair suggest that in contemporary western society attempts to define and protect the home centre on the creation of homogenous spaces with precise boundaries, as was the case in seventeenth-century Netherlands. As before, the levels of physical protection between inside and outside, exclusion of outsiders and ordering of insiders define the safety of the home. But safety today is also dependent on protection against electromagnetic and media intrusions, such as a video entry-phone to monitor visitors, legal action to prevent publication of an unsolicited photograph, or anti-virus software to disarm a computer virus. To feel safe the home must exclude electrosmog and provide a comfortable electromagnetic climate protected by electronic shadows.

87 Harper, p. 48; Tanizaki, pp. 5–6.

88 This does not mean, however, that Japanese society is less ordered than western society. Rather that order is established in different ways.

89 See 'Index of Immaterial Architectures: Television'.

90 Dunne and Raby, *Design Noir*, p. 21.

91 Dunne and Raby, *Design Noir*, p. 26.

92 Dunne, p. 105.

Peter Wilson, Ninja House,
1988. Section and plan.
Courtesy of Bolles + Wilson.
A Filter 1: Mechanical mask;
B Filter 2: Necessary
equipment (stair, WC,
cupboard); C The Glove;
D Tower of Winds.
1 Cone of minimum
electronic interference—an
electronic shadow;
2 Sleeping mat;
3 Rock garden.

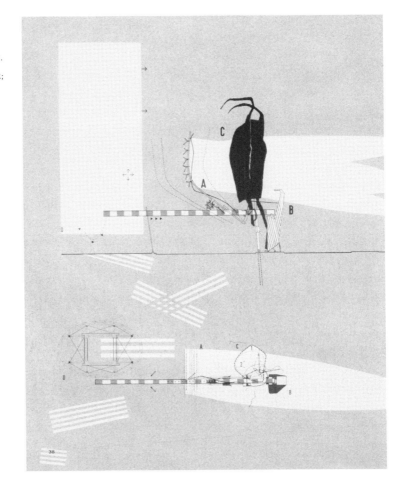

Peter Wilson, Ninja House,
1988. Isometric. Courtesy
of Bolles + Wilson.
A Filter 1: Mechanical mask;
B Filter 2: Necessary
equipment (stair, WC,
cupboard); C The Glove;
D Tower of Winds.
1 Cone of minimum
electronic interference—an
electronic shadow;
2 Sleeping mat;
3 Rock garden.

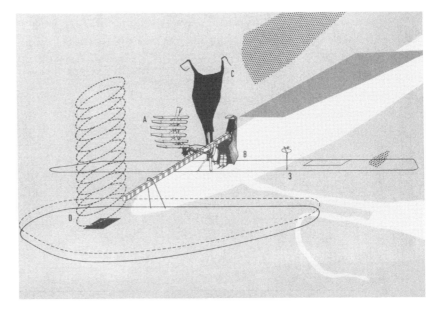

Dunne + Raby, Faraday Chair, 1998. Courtesy of Dunne + Raby.

The Private Home

Today, the home is still habitually associated with the family. But research indicates that this combination occurs less often in reality, especially in a large city such as London, where one in three households is occupied by someone living on their own, a proportion that is expected to increase further.[93] The purpose of such a home is no longer to sustain family members. However, loosening the ties that bind the home to the family does not necessarily undermine the idea of the home developed since the seventeenth century. As the home is equated with the self and personal space, it fits well with single occupancy. But, for some people, a family home is more a home than a home occupied by one person. It is common for a student at the end of the academic year to talk about going home, meaning going home to the family home, as though the place he or she lives in for most of the year is a house but not a home. The concept of home is so grounded in a specific place that it is difficult for someone to have more than one home. But once family ties weaken and new connections grow, the new home will displace the old one. Each new home tends to be a compound of earlier homes, however.

A house is not always a home because one is an object and the other is a perception. It is unusual to feel immediately at home. As the term 'homemaker' indicates, the home is made. And the homemaker does the housekeeping. Like tending a garden, homemaking and housekeeping are active and endless. An effective home works whether the homemaker is home or away. For the traveller, a strong home may provide comfort because it is there and discomfort because it is not here.

Despite rising property prices, the permeability of solid walls to electromagnetic weather, the fluidity of labour engendered by global capitalism and the rush of contemporary life, the idea and image of the home developed in the seventeenth-century Netherlands – a personal and introverted refuge full of objects and memories – is compelling and widely desired today, gaining added poignancy because it is harder and harder to achieve.

THE HOME OF ARCHITECTS

Architecture and Architects

Architecture is more than the work of architects. The importance of the house in the discourse of architects is somewhat ironic because in many countries architects design

93 Bloomfield. Information from a report published by the Greater London Authority, the Government Office for London, the London Development Agency and the Office for National Statistics.

only a small proportion of houses. It is quite possible to discuss houses without discussing architects, as the profusion of magazines and television programmes on homes and homemaking indicate. However, this is a book about architects as well as architecture. Architectural invention equal to that of architects can be found in the work of other architectural producers, such as artists.[94] But as architects still design most houses of note, their home is relevant to a wider discussion of the home.

94 Many of the works discussed in 'Index of Immaterial Architectures' are by artists.

From Home to Home

In the Middle Ages the guilds protected the practice and livelihood of the master mason. In the fifteenth and sixteenth centuries, the Italian Renaissance offered the architect a status higher than that of the master mason. Associated with intellectual and artistic labour, the practice of the architect was distanced from manual craft production associated with the guilds.[95] But Catherine Wilkinson writes that 'Without the protection of an established guild, the architect seems to have had few if any legal safeguards for his practice. A powerful patron might call in other architects at his pleasure or even cancel a project at an advanced stage.'[96] Since the demise of the guilds, therefore, a number of mutually beneficial relations have formed between architects and the state, moving them from one home to another. One of the most cohesive was the Académie Royale d'Architecture founded in France in 1671, in which the architect performed the role of iconographer of the state's buildings and public spaces. The architectural profession is the contemporary manifestation of the contract between the architect and the state, and the home of architects today. It struggles to provide a secure interior in which its members can be ordered, monitored and protected from external threats.

95 Discussed further in 'Chapter 2: Hunting the Shadow'.

96 Wilkinson, p. 128.

Professions acquired prominence in the nineteenth century due to the fluctuations of a rampant industrialized economy that was perceived to be veering close to catastrophe. Capitalism requires the continual construction and destruction of objects, goods and ideas in the search for new markets. To the apparent benefit of practitioners, consumers and the state, organizations such as the professions respond to the desire to manage and contain capitalism's excesses, making more solid and less violent its ebbs and flows, reducing the threat of economic and social disorder. In return for the safe management of an area of unsafe knowledge, the state offers a profession legal protection and a potential monopoly if it can prove that its expertise is superior to others.

Industrialization created a vastly expanded market with many new practices and the subdivision of existing ones. On the one hand, it offered architects more buildings to design and the status and protection of a profession. But, on the other, it diminished

architects' practice. Architects were increasingly separated from construction; by the 1830s the general contractor commonly assumed a number of roles previously undertaken by architects, such as the co-ordination of individual craftsmen. Eliot Freidson writes: 'Gaining recognition as a "profession" was important to occupations not only because it was associated with traditional gentry status, but also because its traditional connotations of disinterested dedication and learning legitimated the effort to gain protection from competition in the labour market.'[97]

97 Freidson, p. 24.

As the professions are a response to the desire for a managed economy and fear of social unrest, the architectural profession is expected to provide stable building use as well as solid building fabric. Industrialization intensified the quantification of space and labour and the classification of buildings by function, assuring the prominence of functionalist theory in early modernism and its influence on architecture since. The classification of buildings by function, in planning applications, building regulations and architects' designs, helps to keep thoughts of function close at hand. One of the principal props of the architectural profession is the claim that architects have expert knowledge of function, even though this contradicts the status of architecture as an art, which is defined by its opposition to utility. To imply that its members can predict building use, the architectural profession promotes models of experience, such as functionalist theory, which suggest a manageable and passive user, unable to transform use, space and meaning. However, the need of architects collectively to deny the creativity of the user is contradicted by individual architects, such as Herman Hertzberger, Lucien Kroll and Bernard Tschumi, who choose to acknowledge that creativity.[98]

98 Hill, *Actions of Architecture*, especially pp. 29–89.

A Weak Home

Architects do not all share the same values but the profession binds them together in a manner unlikely in the art world, for example.[99] As defined by Pierre Bourdieu the accumulation of cultural capital has a direct bearing on financial and social status and is affected by gender, occupation, class and race, which can help or hinder its acquisition.[100] An architect acquires cultural capital as an individual and collectively as a member of a profession. Cultural capital is, however, not assured and has to be defended.

99 Dingwall, p. 5; Freidson, p. 24; Rueschemeyer, p. 41; Rüedi, p. 28.

100 Bourdieu, pp. 171–183. For a discussion of Bourdieu's theory of cultural capital and its relation to the architect see Rüedi, pp. 30–32.

To acquire social status and financial security, architects need a defined area of knowledge with precise contents and limits in which they can prove expertise. Architects' search for a monopoly mirrors the separation of building and designing. With regard to building supervision, architects claim a body of knowledge practised

with equal competence in some respects by building surveyors and project managers. With regard to architectural design, architects claim that they alone make buildings and spaces that deserve the title architecture. In many countries, architect is a term protected in law. The practice of architecture is protected less often. Planning laws and building regulations monitor building production but the design of buildings is exclusive to architects in only a few countries.

Trying to define architectural knowledge is like pouring water into a colander. Cousins describes architecture as a weak discipline because its contents and boundaries are confused.[101] In contrast, a strong discipline has a clearly defined interior and precise boundary. Cousins distinguishes a strong discipline, such as one of the natural sciences, which is purely concerned with objects, from a weak discipline, such as architecture, which involves not just objects but relations between subjects and objects. A profession can indicate its command of a strong discipline and the strength of its practice because such a discipline appears constant and certain. But, as architecture is a weak discipline, the practice of architecture is also weak and the home of architects is anything but stable and solid.

For an individual or a family, home is the fusion of an idea and a place. One cannot easily be separated from the other, as the term 'homeless' indicates. Although the profession is an idea more than a place, it is often housed in a grand building, the physical manifestation of a psychological need, which is sometimes called the house of architects. The transfer from public to private in the seventeenth-century Dutch domestic environment has no direct historical parallel in the home of architects, which remains both public and private.[102] But this home, like other homes, is under threat from without and within. Threats from without include the incursions of users, designers, project managers and other building professionals into a practice that architects consider to be theirs alone, resulting in the architect's increasingly reduced role in building supervision, for example. As design-and-build contracts and project managers proliferate, architects' claim that design is their special skill becomes self-fulfilling, but the proportion of buildings they design remains small. Principal threats from within are the contradictions in a practice that endeavours to combine roles – artist, administrator and product specifier – with values and expectations that cannot be comfortably resolved.

A Weaker Home

A building is supposed to be solid and certain; so too is the practice of architects. One is a reflection of the other. Numerous procedures, such as building regulations and

101 Cousins, 'Building an Architect', pp. 16–17.

102 The guild was as much a home to master masons as the profession is to architects today.

contractual liability ensure that building fabric is solid and certain. As they want to be solidly respectable rather than sued, architects tend to repeat themselves. Threatened from within and without, they are caught in a vicious circle. To promote and defend their idea of architecture they adopt practices, forms and materials already identified with the work of architects, ever diminishing their home. As threats escalate and boundaries weaken, the desire for greater stability is evident in both the family home and the home of architects. Rather than a creative engagement with new conditions, the realization that a home is weak and becoming weaker often results in increasing desire for one that is strong.

2

hunting the shadow

DRAWING FORTH

Drawing the Architect

Associated with manual labour and dispersed authorship, the status of the architect was often low before the fifteenth century.[1] In the Middle Ages the three visual arts – painting, sculpture and architecture[2] – were arts 'confined to the artisan's guilds, in which the painters were sometimes associated with the druggists who prepared their paints, the sculptors with the goldsmiths, and the architects with the masons and carpenters'.[3] First trained in one of the building crafts, the master-mason was but one of many craftsmen and worked alongside them as a contractor and construction supervisor.

The Italian Renaissance offered the architect a new, much higher, status, due principally to the command not of building but of drawing, which was previously but a minor part of building production, a means to copy information rather than generate ideas.[4] Before the fifteenth century some preparatory drawings were made on surfaces that allowed them to be easily erased and only the most important were permanent.[5] Tom Porter writes that potential buildings were developed from 'architectural forms contained within the library of the existing built environment, using other buildings as full-size models or specimens which could be studied and then modified or refined'.[6]

Before the fifteenth century the drawing was thought to be no more than a flat surface and the shapes upon it were but tokens of three-dimensional objects. The Italian Renaissance introduced a fundamental change in perception, establishing the principle that a drawing is a truthful depiction of a three-dimensional world, and a window to that world, which places the viewer outside and in command of the view. 'The 'very word "per-spective" means through seeing', writes Tom Porter.[7] The invention of perspective developed alongside complementary research on the workings of the eye:

> The secret was out. The world is seen by the brain from images in the camera obscura
> of the eye . . . So at last eyes could be thought of as optical devices – mechanisms
> obeying laws of physics and optics. It was an important step philosophically as well as
> being practically useful, revealing the nature of images and perspective for pictures.[8]

New means of replication added further impetus to drawing. Previously information was copied by hand. Only with the invention of woodcut printing on paper at the

1 Kostof, 'The Practice of Architecture in the Ancient World', pp. 6, 11–12 and 26; MacDonald, pp. 28 and 37; Kostof, 'The Architect in the Middle Ages', p. 61.

2 In this chapter, the term 'visual arts' refers to painting, sculpture and architecture. The term 'art' refers to painting and sculpture, except in discussions of architecture as an art and the architect as an artist, and in terms of the conflict of art and life, which is found in all three visual arts. To distinguish between architects and other visual artists, I refer to architects and artists.

3 Kristeller, 'The Modern System of the Arts', p. 176.

4 There is some suggestion that drawing was used more frequently in the late Middle Ages.

5 Robbins, pp. 16–17.

6 Porter, The Architect's Eye, p. 10.

7 Porter, The Architect's Eye, p. 16.

8 Gregory, p. 35.

beginning of the fifteenth century was there an accurate means to replicate a drawing and disseminate it widely. Due to printing developments, cheaper paper, and new means of representation that made a direct, dimensioned and scaled connection between lines on paper and a physical object, the drawing became essential to architectural practice and building production, focusing attention on vision to the detriment of the other senses, such as touch.

The origins of the architectural drawing as an essential element of architectural practice and the architect as a distinct figure, knowledgeable in the visual and liberal arts, independent of the building trades, and associated with intellectual rather than manual labour, lie in the fifteenth and sixteenth centuries. The architect, as we now understand the term, is largely an invention of this period.[9] The (modern) architect and the architectural drawing are twins. Interdependent, they are representative of the same idea: that architecture results not from the accumulated knowledge of a team of anonymous craftsmen but from the individual artistic creation of an architect in command of drawing who conceives a building as a whole at a remove from construction.[10] From the fifteenth century to the twenty-first, the architect has made drawings, models and texts not buildings.

Designing the Architect

The histories of the architect and the architectural drawing are interwoven with that of architectural design. The term design comes from the Italian 'disegno', meaning drawing, suggesting both the drawing of a line on paper and the drawing forth of an idea. Informed by neo-Platonist theories common in the Italian Renaissance, disegno implies a direct link between an idea and a thing. As Vilém Flusser remarks: 'The word is derived from the Latin signum, meaning "sign", and shares the same ancient root.'[11] The conception of design established with the promotion of disegno in the Italian Renaissance states that an idea is conceived and drawn before it is built.[12] To design is, therefore, to draw forth. The sixteenth-century painter and architect Giorgio Vasari was crucial to its promotion: 'one may conclude that this design is nothing but a visual expression and clarification of that concept which one has in the intellect, and that which one imagines in the mind'.[13] Accordingly, rather than eternal and transcendent, an idea could be formulated and drawn forth as the product of creative thought.[14] Erwin Panofsky comments that 'In the middle of the sixteenth century it even became customary to designate not only the content of artistic imagination but also the capacity for artistic imagination with the expression "idea," so that the term approximated the word *immaginazione*.'[15]

9 Architects existed in ancient Egypt, Greece and Rome, for example, and even the medieval master-mason is sometimes described as an architect. But from this point in the text, the term refers to the architect since the beginning of the Italian Renaissance.

10 Only rarely, later in the Middle Ages, did a master-mason deserve and receive public credit for the conception of a building, and such credit was always secondary to the crown, church and God.

11 Flusser, p. 17.

12 Later in this chapter, however, I discuss the threats to this conception of design in the eighteenth and subsequent centuries.

13 Vasari, p. 205.

14 Panofsky, p. 62.

15 Panofsky, p. 62.

16 To claim the status of a liberal art, architecture also needed to show that it was an art that represented nature, for which there were two principal arguments. First, that it followed a natural model, as in a building such as the primitive hut. The second argument, 'developed in the eighteenth century, was that architecture did not represent the superficial appearances of nature, it could and did represent the principles inherent in nature'. Forty, pp. 223–224.

17 Wilkinson, p. 134.

Disegno enabled the three visual arts to be recognized as liberal arts concerned with ideas, a position they had very rarely been accorded previously.[16] Catherine Wilkinson writes:

> *Developed by Vasari (and others) into a theory of artistic creativity, disegno was the foundation of the liberal status of the practice of art, without which it would not have been possible to distinguish painting, sculpture and architecture from, say, silversmithing or furniture-making, and the artist from the craftsman.*[17]

Highly influential, Vasari's *The Lives of the Most Eminent Painters, Sculptors and Architects* was first published in 1550. Describing actual events and others of his own invention, Vasari presents painters, sculptors and architects as heroic figures, laying a foundation for the cult of artistic genius that was later developed in romanticism and modernism. The first significant history of art, *The Lives* marks the creation of the discipline of art history, from which architectural history developed. Vasari also formed the first collection to value drawings as original works of art, the Libro de' Disegni, and in 1563 founded the first art academy, the Accademia del Disegno in Florence. A model for later institutions in Italy and elsewhere, it enabled painters, sculptors and architects to converse independently of the craft guilds. The academy replaced workshop instruction with education in subjects such as drawing and geometry. Since the Italian Renaissance, whether in the studio or on site, the architect has often seen not matter but proportion and line. Asserting the pre-eminence of the intellect, disegno is concerned with the idea of architecture not the matter of building. Leon Battista Alberti notably states that 'It is quite possible to project whole forms in the mind without recourse to the material.'[18]

18 Alberti, *On the Art of Building in Ten Books*, p. 7.

The assumption that 'any artist could design a building since it was the conception of the work that mattered rather than the construction' was fully evident in fifteenth-century Tuscany, as was 'the custom of treating the three arts of painting, sculpture, and architecture as three branches of the same art of design'.[19] Painters and sculptors were commonly commissioned as architects, which Vasari noted and promoted. He furthered the idea of the artist-architect educated in drawing. But of over a hundred artists he mentions in *The Lives* only seven are architects. A number of these are cited not as an architect but as a sculptor and architect, painter and architect, or painter, sculptor and architect, which indicates a certain ambivalence towards the status of the architect in comparison to that of the painter and sculptor. In a discussion of the drawings in Vasari's collections, Wigley identifies a comparable ambivalence towards the architectural drawing:

19 Wilkinson, p. 134.

Andrea Palladio, San Petronio, Bologna, 1579. Façade. Courtesy of the Provost and Fellows of Worcester College, Oxford.

*Vasari . . . drew a frame around each of his drawings, a frame that signified their
elevation to the status of unique works of art by masking the edges of the sheet of
paper and thereby liberating the image from the material world . . . Yet the architectural
drawings in the collection are not framed (with the one exception of a design by Palladio
that receives the lightest frame possible). While this is understandable in terms of the
potential confusion of the architecture of the frame with the architecture that it frames,
the result is that the edges of the paper supporting architectural drawings are exposed.
The drawings were never fully liberated from the material world.* [20]

20 Wigley, 'Paper, Scissors, Blur',
p. 21.

The status of the architectural drawing is uncertain because its purpose is different
from that of the artwork. Robin Evans writes that 'Architectural drawings are projec-
tions, which means that organized arrays of imaginary straight lines pass through the
drawing to corresponding parts of the thing represented by the drawing.'[21] Whether a
perspective or production information, the architectural drawing refers to something
outside itself. Its value as a drawing is secondary to its primary purpose which is to
describe a building and, therefore, it is usually seen in conjunction with other drawings,
whether or not this leads to construction. In contrast to the architectural drawing, the
artwork has an aura because it is unique. It is often an end in itself rather than a
means to an end. The artwork is considered on its own, need not refer to an external
object, and thus appears further removed from the material world and closer to that
of ideas. However, the distancing of art from life, which I discuss in detail later in this
chapter, did not occur suddenly in the sixteenth century but progressively over the
following centuries.

21 Evans, 'Architectural Projection',
p. 19.

Whether celebrated in its own right or a precursor to another work, the drawing
by the painter or sculptor has a higher status than one by the architect, and famous
architects are more often known for their buildings than their drawings. But the drawing
is the key that unlocked the status of the architect and other visual artists. Associated
with intellectual rather than manual labour, the new status of the drawing and the
architect increased the status of the building. In the Italian Renaissance, architecture
was firmly established as a fitting expression of social status in an expanding mercantile
society. The patron and the architect acquired prestige through each other's actions
and support. The architectural drawing established a new etiquette of communication
between the various parties involved in architecture, allowing architects to commu-
nicate with patrons as learned equals.

Adrian Forty writes:

*The pervasiveness of 'design' is to do with the polarities it set up: 'design' provided a
means of creating opposition between 'building' and all that that implied on the one*

hand, and everything in architecture that was non-material on the other hand . . . In other words 'design' concerns what is not construction.[22]

22 Forty, *Words and Buildings*, p. 137.

In the new division of labour that occurred in the fifteenth and sixteenth centuries, design was distanced from construction and the construction site. The attention given to drawing increased the degree and value of design undertaken before construction and created new sites for architectural investigation, ones not necessarily dependent on the building site. Alongside the traditional practice of building, architects acquired new means to practice architecture – drawing and writing – increasingly as important as building.[23] To affirm their status as exponents of intellectual and artistic labour, architects theorized architecture in drawings and books, which could be produced in greater numbers than before after printing developments by Johannes Gutenberg in the mid-fifteenth century. The purpose of such books was to further the knowledge and status of the architect but not just among architects. The first thorough investigation of the architect as artist and intellectual in the Italian Renaissance, Alberti's *Ten Books on Architecture*, originally published around 1450, addressed the education of the patron rather than the architect. Less than fifteen years later, Antonio di Piero Averlino Filarete wrote *Treatise on Architecture*. Notably, as Forty remarks, 'Many of the Renaissance treatises, from Filarete onwards, laid particular stress on the importance of drawing as the first skill to be acquired by anyone aspiring to be an architect', a principle promoted by 'Sebastiano Serlio, whose *Tutte l'opere d'architettura e prospectiva* was the most popular of all sixteenth-century architecture books'.[24] Serlio was the first architect to take full advantage of the conjunction of words and images offered by the convergence of printing developments and architectural discourse. Mario Carpo writes:

23 The fabrication of three-dimensional elements, such as models and components, sits somewhere between drawing and building.

24 Forty, *Words and Buildings*, p. 30.

> *Unlike their ancient and medieval predecessors, Renaissance theorists had the means of simultaneously broadcasting both text and illustrations. The new multimedia approach existed in a complex dialectical relationship (in which causes and effects could not be distinguished) with a paradigm shift of some importance to the architectural culture of the early modern era.*[25]

25 Carpo, p. 45.

26 In this century and the last, however, texts written by architects tend to be less comprehensive than in previous centuries and address architects more often than a wider readership. Koolhaas' *Delirious New York* is an interesting exception.

Often a design does not get built and an architect must be persuasive to see that it does. Sometimes a building is not the best means to explore architectural ideas. Consequently, architects, especially famous ones, tend to talk, write and draw a lot as well as build. Serlio and Andrea Palladio are notable early exponents of this tradition, and Le Corbusier and Rem Koolhaas are more recent ones.[26] If, as Manfredo Tafuri contends, the project of modernity began in the fifteenth century not the twentieth,[27]

27 Tafuri, *Theories and History of Architecture*, p. 16.

28 In this book, the project of

modernity is distinguished from

modernism, which began in

the early twentieth century.

Both continue today. The term

postmodernism is not referred to, and

is within modernism, which has many

strands. For example, postmodernism

is comparable to the modernist

concern for the ambiguous object,

discussed later in this chapter.

the claim that the control of mass media is a defining characteristic of the modern architect applies to Serlio as much as to Koolhaas.[28]

Compatible with an emphasis on drawing, the proliferation of architectural publications affected the architect's experience and understanding of buildings. As Carpo writes:

Medieval master masons imitated buildings that they had only heard about. In order to see his model with his eyes, the medieval master mason necessarily had to visit the original site. For the Renaissance architect, it was often enough to visit the bookseller on the corner of his street . . . For many Renaissance architects, the Pantheon and the Colosseum were not places in Rome. They were places in books.[29]

It is common for architects to visit few of the buildings they admire. The noted building is nearly always first experienced as a representation – most likely a drawing or photograph – before it is experienced as a building. Once visited, such a building may delight or disappoint but the principle that it should be contemplated as an image continues to inform the architect's understanding of architecture.

As architects draw buildings and do not physically build them, the work of the architect is always at a remove from the actual process of building. This gap increased further in the twentieth century due to a change in the training of architects. Some countries, such as France, have a long history of architectural education in the academy. But in the twentieth century this became the norm internationally. Rather than architectural training occurring through building design, construction and supervision, it now occurs mostly through design, which, alongside space and form, Forty identifies as one of the three crucial terms in the vocabulary of modernist architecture.[30] While the architectural apprentice gained experience on mundane office tasks as the junior member of a team, the architectural student is the sole creator of a design, engendering a shift in expectation and ambition. The transfer of architects' training to the university made explicit the division between architectural design and building production, ensuring the prominence of the production of images and, to a lesser degree, words. Even more than before, the architect's status – artistic, intellectual and academic – is associated with the command of drawing and writing.

Independently or together, drawing, writing and building are all examples of architectural research and means to consider and develop architectural design and the architectural discipline. The relations between them are multi-directional. Drawing may lead to building. But writing may also lead to drawing, or building to writing, for example. If everyone reading this text listed all the architectural works that influence them, some would be drawings, some would be texts, and others would be buildings

either visited or described in drawings and texts. Studying the history of architecture since the Italian Renaissance, it is evident that researching, testing and questioning the limits of architecture occur through drawing and writing as well as building.

IDEA, NO MATTER

Shadow of a Shadow

Three interrelated concepts, each latent in disegno, underpin the status of the visual arts and are, therefore, relevant to the status of the architect, architectural design and architecture. First, that ideas are superior to matter; second, the autonomy of art; and third, the creation and contemplation of the artwork. The ancient Greek philosopher Plato, who lived from 427 to 347 BC, is crucial to the development of the concept that ideas are superior to matter and, thus, that intellectual labour is superior to manual labour. He claims that all the things we perceive in the material world are modelled on eternal, immaterial and ideal 'forms'.[31] Consequently, there are two distinct realms. One consists of ideal forms, which only the intellect can comprehend, the other of imperfect, natural and material copies subject to change and decay. As Jonathan A. Hale remarks: 'The higher realm of forms is itself controlled by a finite set of geometric and numerical relationships, a notion that Plato inherited from the Greek mathematician Pythagoras.'[32] According to Pythagoras and Plato, geometry is divine.

Plato distrusted art. As it mimics natural objects, which are already impure copies of pure forms, art merely adds one layer of misrepresentation onto another.[33] Flusser writes that 'Plato's basic objection to art and technology was that they betray and distort theoretically intelligible forms ("Ideas") when they transfer these into the material world. For him, artists and technicians were traitors to Ideas and tricksters because they cunningly seduced people into perceiving distorted Ideas.'[34]

The tracing of a shadow's outline is sometimes cited as the first drawing or painting, and a precursor to the painting as mirror image, its assumed superior.[35] In *The Republic* Plato states that the shadow is even further from the truth than the mirror.[36] Plato's distaste for shadows is evident in the allegory of the cave, in which men imprisoned since childhood are tied so that they can only see the shadows cast by the light of a fire, and not the objects from which the shadows are derived. Held prisoner, the men assume that the shadows are real. Let loose, they at first assume that the shadows are more real than the objects.[37] The allegory of the cave states that

31 Plato, *Timaeus*, p. 121. Plato defines matter as feminine and form as masculine. The term 'matter' refers to mater, mother in Greek. In French, German, Greek, Italian, Latin and Spanish, nature is feminine.

32 Hale, p. 49.

33 Plato distinguishes between arts that produce, and result in things, such as architecture, and arts that imitate, and result in images, such as painting, but considers the difference to be of little significance as things are but images of ideas. Tatarkiewicz, p. 45.

34 Flusser, pp. 17–18.

35 Stoichita, pp. 7–11. Alberti, *On Painting/De Pittura*, p. 61.

36 Stoichita, p. 25.

37 Plato, *The Republic*, pp. 203–206.

just as a shadow is an inconsistent, inaccurate and reductive representation of an object, so too is nature an inconsistent, inaccurate and reductive representation of the realm of ideal forms. Plato states that the material world is a shadow of the world of ideas, and a drawing is a shadow of a shadow. The allegory's message is that the deceptive, shadowy world of appearances should be rejected in favour of understanding the ideal forms on which they are modelled.[38]

Named in recognition of the revival and reinterpretation of Classical ideas, the Renaissance promoted a concept of beauty that favoured form rather than matter. Plato offered a model based on geometric subdivision and universal proportions, which Renaissance architects readily applied to the design of buildings. According to Marsilio Ficino, who founded the Platonic Academy in Florence and provided the first translation of all Plato's works into Latin, 'The beauty of bodies does not consist in the shadow of materiality, but in the clarity and gracefulness of form, not in the hidden bulk, but in a kind of luminous harmony, not in an inert and stupid weight, but in a fitting number and measure.'[39] Ficino's words are consistent with the allegory of the cave. He associates the shadow with the material not the immaterial, which is more often the case today. The dilemma facing the Renaissance architect was how to align architecture with the immaterial while sometimes acknowledging the matter of building. The buildings drawn in Palladio's *The Four Books on Architecture*, 1570, are not those actually built, as Vincent Scully notes:

> But the contrast between the built building and the published drawing is a perfect one in terms of the Renaissance aesthetic, since it is between the Real and the Ideal, the realities of material practice and the immaterial perfection of the Neoplatonic world view. Palladio's villas offer a kind of controlled case history of the basic tension that has done so much to shape western architecture from Antiquity onward.[40]

However, most architects of the time would have known Palladio's buildings through his drawings and seen the immaterial in a building as well as a drawing.

Forming an Idea

To justify the intellectual status of art, Italian Renaissance artists accepted the status of immaterial geometry but undermined Plato's argument that the artwork is always inferior to the idea it depicts. Instead, they argued that it is possible to formulate an artistic idea in the mind, produce the direct visual expression of an idea, and that an artwork can depict 'an otherwise unknowable idea'.[41] However, the degree to which

[38] In contrast to Plato, Aristotle sees no clear distinction between form and matter. But his theory had little influence on Renaissance architecture. While Plato believes that intellect alone is the path to truth, Aristotle recognizes the value of the senses. Aristotle, 'Metaphysics', pp. 790–792.

[39] Ficino, letter to Giovanni Cavalcanti, quoted in Hofstadter and Kuhns, p. 204.

[40] Scully, *Architecture: The Natural and the Manmade*, p. 317.

[41] Forty, *Words and Buildings*, p. 31.

a Renaissance artist was considered to be creative had limits. According to Plato the divine powers created the world by giving form to formless matter, while Christian theology states that God made the world out of nothing. As to be creative was to be divine, a Renaissance artist was rarely described as such and only in the eighteenth century was the term regularly applied to an artist as well as to God.[42]

Although the concept that ideas are superior to matter is still widespread and rarely questioned, Plato's assumption that ideas are synonymous with geometric forms is either ignored or evident as but an echo. In architectural discourse, there are two principal meanings of the term 'form'. Forty writes that 'There is in "form" an inherent ambiguity, between its meaning "shape" on the one hand, and on the other "idea" or essence: one describes the property of things as they are known to the senses, the other as they are known to the mind.'[43] To associate architecture with the immaterial, form as shape draws attention to the surface of a building not its mass. But form as idea is understood to exist on a higher level than form as shape, the more common use of the term in architectural discourse. To resolve this dilemma, the two meanings are sometimes (con)fused. The purity of (a geometric) shape is associated with purity of thought. For example, in Le Corbusier's early twentieth-century experiments with purism in art and architecture and his neo-Platonist description of architecture as the play of primary forms in light,[44] there is an echo of Plato's praise for the beauty of 'solids produced on a lathe or with ruler and square'.[45] As Karsten Harries remarks, 'We get here a hint why this perennial Platonism should so easily have allied itself with the machine aesthetic.'[46]

ART AND AUTONOMY

A Different Beauty

In *Theory of the Avant-Garde* Peter Bürger describes the transformation of art from sacral, to courtly, to bourgeois.[47] In sacral art, for example in the high Middle Ages, production was a collective craft, reception was collective and sacral, and the artwork was a religious cult object. In courtly art, for example at the court of Louis XIV, production was individual, reception was collective and social, and the artwork was a representational object. In bourgeois art, the artwork is produced by one individual and contemplated by another because its purpose is the 'portrayal of bourgeois self-understanding'.[48] Bourgeois art was fully formed by the end of the eighteenth century and continues today.[49]

[42] Kristeller, *Renaissance Thought and the Arts*, p. 250.

[43] Forty, *Words and Buildings*, p. 149.

[44] Le Corbusier, *Towards a New Architecture*, p. 31.

[45] Plato, *Philebus*, p. 51.

[46] Harries, *The Ethical Function of Architecture*, p. 229. Colin Rowe notes that the proportions of Renaissance architecture, especially Palladio's villas, influenced Le Corbusier's designs in the 1920s. Rowe, 'The Mathematics of the Ideal Villa'.

[47] Bürger, p. 48.

[48] Bürger, p. 48.

[49] Bürger, p. 49.

In the eighteenth century, the desire for a comprehensive overview was no less than in previous centuries but, with an unprecedented confidence in reason and empirical science, a new path to understanding was affirmed. For example, despite the development of the physical sciences in the seventeenth century, no theory of matter achieved wide acceptance to the degree that the theories of Isaac Newton, writing at the end of the seventeenth and beginning of the eighteenth century, were largely accepted for nearly two hundred years. Departing from the concept that matter is featureless, Newton concluded that material objects possess mass and are dependent on forces of attraction and repulsion as in a mechanical system.

Applying empirical investigation to the operations of the mind, John Locke, George Berkeley and David Hume ultimately fuelled the increasing emphasis given to individual experience in the eighteenth century, which culminated in romanticism at the end of the century.[50] In *Essay concerning Human Understanding*, 1690, Locke argues that ideas are not innate but dependent on experience, undermining the universality of ideas and distrust of the senses in Platonic theory.[51] Although Locke continues to prioritize vision, the mind is not indifferent to the body. Roy Porter writes:

> *'Ideas' arose from an external material thing (e.g. snow) provoking first a sensation and then a reflection which involved an 'idea': thus the sensation of snow would lead to the idea of 'white,' an 'idea' thus being the 'object of understanding.' Locke's usage was original: 'ideas' are in our minds, not only when we think but also when we see or respond to our sense inputs. The objects of perception were thus not things but ideas, which stemmed from objects in the external world but which also depended upon the mind for their existence.*[52]

Locke's aim was to understand how we think and identify the limits of what we know, as Ernest Tuveson acknowledges:

> *Yet through the ages men had assumed that the object of knowledge is truth – the real truth, whether of objects proper or of the transcendent ideas which the objects represent. Locke, on the contrary, asserted that the essences of things are unknowable, that all we can know assuredly is the ideas within our own circle of consciousness.*[53]

Stating that character and consciousness are not consistent and stable but products of experience – a dialogue between the material environment, senses, knowledge, memory and interpretation – empiricism countered the continental rationalist tradition in which certain knowledge is acquired by the mind alone. But empiricism also led to the identification of its own limits.[54] Norman Davies writes that: 'Hume,

[50] In that empiricism favours the analysis and ordering of information according to a logical system, it may spawn a means of investigation that dismisses intellectual speculation and denies anything that cannot be defined and objectified.

[51] Discussed in 'Index of Immaterial Architectures: Lily'.

[52] Porter, *Enlightenment*, pp. 63–64. Porter elaborates further in *Flesh in the Age of Reason*, pp. 75–77, 127, 470–474.

[53] Tuveson, p. 25.

[54] Porter, *Enlightenment*, p. 163.

whose *Treatise on Human Nature* (1739–40) pursues a rational inquiry into under-standing, passions, and morals, ends up denying the possibility of rational belief. Eighteenth-century rationalism concluded after all that irrationality may not be entirely unreasonable.'[55] In 1757 Hume wrote that 'Beauty is no quality in things themselves: it exists merely in the mind which contemplates them; and each mind perceives a different beauty.'[56] This new understanding of creativity transformed conceptions of art, the artwork, artist and viewer. No longer was art a cohesive body of knowledge of known values and images dependent on universal proportions, and neither was imagination tied to objective truth. The assumption that ideas are not innate and universal focused new attention on the operations of the individually creative mind. Wandering in a picturesque garden was one means to explore individual experience in the eighteenth century.[57] Appreciating an artwork was another.

The concept of the individual, drawn to socially acceptable pleasures, is useful to an expanding capitalist economy as it fuels consumption. But, apart from the activities of the entrepreneur, individualism is less compatible with the demands of production. In bourgeois society 'The citizen who, in everyday life has been reduced to a partial function (means-ends activity) can be discovered in art . . . Here one can unfold the abundance of one's talents, though with the proviso that this sphere remain strictly separate from the praxis of life.'[58]

The transfer from one art period to another was not smooth or sudden. For example, sacral and courtly art overlapped in fifteenth-century Italy in that production was individual and reception collective, but the artwork was either a religious cult object or a representational object.[59] The Italian Renaissance was the first stage in the development of the autonomy of art, which reached fruition as a concept in bourgeois society.[60] Art is autonomous in bourgeois society in the sense that autonomy 'defines the functional mode of the social subsystem "art": its (relative) independence in the face of demands that it be socially useful'.[61] In the second half of the eighteenth century, alongside science and morality/ethics, art emerged as one of three inde-pendent value systems within European culture, each with its own specific concerns.[62] Immanuel Kant provided the first detailed codification of the three systems in *Critique of Pure Reason, Critique of Practical Reason* and *Critique of Judgement*, published respectively in 1781, 1788 and 1790. As empirical investigation without a priori concepts is impossible, Kant concludes that we can gain certain knowledge not of reality but aspects of *our* reality.[63] Thus, he limits the authority of scientific reason and detaches aesthetic judgement from other concerns to affirm the creative imagi-nation. Aesthetic quality is subjective and potentially of common value but distinct from the useful. Consequently, architecture has limited aesthetic potential, less even than the garden, he decides.[64]

[55] Davies, p. 598.

[56] Hume, 'Of the Standard of Taste', pp. 136–137. See Forty, *Words and Buildings*, pp. 228–229.

[57] Discussed in 'Index of Immaterial Architectures: Lily'. With references to garden design, the 1780 treatise by Nicholas le Camus de Mèzieres advocates an architecture that focuses on the senses and emotions.

[58] Bürger, pp. 48–49.

[59] Bürger, p. 41.

[60] Dutch seventeenth-century paintings are a precursor to bourgeois art. Schama remarks that the strong sense of civic duty in seventeenth-century Dutch society means that to describe it as bourgeois is not totally accurate. Schama, p. 568.

[61] Bürger, p. 24.

[62] Skirbekk and Gilje, p. 293.

[63] Tarnas, p. 345.

[64] Kant, *Critique of Judgement*, p. 186.

The meaning of design changed somewhat in the eighteenth and nineteenth centuries. Opposed to utility, the classification of the fine arts – notably poetry, music, painting, sculpture and architecture – is primarily an invention of the eighteenth century. Associated with utility, the design disciplines that proliferated due to industrialization, such as product design, are categorized as applied arts at best. In the Renaissance a form was synonymous with an idea.[65] But in the nineteenth century a form could be without meaning and ready for mass production. With reference to the codification of formal type by J.N.L. Durand, Alberto Pérez-Gómez writes: 'The architect's only concern should be . . . the most convenient and economical "disposition". Here is the direct precedent of twentieth-century functionalism . . . The architecture of the Industrial Revolution owed to Durand the first coherent articulation of its principles and intentions.'[66] Among the fine arts, which include the three visual arts, only in architecture is the term design regularly used today. Many people associate design with the newer design disciplines, which affects how architectural design is understood. But in the discourse and practice of architects, the older meaning of design, as drawing ideas, and the newer meaning of design, as drawing appliances, are both in evidence, except that ideas are now understood as provisional not universal.

65 The Renaissance was named in recognition of the revival and reinterpretation of classical antiquity, notably Plato's claim that all the things we perceive in the material world are modelled on the ideal 'forms' of a divine geometry. Plato, *Timaeus*, p. 121.

66 Pérez-Gómez, pp. 302–311.

Art and the Avant-Garde

The early twentieth-century artistic avant-garde rejected the autonomy of art, which it characterized as a construct of bourgeois society intended, first, to contain art and, second, to exploit it for wider commercial application where possible. The avant-garde aimed to annul the distinction between art and life. But rather than merging art with the everyday life of bourgeois society, it aimed to establish an alternative fusion of art and life.[67] In 'The Author as Producer' Benjamin argues that the artist should no longer be a purveyor of aesthetic goods but an active force in the transformation of ideological processes.[68] In 'The Work of Art in the Age of Mechanical Reproduction' he states that mechanical reproduction, which substitutes a plurality of copies for a unique existence, eliminates the aura of art, redefines the boundaries of culture, and frees art from its dependence on tradition.[69] He concludes that industrialization offers collective production and reception on a massive and hitherto unknown scale, transforming the production of art from the representation of myths to the analysis of illusions and the reception of art from the ritualistic contemplation of the individual to the political perception of the masses.

According to Benjamin, montage, the principal artistic strategy of the early twentieth-century avant-garde, is the means of this transformation. Benjamin identifies

67 Bürger, p. 49.

68 Benjamin, 'The Author as Producer', p. 230.

69 Benjamin, 'The Work of Art'.

Baroque allegory as an important inspiration for twentieth-century montage.[70] But the value eighteenth-century empiricism gave to subjective experience also provided a context in which montage could later flourish. Montage involves the depletion of previous meanings and the formulation of new ones by the appropriation and dialectical juxtaposition of fragments in a new context. It is a procedure in which one 'text' is read through another. Montage is dialectical, internally within itself and externally to its context. As the resultant complexity often denies a simple resolution, the reader, viewer or user has a constructive role in the formulation of the work, and meaning is seen to be transitory and cultural.

Benjamin argues that montage is the essential characteristic of contemporary society and mass production, and that increased speed and fragmented space are common to both. Some commentators argue that the seamless networks of contemporary communication now dissolve the montage of experiences.[71] But the continuing importance of montage is evident in the computer and television. The computer is a montage machine in which material is scanned, collected, stored, combined and disseminated.

Benjamin often states that the value of montage depends upon its ability to shock, which he ascribes in particular, but not exclusively, to film. From Karl Marx, Benjamin appropriates the idea of a historically generated and collective dream. He aims to dispel the dream's mythic power by revealing its origins, thereby transforming dream images into dialectical images that shock the masses into wakefulness and place the positive aspects of the collective dream at the disposal of political action. With reference to Brechtian epic theatre he writes: 'Here – in the principle of interruption – epic theater, as you see, takes up a procedure that has become familiar to you in recent years from film and radio, press and photography. I am speaking of the procedure of montage: the superimposed element disrupts the context in which it is inserted.'[72] Through interruption, Brecht aimed to encourage a degree of critical detachment from the audience. As Benjamin writes: 'To put it succinctly: instead of identifying with the characters, the audience should be educated to be astonished at the circumstances under which they function.'[73]

Benjamin overstates the consequences of montage and the effectiveness of shock as a means to change perceptions. His predictions – the demise of the aura of art and the politicization of art through mass production – have proved incorrect. In reducing the distinction between art and life, the early twentieth-century avant-garde unintentionally helped to increase the number, type, location, and financial value of objects and practices identified as art. The continuing relevance of montage as a critical and creative tool and the effectiveness of shock and interruption are questionable now that montage is an accepted strategy of art and advertising. Today, art is evermore

70 Benjamin, *The Origin of German Tragic Drama*, pp. 159–161.

71 Baudrillard, pp. 126–127.

72 Benjamin, 'The Author as Producer', p. 234.

73 Benjamin, 'What is Epic Theater?', p. 150.

subject to the demands of the market. But in the face of all evidence to the contrary, the autonomy of art from life is restated. The aura of the unique artwork produced by one individual and contemplated by another maintains a hold over the familiar perception of art because it affirms the status and value of art. The (mythical) autonomy of art remains a concept useful to bourgeois society.

Architecture and the Avant-Garde

Bürger confines the avant-garde to the early twentieth century. In the post-war era he recognizes only a neo-avant-garde which 'institutionalizes the avant-garde as art and thus negates genuinely avant-gardist intentions'.[74] However, his characterization of the early twentieth-century avant-garde as the original and the post-war neo-avant-garde as the copy is pessimistic. Avant-gardism takes different forms at different times and, as Benjamin Buchloh asserts, even the repetition of an early twentieth-century avant-garde artistic strategy is not a simply a copy if the context is significantly different.[75]

74 Bürger, p. 58.

75 Buchloh, p. 43.

Bürger does not explain why architecture is absent from *Theory of the Avant-Garde*. For a number of reasons, the early twentieth-century architectural avant-garde must, at least in part, be defined in terms other than those commonly associated with the artistic avant-garde. First, one of the principles of montage – the incorporation of 'fragments of reality' that shock the viewer into formulating new understandings – is less effective in architecture because material fragments are expected in a building, and a fragment must be unusual to be noticed. Second, as architecture is socially useful and a visual art, the distinction between life and art is of limited relevance. Third, early modernist architects' criticism of bourgeois society was less categorical and consistent than that of the artistic avant-garde. Fourth, functionalism, which dominated early modernist architectural theory, is compatible with the principles of production in bourgeois society. Liane Lefaivre and Alexander Tzonis define functionalism as 'a rhetoric in the service of the mercantile class seeking to legitimize the norm of efficiency as the highest in all facets of human life'.[76] Referring to early modernist architecture, Larry Ligo remarks that 'the number of narrow functionalist statements in any one architect's writing probably outnumbered the statements about more profound aspects of architecture'.[77] But the statements of early modernist architects were often more functionalist than their buildings, some of which evoke strategies familiar to the early twentieth-century artistic avant-garde, such as montage, shock, the mass production of signs, and an alternative fusion of art and life.

76 Lefaivre and Tzonis, p. 40.

77 Ligo, p. 13.

Two distinct and contradictory models are evident in Benjamin's advocacy of montage. The first is didactic, intended to shock and offer little space for interpretation, countering the suggestion that in montage the viewer is creative. The directness and clarity of the message match the seamless combination of fragments into a coherent image.[78] The second is less likely to shock and more likely to resist a single interpretation. Ambiguous, incomplete and even confusing, it fully involves the viewer in the formulation of meaning. Offering no clear message, Benjamin's 1935 second draft[79] for *The Arcades Project*,[80] an investigation of the nineteenth-century Parisian arcades, is an example of ambiguous montage. The second model of montage is particularly appropriate to architecture. Shock may help to promote new ideas and spaces. But it wears off quickly and is only partly relevant to architecture as most buildings are experienced not all at once but over time and in fragments. The user's experience depends on complex juxtapositions of many moments and conditions that resist easy resolution.

Like art, architecture can be either didactic or ambiguous. Early twentieth-century art was often didactic, as was early modernist architecture. But architects promoted authority with one hand and ambiguity with the other. For example, the widely published entrance façade of the Paimio Sanatorium, with alternate rows of solid walls and windows, conforms to the tenets of functionalism. But the less photographed and less homogenous rear façade consists of distinct fragments. Both façades are crucial to the montage. Although the entrance façade, and an element such as the silent wash-basin,[81] is didactic and functionalist, as a whole the Sanatorium is ambiguous. Tafuri notes: 'What joins together the entire Modern Movement is . . . the concept of architecture as *ambiguous object* . . . The observer becomes more and more the user who gives meanings to the object or to the series, and who is more and more caught and absorbed in this ambiguous collocation.'[82] Tafuri identifies the origins of ambiguous modernism in the eighteenth century, which gave new value to individual experience and encouraged the production and exploration of ambiguous objects, such as the picturesque garden, in which meanings are relative not absolute, a process that the mass production of signs later extended.[83]

Two further projects – the Weissenhof Siedlung and Barcelona Pavilion – indicate the oscillation between the ambiguous and didactic in early modernist architecture. The Siedlung was built for a 1927 housing exhibition in Stuttgart organized by the Deutsche Werkbund, the German Arts and Crafts Society. The host city funded the Siedlung and acquired the houses and flats at the end of the exhibition. The Siedlung includes buildings by many noted modernist architects, such as Peter Behrens, Walter Gropius, Ludwig Hilberseimer, Le Corbusier, J.J.P. Oud, Hans Poelzig, Adolf Rading, Hans Scharoun, Max Taut and Mies, its curator. Within the overarching

78 Turning [...] politicians a[...] Heartfield p[...] of didactic montage. In *Hurrah, the Butter is Finished*, dated 19 December 1935, a quotation from a speech by Hermann Goering, 'Iron always makes a country strong, butter and lard only fat', is juxtaposed to the image of a family chewing iron. A photograph of Hitler hangs on the wall behind.

79 Benjamin, 'Paris, Capital of the Nineteenth Century'. The draft is divided into six sections. Each focuses on a specific dialectic, which is not consistent from section to section. For example, in the final section, 'Haussmann or the Barricades', the opposition between two ideas is more obvious than in the third, 'Grandville or the World Exhibitions'.

80 *The Arcades Project* is indebted to Louis Aragon's study of the Passage de l'Opéra, *Paris Peasant*. While Aragon, a surrealist, evokes the arcades, Benjamin traces the history of their production and identifies their importance as an early space of consumer capitalism. Benjamin, *The Arcades Project*; Aragon, *Paris Peasant*.

81 Discussed in 'Chapter 1: House and Home'.

82 Tafuri, *Theories and History of Architecture*, p. 84.

83 Tafuri, *Theories and History of Architecture*, p. 85; Benjamin, 'The Work of Art in the Age of Mechanical Production'.

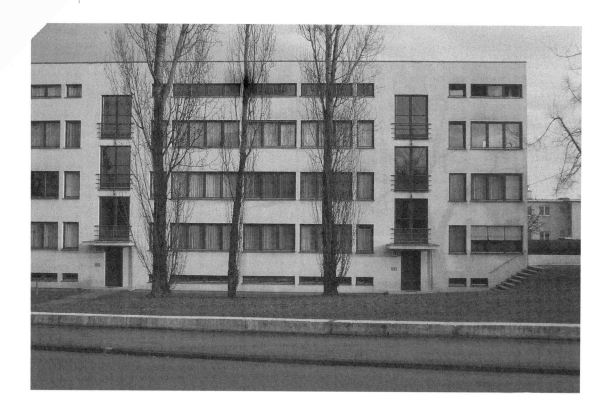

Ludwig Mies van der Rohe, Weissenhof Siedlung, Stuttgart, 1927. Front elevation. Photograph, Jonathan Hill.

theme of modernism, the Siedlung presents differing design agendas. For example, its curator was least devoted to functionalism. Considering function too unpredictable to influence design, Mies produced an outer frame that tenants could transform internally. Other designs, such as those by Scharoun and Rading, are more specific to site and function. The Siedlung presents a reasonably coherent image of early twentieth-century European modernism and encouraged the foundation of CIAM in 1928. A prototype built to test and promote a product, it furthered the mass production of signs as well as objects. Associated with internationalism and 'the progressive optimism of the Weimar Republic', its purpose was to bind together a new way of life and a new visual and spatial language.[84] Shocking at first and with a specific social agenda, as a building exhibition the Siedlung was didactic. But use may make an object more ambiguous. As housing it soon became familiar and open to the varied interpretations of its users. As curator and architect, Mies was aware of these two conditions: the didactic and the ambiguous.

Soon after the end of the Stuttgart exhibition, Mies designed the German Pavilion for the 1929 Barcelona Universal Exposition. The Barcelona Pavilion is sometimes

84 Jones, p. 11.

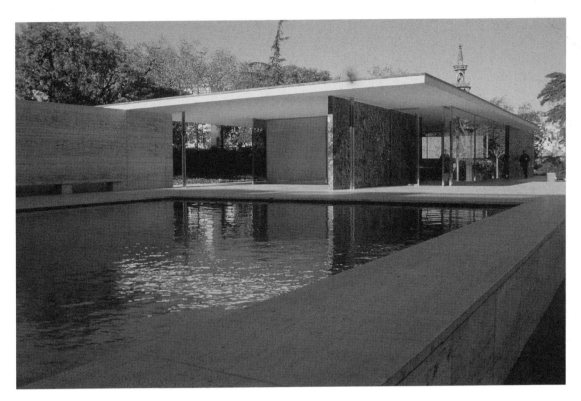

Ludwig Mies van der Rohe, Barcelona Pavilion, 1929–1930. Photograph, Simon Haycock.

associated not with the optimism of the Weimar Republic but with its indecision and conciliatory posture. Noted and damned for its silence, mud as well as praise has been thrown at the Pavilion. Evans describes it as 'the architecture of forgetting' because it denies the politics and violence of its time.[85] But Tafuri interprets its silence in more positive terms.[86] Mies commonly designed through perspectives as well as plans. Just a few lines and surfaces, with large areas of paper left blank, is typical of Mies' drawing style. The gaps in such a drawing are cognitive as well as spatial.[87] A similar concern is apparent in the building.[88] Shocking at first, as an exhibition of modernism the Pavilion was didactic. Abstraction and absence of everyday function added ambiguity.[89] But demolition in 1930 prevented it from being tested.

85 Evans, 'Mies van der Rohe's Paradoxical Symmetries', p. 268.

86 Tafuri, *Architecture and Utopia*, p. 148.

87 The montage of gaps is discussed in 'Index of Immaterial Architectures: Nordic Light'.

88 The Pavilion is discussed further in 'Index of Immaterial Architectures: Lily'.

89 Lack of function also underpins the Pavilion's status as an object of contemplation equivalent to an artwork, which I discuss in 'Index of Immaterial Architectures: Lily'.

CREATION AND CONTEMPLATION

Artist and Architect

The assumed superiority of intellectual labour depends on its opposition to manual labour. Tainted with manual labour before the Italian Renaissance, artists and architects have since endeavoured to identify their labour as intellectual. The practice of architects may involve less manual labour than that of the painter or sculptor, and the artwork may be as material as the building. But the artwork is more often associated with intellectual labour because it better answers a paradox: to be associated with the world of ideas a material object must be considered immaterial. The artwork is more likely to be understood as immaterial because of the way it is produced and experienced.

Intellectual labour is associated with individual production. In art the idea of the artist determines that a work is art, supported and validated by the gallery and other mechanisms of the art world. The fabrication of the artwork may occur elsewhere by others, who receive no public credit. A protective frame to the artwork, the gallery highlights intellect over artifice, the individual over the group. Artistic practice may involve a number of collaborations but the journey from idea to matter can appear direct and individual even if this is an illusion. Consequently, the artist can more convincingly claim authorship of the artwork than the architect can claim authorship of the building. The collaborative nature of architectural design and building production is more obvious and visible. Involving a team of architects, structural engineers, contractors, quantity surveyors, clients and others in negotiation with various statutory bodies, the many intermediaries and intermediary stages stretch and blur the link between idea and matter, author and product. However, a building of sufficient quality is usually described as the design of a single architect, most often the principal partner of an architectural firm. The illusion of sole authorship is important to architects because of the assumption that art is the product of individual creativity.

Viewer and User

Artistic interpretation is understood as subjective. But the interpretation of the artist and gallery is given greatest value and attention because it is assumed that subjective interpretation does not deny the authority of the artist and the potential for common meaning. The artwork in the gallery is primarily experienced in a state of contemplation,

which encourages an empathetic relationship between the viewer and the viewed. Benjamin identifies absorbed concentration as a quality of contemplation: 'art demands concentration from the spectator . . . A man who concentrates before a work of art is absorbed by it. He enters into this work of art the way legend tells of the Chinese painter when he viewed his finished painting.'[90] Contemplation reinforces the hierarchy of the senses – with vision at its pinnacle – that is a foundation of western culture. Juhani Pallasmaa writes:

> Since the Greeks, philosophical writings of all times abound with ocular metaphors to the point that knowledge has become analogous with clear vision and light the metaphor for truth . . . During the Renaissance the five senses were understood to form a hierarchical system from the highest sense of vision down to touch . . . The invention of perspectival representation made the eye the centre of the perceptual world as well as of the concept of the self.[91]

The contemplation of art is primarily a form of visual awareness, of a single object by a single viewer, in which sound, smell and touch are as far as possible eradicated. Placed in a hermetic enclosure and protected against decay, the artwork is seen and not used. The viewer leaves no trace or mark because touch would undermine the artwork's status as an idea and connect it to the material world. In contrast, everyday use brings the building's materiality to the fore. It is touched, marked and scuffed. The habitual and tactile experience of the building sits uneasily with the concept that ideas are superior to matter, limiting the building's status as an art object. Although it is possible to experience the building in circumstances similar to the contemplation of art, when visiting a famous monument for example, contemplation is not the most familiar or positive way to experience the building because it ignores the creative irreverence of the user. However, to affirm the status of the architect as an artist and architecture as an art, the experience of the building is often equated with the contemplation of the artwork in a gallery. Based on art history, architectural histories often discuss the building as an object of artistic contemplation and imply that this is the familiar experience of the building. The reader is encouraged to view the drawing as the fount of creativity and to equate the experience of the drawing with the experience of the building.[92] Due to its limited material presence, abstract representational codes, association with the world of ideas, and exhibition in galleries and museums, the architectural drawing aligns architectural design and architecture with intellectual labour and the individual production and appreciation of the artwork.[93]

[90] Benjamin, 'The Work of Art', p. 239.

[91] Pallasmaa, pp. 6–7.

[92] Viewing the photograph as an object of artistic contemplation further implies that this is the appropriate way to experience the building.

[93] Even though its status is less than that of the drawing by the artist.

ARCHITECTS OF ABSTRACTION

The Abstraction of Space

According to the early twentieth-century avant-garde, the autonomy of art ultimately serves capitalism because it allows non-productive intellectual speculation excluded in other areas of society, which can be contained and marginalized within art or adapted, applied and exploited for further profit beyond its boundaries.[94] Architecture is subject to some of the struggles for and against autonomy that are evident in the other visual arts, when a design is regarded as an object of artistic contemplation, for example. Lefebvre, however, contends that architectural design is neither speculative nor marginal and lacks any degree of autonomy. Instead it directly serves the market. The practice of architects is but one component of the abstraction of space in a capitalist economy, which fragments space into narrow specializations compatible with the division of labour. Each specialist is equivalent to a technician on the factory floor, conversant in a particular skill but with little understanding and awareness of the whole:

> The dominant tendency fragments space and cuts it up into pieces. Specializations divide space among them and act upon its truncated parts, setting up mental barriers and practico-social frontiers. Thus architects are assigned architectural space as their (private) property, economists come into possession of economic space, geographers get their own 'place in the sun,' and so on.[95]

The space assigned to architects is 'the space of the dominant mode of production . . . governed by the bourgeoisie'.[96] Forty remarks: 'For Lefebvre the capitalist domination of space, both by imposing functional categories upon it physically, and by imposing an abstract schema through which the mind perceived space, was one of capitalism's most innovative acts.'[97] Lefebvre concludes that users are the principal victims of the abstraction of space because they too are presented as abstractions and the lived experience and production of space is denied.

A concept with roots in the theories of Plato and René Descartes among others, the hierarchy of mind and body informs how architects consider users. In 1641 Descartes wrote: 'I am, I exist, that is certain. But how often? Just when I think.'[98] Rob Imrie notes that architects commonly define users as mental abstractions, ignoring bodily diversity, because they conceive the body as a machine and, consequently, as passive. He recognizes that such a conception is not particular to architects, and is equally evident in western science and medicine, for example:

94 Bürger, pp. 48–49.

95 Lefebvre, p. 89.

96 Lefebvre, p. 360.

97 Forty, 'Flexibility', p. 9.

98 Descartes, p. 53. *Discourse on Method and Meditations on First Philosophy* were first published in 1637 and 1641 respectively. This quotation is from the latter.

These conceptions of the body have their roots in the post-Galilean view which conceives of the physical body as a machine and a subject of mechanical laws. The body, in this view, is little more than an object with fixed, measurable, parts; it is neutered and neutral, that is, without sex, gender, race, or physical difference. It is residual and subordinate to the mind, or that realm of existence that is characterised by what the body is not; such as, self, thought, and reason.[99]

99 Imrie, p. 3.

The Production of Space

Lefebvre identifies the drawing as the architect's principal means to render spaces and users abstract. The drawing's primary purpose is to describe an object that contains and subdivides geometric space.[100]

100 According to Evans the drawing's hegemony over architectural practice has never really been challenged and is often unacknowledged. Evans, 'Translations from Drawing to Building', p. 156.

Within the spatial practice of modern society, the architect ensconces himself in his own space. He has a representation of this space, one which is bound to graphic elements – to sheets of paper, plans, elevations, perspective views of façades, modules, and so on. This conceived space is thought by those who make use of it to be true, despite the fact – or perhaps because of the fact – that it is geometrical: because it is a medium of objects, an object in itself, and a locus of the objectification of plans. Its distant ancestor is the linear perspective developed as early as the Renaissance: a fixed observer, an immobile perceptual field, a stable visual world.[101]

101 Lefebvre, p. 361.

The only architect Lefebvre praises, in a short passage on the Sagrada Familia, Barcelona, is Antonio Gaudí, who attempted to build without drawing and planning.[102] Evans writes:

102 Lefebvre, p. 232.

103 Evans, *The Projective Cast*, pp. 333–334.

Gaudí spent forty years on the Sagrada Familia, his final decade devoted exclusively and obsessively to modelling, building and carving it, yet at his death the portals and towers of one transept were barely complete. In the later stages, he had been able to dispense with architectural drawing, supervising everything personally instead.'[103]

104 Watson, p. 100.

105 In *Words and Buildings*, pp. 265–266, Forty writes that 'there were broadly three different senses in which "space" was used by architects and critics in the 1920s: space as enclosure; space as continuum; and space as extension of the body'. All remain familiar today.

Victoria Watson notes that 'Lefebvre does not mention the unusual circumstances of the church's production, but it is likely that he was aware of these circumstances and saw in them . . . the spontaneous production' he praises many times in *The Production of Space*.[104]

Most architects consider space to be malleable according to the order of the architect.[105] Rarely does an architect understand space in terms familiar to Lefebvre,

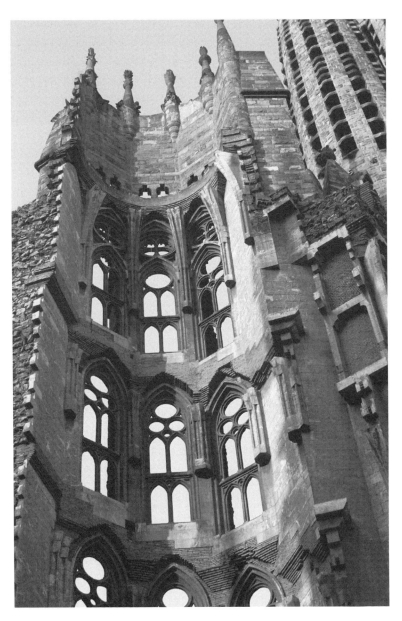

Antonio Gaudí, Sagrada Familia, Barcelona, 1882–. Photograph, Tanis Hinchcliffe.

as complex, grounded in everyday life, and made and transformed by experience.[106] Lefebvre describes the user in two ways, as a negative abstraction, and as an appropriator–producer attacking the functionalist domination and fragmentation of spatial practice. In a dialectical engagement of the body with the physical environment, the user is producer, appropriator and product of space, moving in reaction to the city and projecting bodily movements onto the city. Lefebvre writes that 'The user's space is lived – not represented (or conceived). Compared with the abstract space of the experts (architects, urbanists, planners), the space of the everyday activities of users is a concrete one, which is to say subjective.'[107] Lefebvre states that as the space of architects is designed not lived, architects have no authority over the space of the user and no part to play in the formulation of use, which appropriates and transforms buildings.

106 One such architect, Moholy-Nagy, is discussed later in this chapter.

107 Lefebvre, p. 362.

REDRAWING DRAWING

Drawing the Building

Architecture, architectural design and the architectural drawing are damned from many directions. Conceived as a one-way process, design accepts the superiority of the intellect, denigrates matter, and denies the creativity of the user and other specialists involved in building production. The drawing, which is synonymous with design, does much to define the status of the architect as an artist and architecture as an art, which the process of building and the experience and matter of the building may hinder. The drawing limits architectural innovation, serves property speculation, and fails to provide the means for a convincing dialogue with users. In the following pages I focus on what such assumptions ignore.

It is rare for an architect to build without drawing. Even if the architect begins to design without drawing, the drawing is nearly always the principal means of communication in all phases of building.[108] For the architect, the drawing is as real as the building. First, because the architect makes the drawing but not the building. Second, because the architect has greater control over the drawing than over the building. Third, because the drawing is closer to the architect's creative process: it is made before the building. However, the architect's absorption in the drawing is only a problem if it is unquestioned.

The architectural drawing depends on related but contradictory concepts. One indicates that design is an intellectual and artistic activity distant from the grubby

108 The drawing is less essential to the artist, and may have little relevance to contemporary art forms such as video art and performance.

materiality of building. Another claims that the drawing is the truthful representation of the building, indicating architects' mastery of the seamless translation of ideas into matter. Architects build drawings, models and texts. They do not build buildings. But architects often try to deny the gap between the representation and the building because it questions their authority. The drawing is a projection in that an invisible line links a point on the paper to one on the building. But the journey from one to the other is not direct. All representations omit as much as they include. The drawing, model, photograph and text all provide ambiguous and elusive information, an uncomfortable thought for any architect. Rarely do marks on paper equate to marks on site. To translate the drawing into the building requires an intimate knowledge of the techniques and materials of drawing and building.

To contradict Lefebvre, the drawing does have a positive role if the differences between the drawing and the building, and their similarities, are acknowledged and used knowingly. All practices need an articulate language to develop complex ideas and propositions before or without their physical application. The drawing is a means to explore and develop ideas, to speculate on space, form, matter and use. It also offers creative opportunities independent of the restrictions and compromises of building. A sixfold investigation of the architectural drawing is necessary. First, to consider how the architectural drawing and the building are similar and different. Second, to look at drawings elsewhere, studying other disciplines that have developed articulate means to draw qualities relevant to architecture. Third, to develop new ways to draw architectural qualities excluded from the architectural drawing and other drawings. Fourth, if these qualities cannot be drawn, to find other ways to describe and discuss them. Fifth, to focus on the architectural potential of the techniques of drawing. Sixth, to bring designing and building closer to each other.

Building the Drawing

On the one hand, bringing designing closer to building suggests building without drawing or at least that the importance of drawing is diminished, which questions the architect's status and practice. On the other hand – if to design is to draw – it means that drawing is building. The drawing is most often understood as a representation but it can also be an analogue, sharing more of the building's characteristics.[109] When architects assume that the drawing is similar to the building they usually mean that the building looks like the drawing. But the drawing as analogue allows more subtle relations – of technique, material and process – to develop between drawing and building. Here a dialogue exists between what is designed and how it is designed,

109 The architectural drawing may also be an analytical representation not intended for building, as in Evans, *The Projective Cast*, and Steadman, *Vermeer's Camera*.

between design intention and working medium, between thought, action and object. Building the drawing as well as drawing the building. For example, if the building is to be made of artificial light, it can first be modelled in artificial light and drawn in photograms so that the techniques and materials of drawing are also those of building. As an analogue to the building, the drawing can be cut, a line built, erased and demolished. Discussing her experience as a student and tutor, Elizabeth Diller writes that 'At Cooper, drawings didn't just happen. They were constructed, analogously to buildings . . . Erasure was additive – a white scar of a thought undone and left in the drawing as part of its permanent record. Dirt was evidence of labour expended.'[110] In building the drawing any instrument is a potential drawing tool that can question the techniques of familiar building construction and the assumed linearity of design, so that building and drawing occur in conjunction rather than sequence, as in Juliet Quintero's proposal for Alices' House, 2004.[111] The house explores the relations between the private Alice Liddell and her public but fictional other, Alice of *Alice's Adventures in Wonderland*.[112] Fusing electromagnetic technologies, crystallized sugar and Victorian furnishings, the gradual building of the house mirrors the identity of Alice as she frees herself from the confines of the narrative world, and returns to a reality where the architecture of the home breaks the grip of eternal childhood.

110 Diller, 'Autobiographical Notes', p. 131.

111 Jonathan Hill and Elizabeth Dow, tutors, Diploma Unit 12, The Bartlett School of Architecture, University College London, 2004.

112 Lewis Carroll, *Alice's Adventures in Wonderland*, was first published in 1865.

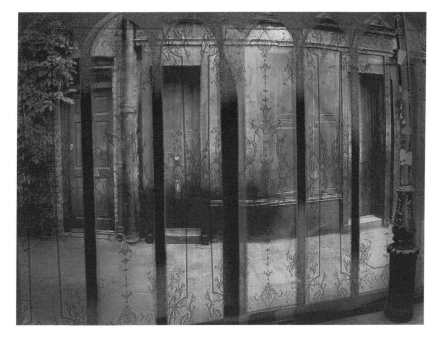

Juliet Quintero, Alices' House, 2004. Conservatory of sugar glass and silver leaf. Courtesy of Juliet Quintero.

Juliet Quintero, Alices'
House, 2004. Detail, curtain
wall of crystallized sugar
and nylon. Courtesy of
Juliet Quintero.

Juliet Quintero, Alices'
House, 2004. Detail,
static wallpaper. Courtesy
of Juliet Quintero.

As a representation, the drawing may consider all the senses but vision is usually its primary concern. As an analogue, a more direct engagement with the senses is possible. Conceiving the drawing as an analogue, as well as a representation, is a means to make the experience of the drawing a little more like that of the building and thus to begin to consider the creative appropriations of the user. The architect's understanding of space, like that of the user, can combine the objective and the subjective, the concrete and the conceptual. Contrary to Lefebvre's claim that design cannot engage issues of use, it is essential that architects understand the type of user a design suggests. The user can be passive, reactive or creative whatever the character of the space, but space and use often inform each other.

Drawing the Digital

Today most architectural drawings are produced on the computer, for which significant claims are made. But does it indicate a fundamental change in the practice of architects? In a number of ways, drawing on the computer is similar to drawing on paper. First, the frame of the computer screen isolates drawing from the material world, which recalls the drawing board that frames the paper placed upon it. Second, the computer drawing may begin with a surface that is black or coloured rather than white, and depict meaty objects rather than airy lines. But it extends earlier investigations into the immaterial because it is illuminated, and light is synonymous with space. Referring to the Italian Renaissance, Evans remarks: 'So too in architectural drawing, light showed up late. And what it showed up when it arrived was space.'[113]

113 Evans, *The Projective Cast*, p. 109.

Third, whether paper or illuminated, the drawing surface and the lines upon it are understood as immaterial. Current concern for the virtual develops the architect's long fascination for the immaterial. Fourth, the computer drawing is still primarily concerned with the depiction of objects that define spaces, and architects continue to associate architectural development with formal development. Fifth, the computer can combine two, three and four dimensions but so can the drawing on paper if it is an analogue or combined with a model. Sixth, the roles performed by computer drawings, such as the provision of production information, are similar to those of earlier drawings.

Seventh, rather than look down at the drawing board, the architect faces the computer screen as if it is a window or mirror. But, as architects already view the drawing as a window to another world and a mirror of the self, moving from the horizontal to the vertical is unlikely to engender a significant transformation in perception and production. Equally, there is little indication that writing has changed significantly due to the shift from a horizontal to a vertical surface.

Eighth, the CD has not replaced the book, neither has the internet superseded the library and museum. Libraries existed before the invention of the printing press but contained far fewer books. Mechanical printing increased both the number of different books and the number of copies of a specific book. It made possible the extensive cataloguing and cross-referencing associated with the modern library, which mirrors at a larger scale the system of notes within a book. The internet works in a comparable manner but at an even greater scale and speed. Using a search engine is much faster than wandering past lines and lines of book stacks, if not necessarily more enjoyable. Offering extra opportunities to play with space and time, the computer facilitates rapid and simultaneous interactions between diverse information and diverse individuals. It allows the juxtaposition of media – digital animation, film and music – unlike the words and pictures available in a library.[114] The desire to collect the world together in one place is not new, however. One precursor to the internet is the seventeenth-century cabinet of curiosities – a museum in miniature – which displayed its collector–curator's knowledge and travels. Another precursor is the grand museum of the Enlightenment.[115] The internet combines the scale of the museum and the idiosyncrasy of the cabinet of curiosities. The multi-media juxtapositions of the computer are additions to those already available in libraries and museums. That spatial and temporal juxtapositions are more readily available does not mean that the desire to make them is new. For example, it is sometimes assumed that the CD is spatial and the book is linear, but many books are neither conceived nor experienced from beginning to end.

The computer does transform design in significant ways, however. First, the 'original' drawing is within the computer not on paper, and it can very easily be changed, further confusing the idea of an original artwork hand-drawn by an individual artist.[116] Often a digital presentation drawing looks more like a photograph than a drawing, depicting a deceptive 'reality' for marketing purposes rather than an abstract ethereal language for artistic status. To gain photography acceptance as an art and admittance to the art gallery, which it was at first denied, photographers either destroyed the negative or produced a limited number of prints. Such tactics are applicable to the digital image. Second, although computer drawing seems to entail removing or overlaying a surface, the digital field remains. Only when printing occurs is ink actually overlaid on paper. Drawing on paper allows one material to be laid on another, and drawing to be analogous to building. Even more than the drawing on paper, the digital image is likely to be only a representation, unless, for example, the architect wants to build with artificial light, when it can be an analogue too. The digital image continues the tradition Evans identifies – of drawing as drawing light – but differs in that it is an actual and artificial illumination rather than a representation of natural illumination. Once printed, however, it is a representation.

114 But not the pleasure of touching a book.

115 Discussed in 'Index of Immaterial Architectures: Lily'.

116 Advances in printing between the sixteenth and twentieth centuries had already confused the status of the architectural drawing.

Two further transformations are still more significant: CAD/CAM and cybernetics. Since the Italian Renaissance, the status and practice of the architect have depended upon the command of drawing over building and the distance of drawing from building, two ideas in uneasy partnership. Most architects draw on the computer much as they draw on paper, as a means to visualize form. The conjunction of computer-aided design (CAD) and computer-aided manufacture (CAM) offers quite different potential supported by rapidly increasing computational capability. CAD/CAM aligns thinking, drawing and making, so that the architect can more accurately claim that to be in command of drawing is to be in command of building. But CAD/CAM also allows design to more readily become a fluidly collaborative process that reflects and responds to a complex range of factors and opinions, shifting the economics of building production towards customization rather than repetition, as in sixteen* makers, Blusher, 2001.[117] CAD/CAM allows the architect to communicate with fabricators and other building consultants, such as the structural engineer, directly via the computer. As paper is absent and ideas are applied, the drawing is less readily understood as an isolated artwork. Bringing building closer to drawing and the ambiguities of architectural authorship to the fore, CAD/CAM questions the history of the architect and division of labour in a manner that recalls the thirteenth century as well as the twenty-first. In that it depicts actions and objects in four dimensions rather than plans

117 Phil Ayres, Nick Callicott, Chris Leung and Bob Sheil are the members of sixteen* makers.

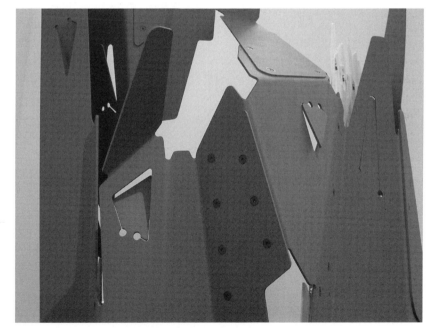

sixteen* makers, Blusher, 2001. Installation at the New Art Gallery Walsall, 2001. Photograph, Nick Callicott. Courtesy of sixteen* makers.

sixteen* makers, Blusher,
2001. CAD/CAM data
for tool path of CNC
plasma cutter. Courtesy
of sixteen* makers.

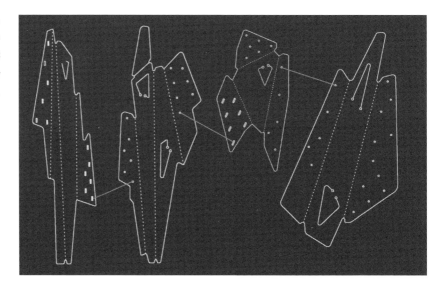

sixteen* makers, Blusher,
2001. Steel fabrication
undertaken by Ehlert GmbH,
Güsten, Germany.
Photograph, Nick Callicott.
Courtesy of sixteen* makers.

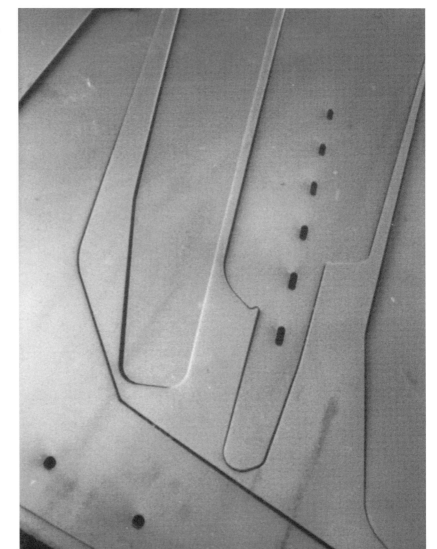

and elevations in two, CAD/CAM investigates building as a process as well as the building as an object, providing added relevance to drawing as an analogue to building and the drawing as an analogue to the building.

Informed by cybernetics, which identifies similarities in the processing of information in organic and inorganic systems, some architects advocate the computer's ability to model the behaviour of natural systems.[118] In *An Evolutionary Architecture*, 1995, John Frazer proposes a natural model for architecture, with the computer as facilitator. In a continuous and interactive dialogue with its environment, architecture here is a dynamic system that emerges, mutates and evolves in a non-linear, iterative manner: 'Not a static picture of being, but a dynamic picture of becoming and unfolding – a direct analogy with a description of the natural world.'[119] Evolutionary architecture repeats the promotion of causality and efficiency in functionalist theory. Ligo and Edward De Zurko discuss functionalist theory in terms of three analogies, the mechanical, moral and organic, all implicit in Frazer's thesis.[120] The mechanical analogy draws a relationship between the characteristics of the building and the machine. The moral analogy states that, in honestly displaying its purpose and the relations of its parts, the building can act as a model for user behaviour.

> The organic analogy calls attention to qualities that architecture has or should have in common with nature as represented by either plant or animal life. The organic analogy began as a simple comparison of external forms and their relation to function; it developed, especially around 1750, toward a comparison of the process by which natural and created forms grow.[121]

In recognition that needs are often changing and unpredictable, mid-twentieth-century reactions to functionalism focused initially on flexibility, which assumes that a building can absorb or adapt to reflect changes in use. Although it is not determinist, flexibility is a continuation of functionalist principles in that it assumes that the architect can create a system that caters for the users' future needs. Evolutionary architecture is a further extension of the tradition that leads from functionalist theory to flexibility. But it departs from both in that evolutionary architecture is as responsive to its environment as it is to the architect or user. In functionalist architecture there is but one designer, the architect, and the user is passive. In flexible architecture the user is reactive more often than creative. In evolutionary architecture the architect is not the only designer. The term 'design' no longer applies just to the process before construction but continues throughout the building's life. Computers are involved in the initial design process and the building's operation. Rather than the building serving the user or the user serving the building, they co-operate with each other.[122]

[118] Norbert Wiener first defined cybernetics in the mid-twentieth century.

[119] Frazer, p. 103.

[120] Ligo, p. 9; De Zurko, p. 45.

[121] Ligo, p. 9.

[122] Pask, p. 80.

Frazer headed the team of computer consultants on the Generator Project, 1976, Cedric Price's proposal for a company retreat for the Gullman Paper Corporation, Florida. The Generator was a collection of interchangeable components on a grid of foundations with an integrated computer system that allowed rapid changes of arrangement and configuration. However, Frazer and his team were concerned that the Generator's users would not fully recognize and utilize its potential for change. As boredom is 'a characteristic of intelligence, and therefore of the Generator' they proposed that it would 'make suggestions for its own reorganization' to stimulate users into action.[123] In addition to the architect and user, in Price and Frazer's proposal there is another animate and creative participant in the formulation of architecture: the building, sometimes reacting to the other participants, sometimes acting independently. The assumption that architecture is made for its users is subtly addressed in such work. The Generator questions the assumption that it is possible to create a building that meets the needs of its users and suggests, instead, that an animate and unpredictable building may be a more stimulating companion. Price concludes that 'Architecture should have little to do with problem-solving – rather it should create desirable conditions and opportunities hitherto thought impossible.'[124]

123 Frazer, p. 41.

124 Price, 'Generator Project', p. 86.

Drawing the Building and Building the Drawing

The term 'design' has many meanings. One refers to an idea in the mind, others to a process, an object described in a set of drawings, an object constructed, and an idea that leads seamlessly to building. These various meanings can be complementary, binding idea, drawing and object. But that they are as often contradictory is positive rather than negative, encouraging a knowing and subversively creative response to both drawing and building. Drawing the building and building the drawing are two alternatives of architectural drawing. But they may also be compatible activities that occur either in sequence or together. Particular pleasure and creative tension exists where representation and analogue overlap, one feeding the other. The construction of a physical prototype, building a drawing with tangible architectural qualities, CAD/CAM and cybernetics are each valuable to the architect interested in the analogue as well as the representation.

DRAWING THE IMMATERIAL

Immaterial Paper, Immaterial Line

Building the drawing means that the drawing is a physical construction with tangible architectural qualities and that the drawing is analogous to the building in terms of its production and reception. Conceiving the drawing as an analogue means that it can become more like the building but it also enables the building to be more like the drawing. For example, a line drawing literally suggests a building of line not mass. Some of the most innovative architectural developments have arisen not from speculation in building but through the translation of particular qualities of the drawing to the building. One important characteristic of the drawing – that it is associated with mind rather than matter and is less material than the building – encourages architects to build with an equal lack of material, to try to make architecture immaterial. That the products of architects' daily endeavours – words and drawings – are of limited physical presence undoubtedly affects what they do and think, whether conscious or not. We pretend that the drawing paper and the lines upon it are not there. We pretend that they are immaterial. Wigley writes:

> Paper . . . occupies a liminal space between the material and the immaterial. This allows it to act as a bridge across the classical divide between material and idea. Drawings are seen as a unique form of access to the thoughts of the people that make them. Indeed, they are simply treated as thoughts. It is as if the materiality of the medium is transformed by the quasi-immateriality of the support rather than simply exposed by it. A certain way of looking at paper, or rather a certain blindness to it, allows physical marks to assume the status of immaterial ideas. [125]

Immaterial Space

One of the defining characteristics of modernism – the manipulation of space – further aligns the practice and product of architects with the immaterial and intellectual. Forty writes that 'More than anyone else, it was the German architect and theorist Gottfried Semper who was responsible for the introduction of "space" as the principal theme of modern architecture.'[126] Most theories identify the origins of architecture in a solid and protective home. Semper argues, however, that architecture originates in the woven fabrics that generate and enclose domestic space when placed on the ground

[125] Wigley, 'Paper, Scissors, Blur', p. 11.

[126] Forty, Words and Buildings, p. 257. For a detailed discussion of the many uses of the term 'space' in architecture, refer to Forty, Words and Buildings, pp. 256–275, and van de Ven, Space in Architecture. For a discussion of space in relation to light and Mies' aphorisms 'less is more' and 'almost nothing', refer to 'Index of Immaterial Architectures: Milky-White Glass' and 'Night Light'.

127 Semper, 'Style in the Technical
and Tectonic Arts or Practical
Aesthetics', p. 254.

128 Semper, 'Style in the Technical
and Tectonic Arts or Practical
Aesthetics', p. 254.

129 Space is sometimes identified
with the material rather than the
immaterial, for example by Plato. For
further discussion of Semper, refer to
'Index of Immaterial Architectures:
Fireworks' and 'Sgraffito'.

130 Wigley cites Adolf Loos and Le
Corbusier as architects who continued
Semper's appreciation of dressing.
Wigley, *White Walls, Designer
Dresses*, pp. 10–11. For a discussion
of Loos, refer to 'Index of Immaterial
Architectures: Sgraffito'.

131 Mallgrave, p. 13.

132 Mallgrave, pp. 2–6.

133 As early modernist buildings
were first depicted in black and white
photographs, their walls were often
presented as white even if this was
not the case in reality.

134 In 'Chapter 1: House and Home'
I note the association of the white
modernist wall with the white male
body. However, I do not consider the
immaterial to be gendered.

135 To make the wall seem
weightless and a continuous surface,
an early modernist window often had
a thin frame set close to the outer
edge of the window reveal.

136 Moholy-Nagy, p. 60. Other
notable advocates of architecture as a
dynamic space–time continuum are
Theo van Doesburg and El Lissitzky.

or hung in the air: 'it remains certain *that the beginning of building coincides with the beginning of textiles*'.[127] He further contends that the woven fabric has precedence over the solid wall:

> for it remains certain that the use of the crude weaving . . . as a means to make the 'home,' the inner life separated from the outer life, and as the formal creation of the idea of space – undoubtedly preceded the wall . . . The structure that served to support, to secure, to carry this spatial enclosure was a requirement that had nothing directly to do with space and the division of space.[128]

In defining the first architectural act to be the enclosure and generation of domestic space by surfaces of little substance – lines woven into fabric – Semper doubly ties architecture to the immaterial.[129]

Modernism acquired from Semper added fascination for space and a delicate dressing as thin as paint and reminiscent of paper.[130] In 1834 Semper produced a short pamphlet, *Preliminary Remarks on Polychrome Architecture and Sculpture in Antiquity*, which 'in many respects provides the key to his later theory'.[131] In agreement with early nineteenth-century research,[132] and countering previous assumptions that ancient Greek architecture was unadorned, Semper argues that it was dressed in paint, noting that even white marble received a layer of white paint. In the early nineteenth century, ancient Greek architecture was the focus of a wider debate between the merits of monochromatic forms and polychromatic surfaces. Early modernism refers to both traditions in that it assumes that light plays best on forms that are dressed in layers of paint and render. Early modernist walls are usually of a single colour but white[133] is especially favoured because it consciously recalls moral rectitude and subconsciously recalls white drawing paper.[134] White paper seems not to be there and a dressing of white paint makes form appear less material,[135] affirming the artistic and intellectual status of architectural design. Although it is nearly a hundred years old, the language of early modernist architecture is replicated over and over again today. Even when forms are newly drawn on the computer, surfaces such as titanium continue the desire for an architecture as insubstantial as paper.

Many early modernist architects considered space to be the essence of architecture. But some rejected space as enclosure, associated with Semper, in favour of a dynamic space–time continuum, which Moholy-Nagy articulates in *Von Material zu Architektur*, a 1928 Bauhaus publication translated into English in 1930 as *The New Vision: From Material to Architecture*.[136] In the preface to the 1947 edition of *The New Vision*, Walter Gropius writes: 'Today we are confronted by new problems, e.g., the fourth dimension and the simultaneity of events, ideas foreign to former periods,

but inherent in a modern conception of space.'[137] Moholy-Nagy's understanding of space relies on early twentieth-century developments in art and physics. Questioning linear perspective, cubists noted that we understand a space not just in an instant but in relation to all our other experiences of that space accumulated over time from many viewpoints. In the 1905 theory of special relativity and 1916 theory of general relativity Albert Einstein refutes the Newtonian distinction between energy and matter, as mass.[138] Describing space as a dynamic field defined by the three dimensions of space and one of time, Einstein writes:

> Till now it was believed that time and space existed by themselves, even if there was nothing else – no sun, no earth, no stars – , while now we know that time and space are not the vessel for the universe, but could not exist at all if there were no contents, namely no sun, earth and other celestial bodies.[139]

Moholy-Nagy agrees that space does not have an independent existence: 'A definition of space which may at least be taken as a point of departure is found in physics – "space is the relation between the position of bodies".'[140] But these bodies are mere necessity, his principal concern is the relation between spaces: 'Space creation becomes the nexus of spatial entities, not building materials. Building material is an auxiliary, just so far can it be used as medium of space-creating relations. The principal means of creation is the space itself.'[141] Moholy-Nagy describes space as *'this material'*[142] and writes that 'The phrase "material is energy" will have significance for architecture by emphasizing relation, instead of mass.'[143] The recognition that matter is energy focuses attention on space as a kinetic force-field of fluid relations and minimal substance, he contends. Space is the material of immaterial architecture.

Identifying light as a principal means to articulate space Moholy-Nagy experimented with a number of media, including photography, film and installations. Exposing objects on light-sensitive paper for a controlled time period produces a photogram, a technique probably invented by William Fox Talbot in the 1830s, and often used by Moholy-Nagy. The photogram reverses the relationship between solid and light so that objects appear ethereal and space tangible. Between 1922 and 1930, Moholy-Nagy created *Light–Space Modulator*, which consists of polished discs and screens that reflect light and cast shadows as they rotate. Combining mechanism, light and shadow, *Light–Space Modulator* exists as a complete work only in motion. *Light Play Black–White–Grey*, the title of Moholy-Nagy's 1932 film of *Light–Space Modulator*, further aligns light with space.

Moholy-Nagy's identification of light with space is common among architects and confirmed by Gropius in his preface to *The New Vision*.[144] In 1928 Giedion wrote that

137 Gropius, 'Preface', p. 6.

138 Einstein.

139 Einstein, from an interview in *The Times*, 1919, repeated in van de Ven, p. 45.

140 Moholy-Nagy, p. 57.

141 Moholy-Nagy, p. 62.

142 Moholy-Nagy, p. 57.

143 Moholy-Nagy, p. 61.

144 Gropius, 'Preface', p. 6.

László Moholy-Nagy,
Light–Space Modulator
(Licht–Raum Modulator),
1922–1930, reconstructed
1970. Courtesy of Collection
Van AbbeMuseum,
Eindhoven.

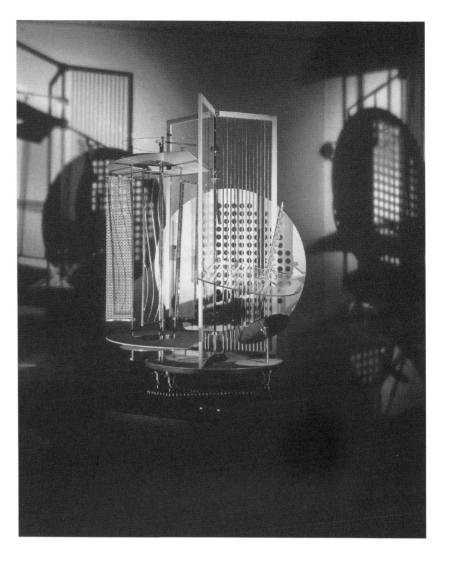

145 Giedion, *Building in France*,
p. 169. Giedion refers to Le
Corbusier's housing at Pessac, 1926.

'There arises – as with certain lighting conditions in snowy landscapes – that dematerialization of solid demarcation that distinguishes neither rise nor fall and that gradually produces the feeling of walking in clouds.'[145] Giedion's *Space, Time and Architecture* owes a considerable debt to Moholy-Nagy. First published in 1941, well after the early experiments in modernism, *Space, Time and Architecture* was written in hindsight and defined canonical modernism for many years afterwards. Giedion presents modernism as a coherent movement with the concept of space–time linking architecture to developments in physics and art, implying that the intermingling of

disciplines mirrors the intermingling of spaces. He quotes the mathematician Hermann Minkowski speaking in 1908: 'Henceforth space by itself, and time by itself, are doomed to fade away into mere shadows, and only a kind of union of the two will preserve an independent reality.'[146] In art Giedion notes the importance of cubism: 'The presentation of objects from several points of view introduces a principle which is intimately bound up with modern life – simultaneity . . . The cubists dissect the object, try to lay hold of its inner composition. They seek to extend the scale of optical vision as contemporary science extends the law of matter.'[147]

As in the 1920s, architects today assume that space is a defining characteristic of architecture. Semper and Moholy-Nagy – respectively the most articulate advocates of space as enclosure and space as continuum – also identify space as extension of the body, Moholy-Nagy in more dynamic terms than Semper. Moholy-Nagy remarks that through movement users can adjust their experience of space. With regard to space creation he mostly refers to architects. But he also suggests that the creation and experience of space can be one: 'The dance is an elemental means for realization of space-creative impulses. It can articulate space, order it.'[148] Here, Moholy-Nagy understands space as an extension of the body in dynamic relations with other spatial forces.[149] Such a conception of space locates the immaterial in experiences rather than abstractions. An alternative to Lefebvre's advocacy of space made by the user and many architects' advocacy of space made by the architect, Moholy-Nagy cites the spatial creativity of the architect and the user.

Hunting the Shadow

In *The Ten Books on Architecture* Vitruvius writes that knowledge of geometry, philosophy, music, medicine, law and astronomy is as important as an expertise in building construction.[150] He adds, however, that 'architects who have aimed at acquiring manual skill without scholarship have never been able to reach a position of authority to correspond to their pains, while those who relied upon theories and scholarship were obviously hunting the shadow, not the substance'.[151] Vitruvius is correct in his assumption that some architects are hunting the shadow, but not one limited to or by theory. Hunting the shadow, hunting immaterial architecture, is an important and creative architectural tradition invigorated by theory.

From antiquity to the twentieth-first century the concepts of matter in art, science and philosophy have changed many times but the assumed inferiority of matter has not. The highly influential concept that ideas are superior is nothing but a prejudice. One option is to dismiss it, concluding that its effect on architecture is negative because

146 Giedion, *Space, Time and Architecture*, p. 14.

147 Giedion, *Space, Time and Architecture*, pp. 432–443.

148 Moholy-Nagy, p. 57.

149 Moholy-Nagy's assessment of the architectural implications of space–time is much more thoughtful and detailed than that of Giedion, who also has nearly nothing to say about the creation of space by users.

150 Vitruvius, pp. 5–6. *The Ten Books* is a description of what Vitruvius thinks the architect should be and do, as much as a reflection of the actual practice and status of the architect, which was not high in ancient Rome. William L. MacDonald writes that 'architects were mostly from the lower social strata'. MacDonald, 'Roman Architects', p. 37.

151 Vitruvius, p. 5.

it denies the solid materiality of architecture and encourages architects to chase after artistic status that they will never fully attain, may not need, and should question. But the desire to make architecture immaterial should not be automatically denied and has alternative motives and positive consequences, as well as a long tradition.

Vitruvius locates the origin of architecture in a primitive shelter formed of solid matter while Semper associates it with a domestic enclosure that is spatial and barely material. However, they agree that an immaterial and ephemeral force preceded architecture, to becomes its focus:[152]

152 Now the television – also flickering, glowing and immaterial – is the focus of the home.

Therefore it was the discovery of fire that literally gave rise to the coming together of men, to the deliberative assembly, and to social intercourse. And so, as they kept coming together in greater numbers into one place, finding themselves naturally gifted beyond the other animals in not being obliged to walk with faces to the ground, but upright and gazing upon the splendour of the starry firmament, and also in being able to do with ease whatever they chose with their hands and fingers, they began in that first assembly to construct shelters.[153]

153 Vitrivius, p. 38.

The first sign of human settlement and rest after the hunt, the battle, and wandering in the desert is today, as when the first men lost paradise, the setting up of the fireplace and the lighting of the reviving, warming, and food-preparing flame. Around the hearth the first groups assembled; around it the first alliances formed; around it the first crude religious concepts were put into the customs of a cult.[154]

154 Semper, 'The Four Elements of Architecture', p. 102.

conclusion

immaterial–material

conclusion

Immaterial Architecture

Western discourse depends on the binary opposition of terms – one superior, the other inferior – that are assumed to be separate and distinct, one *external* to the other',[1] such as immaterial philosophy and material architecture. But such terms are in fact interdependent and inseparable, undermining dualistic discourse. Architecture is built into philosophy, whether in spatial metaphors such as interior and exterior or in references to philosophical discourse as a sound edifice built on solid foundations. But to protect its status philosophy must conceal its dependence on architecture. Philosophy 'attempts to subordinate architecture precisely because it is so indebted to it. Philosophical discourse is only able to preserve the image of architecture with which it organizes and describes itself by veiling its indebtedness to that image', writes Wigley.[2]

Hidden within one another, the terms material and immaterial blur and slip, questioning other terms such as intellectual and manual, form and formless, real and virtual. One familiar meaning of the immaterial refers to the realm of ideas. Few people today agree with Plato that matter is modelled on ideal forms, but associating the immaterial with the intellectual is common. Countering Plato's coupling of ideas and forms the immaterial is sometimes associated with the formless, from which some of its fascination derives. But the formless is not absence of order, it is order that is unacceptable.[3]

My concern is not the immaterial alone or the immaterial in opposition to the material. Instead, I advocate an architecture that embraces the immaterial and the material. Since the eighteenth century ideas have more often been grounded in experience and interpretations have more often been personal. The immaterial architecture I propose is less the absence of matter than the perceived absence of matter.[4] Whether architecture is immaterial is dependent on perception, which involves creative interpretation, fictions rather than facts. Gregory writes that 'visual and other perception is intelligent decision-taking from limited sensory evidence. The essential point is that sensory signals are not adequate for direct or certain perceptions, so intelligent guesswork is needed for seeing objects.'[5] Consequently, permeated by memory, 'perceptions are hypotheses. This is suggested by the fact that retinal images are open to an infinity of interpretations.'[6] Binding immaterial architecture to perception focuses attention on the 'capacity to just perceive one perceiving'[7] and the relations between architectural objects, spaces and users.

Pallasmaa writes that 'Instead of mere vision . . . architecture involves realms of sensory experience which interact and fuse into each other.'[8] The appreciation of immaterial architecture is especially complex, and a challenge to the familiar experience

[1] Derrida, p. 157.

[2] Wigley, *The Architecture of Deconstruction*, p. 14.

[3] Douglas, p. 104.

[4] Explored especially in 'Index of Immaterial Architectures'.

[5] Gregory, p. 5.

[6] Gregory, p. 10.

[7] Turrell, in Andrews and Bruce, '1992 Interview with James Turrell', p. 48.

[8] Pallasmaa, *The Eyes of the Skin*, p. 29.

of architecture.[9] The richness of the user's experience of any building depends on awareness of all the senses, but immaterial architecture may trigger a sense more often associated with the immaterial, such as smell, and question one more often associated with the material, such as touch. The experience of immaterial architecture is based on contradictory sensations, and is appropriate to an active and creative engagement with architecture. The complexity of the whole experience depends upon the user's interpretation of what is present and absent. To experience the full character of the juxtaposition requires, therefore, an understanding of the conflict, whether pleasurable or not, and speculation on an imagined space or object.[10]

Immaterial Home

The statement 'All that is solid melts into air' encapsulates the force of a capitalist society that, in expanding cycles of destruction, production and consumption, undermines all that is assumed to be solid, such as the home.[11] But in undermining the safety of the home, a capitalist society feeds desire for a home that is evermore safe. Sibley argues that while the apparent stability of the home may provide gratification it can also, simultaneously, create anxiety because the security and spatial purification the home offers can never be fully achieved. Often the consequence is an increasingly intense need for stability not an awareness of its limits: 'Generally, anxieties are expressed in the desire to erect and maintain spatial and temporal boundaries. Strong boundary consciousness can be interpreted as a desire to be in control and to exclude the unfamiliar because the unfamiliar is a source of unease rather than something to be celebrated.'[12] Referring to Sigmund Freud's 1919 essay on the uncanny, Sibley adds that 'this striving for the safe, the familiar or *heimlich* fails to remove a sense of unease. I would argue that it makes it worse.'[13] However, Freud offers another meaning of *heimlich*: 'Concealed, kept from sight, so that others do not get to know about it.'[14] Striving for the familiar is ineffective because the home can never be safe enough and the *heimlich* is not what it seems. Heynen writes:

> It is not without reason that dwelling is the key metaphor that Freud uses in his reflection on the uncanny. According to Freud, the most uncanny experience occurs in the environment that is most familiar to us, for the experience of the uncanny has to do with the intertwining of heimlich (*what is of the house, but also what is hidden*) and unheimlich (*what is not of the house, what is therefore in a strange way unconcealed yet concealed*).[15]

9 Use can be a reaction to habit, result from the knowledge learned through habit, or be based on habit, as a conscious and evolving deviation from established behaviour.

10 For a discussion of the juxtaposition of the senses, refer to 'Index of Immaterial Architectures: Nordic Light' and 'Silence'.

11 Marx and Engels, p. 476.

12 Sibley, 'Comfort, Anxiety and Space', p. 108.

13 Sibley, 'Comfort, Anxiety and Space', p. 115.

14 Freud, 'The "Uncanny"', p. 223. This is a quotation from a dictionary, Daniel Sanders, *Wörterbuch der Deutschen Sprache*, 1860.

15 Heynen, p. 223.

16 The uncanny is a perception

not a property of a space.

The uncanny is experienced when something familiar is repressed but returns as unexpected and unfamiliar.[16] The uncanny operates where the *heimlich* (homely) and *unheimlich* (unhomely) converge. One is at home but out of place.

Sibley does not reject all attempts to construct a stable order. Instead he argues for the merits of both defined boundaries and spatial porosity. As an example he considers the child's experience of the home. He writes that the

> *negative view of strongly classified environments fails to take account of evidence from*
> *research in group therapy that children (and adults) need firm boundaries in order to*
> *develop a secure sense of self. If members of a family 'live in each other's laps', in a*
> *boundary-less, weakly classified home, or they are 'enmeshed' as Salvador Minuchin*
> *put it, there is a danger that children, in particular, will not develop a sense of*
> *autonomy.*[17]

17 Sibley, 'Comfort, Anxiety and

Space', p. 116; Minuchin.

When it is identified with the formless, the immaterial is associated with all that appears to threaten society, architecture and the home, whether insidious disorder inside or lurking danger outside. But the threat of the immaterial is imagined as much as it is real. The desire for an architecture that is safe and secure can never be fulfilled. Instead, it may increase anxiety and further desire for an architecture that is evermore safe. Replacing a static and material architecture with one that is fluid and immaterial is no solution, however. Instead, compatibility between the spaces of a home and the habits of its occupants is desirable. A tightly structured group of people occupying a loose spatial configuration will create tension and anxiety, as will the opposite. However, matching users to spatial configurations fails to take account of changing users and changing needs.[18] Instead, a home must have the potential to be both spatially tight and loose. To accommodate evolving conceptions of the individual and society, architecture must engage the material and the immaterial, the static and the fluid, the solid and the porous. An architecture that is immaterial and spatially porous, as well as solid and stable where necessary, will not change established habits. Rather it may offer those habits greater flexibility.[19]

18 One failing of functionalism is that

it assumes that needs do not change.

19 Discussed further in 'Index of

Immaterial Architectures'.

Immaterial Practice

The practice of architects is expected to be as solid and reassuring as their buildings. With regard to immaterial architecture, therefore, architects are understandably cautious. An architect who persuades a client of the merits of an architecture that is insubstantial and unpredictable still faces numerous difficulties to see it built, such as

building regulations and contractual liability. On a more fundamental note, immaterial architecture revels in qualities – the subjective, unpredictable, porous and ephemeral – that are contrary to the solid, objective and respectable practice expected of a professional.

The stability of architects' practice is a myth, however. Cousins states that the discipline of architecture is weak because it involves not just objects but relations between subjects and objects.[20] As the discipline of architecture is weak, so too is the practice of architects. But, weak is not pejorative here. Rather it is the strength to be fluid, flexible and open to conflicting perceptions and opinions. The practice of architects needs to confidently reflect the nature of the architectural discipline. Architecture must be immaterial and spatially porous, as well as solid and stable where necessary; and so should the practice of architects.

In this book I refer to the architect caught between the immaterial idea and the material object, the creative artist and the solid professional. In the discourse and practice of architects, the older meaning of design, as drawing ideas, and the newer meaning of design, as drawing appliances, are both in evidence, except that ideas are now understood as provisional not universal. Professionalism fits the newer conception of design in particular, and is less compatible with design as it was first conceived. A profession's claim to a monopoly depends upon superior expertise and competence; it is neither expected nor paid to generate ideas. But the architectural profession is unusual in that it claims to be innovative. Architects' claim that only they produce buildings that deserve to be called architecture uncomfortably fuses the desires of an artist and the needs of a professional. Other architectural producers, such as artists, are as dependent on the status of immaterial ideas but may face less pressure to produce solid objects from a solid practice. Immaterial architecture is an especially poignant and rewarding challenge for architects because it forcefully confronts what they practice and produce.

Immaterial Book

In the Renaissance the building was connected to the immaterial through the ideas it presented, which had much to do with form and little to do with matter. Weston remarks that later 'The Classical view that forms were independent of matter was no longer tenable, and from the early eighteenth century onwards scientists and engineers began to devote increasing attention to understanding and quantifying properties of materials.'[21] In the nineteenth century the assumption that a particular tectonic language is innate within each material became familiar in architectural discourse.

20 Cousins, 'Building an Architect', pp. 13-22.

21 Weston, p. 70.

Semper was particularly influential in its development: 'In the first place, every work of art should reflect in its appearance, as it were, the material as physical matter . . . In this way we may speak of a wood style, a brick style, an ashlar style, and so forth.'[22] Giving it positive value and an active role, Semper undermines the long philosophical tradition that disregards matter. Influenced by Semper, Loos states that 'Every material possesses its own language of forms, and none may lay claim for itself to the forms of another material.'[23] However, Loos' discourse on the relations between materials and forms is reductive in comparison to that of Semper, who stresses the transfer of an idea from one material to another, with some modification to both, to the point that 'men in times of high artistic development also *masked the material of the mask*'.[24] Alois Riegl notes that 'Whereas Semper did suggest that material and technique play a role in the genesis of art forms, the Semperians jumped to the conclusion that all art forms were always the direct product of materials and techniques.'[25] Modernism encapsulates this simplification in the phrase 'truth to materials'. Here the material speaks and the architect responds, as in Louis Kahn's remark – both comical and thoughtful – that 'When you are designing in brick, you must ask brick what it wants or what it can do.'[26] Rather than coupling tectonics to materials, I argue for the interdependence of the subject, method and matter of architecture. What then are the subject, method and matter of an architectural book?

In Benjamin's *The Arcades Project*, montage is the subject, method and matter.[27] Unfinished at the time of his death, Benjamin initially intended to construct *The Arcades Project* from the juxtaposition of fragmentary quotations from the nineteenth century. His second 1935 draft is an example of ambiguous montage.[28] With a grid of holes punched through its pages front and back, *Chora L Works: Jacques Derrida and Peter Eisenman* explores the idea that the absence of material is not necessarily the same as the absence of meaning.[29] The presence of holes is formed by the absence of paper. Each hole marks the absence of a section of the text but not an absence in meaning because the reader can either identify the missing word or select a new one. In 'The Death of the Author' Roland Barthes recognizes that the journey from author to text to reader is never seamless or direct. Questioning the authority of the author, he states that reading can be a creative activity that constructs a text anew, and argues for a writer aware of the creativity of the reader.[30] *The Arcades Project, Chora L Works* and 'The Death of the Author' address the creative role of the reader in the formulation of the text through the creation of gaps, interpretative and literal.[31]

Like other books this one is made of ink and paper. As my principal concern is the perception of the material as immaterial, the immaterial is conjured forth not by a lighter paper or holes cut into its surface but by the ideas of the reader, formulating

22 Semper, 'On Architectural Styles', p. 269.

23 Loos, 'The Principle of Cladding', p. 66.

24 Semper, *Der Stil*, p. 257.

25 Riegl, p. 4.

26 Kahn, in Wurman, p. 152.

27 Matter here is a fragment of information rather than a fragment of paper.

28 Benjamin, 'Paris, Capital of the Nineteenth Century'.

29 Derrida and Eisenman.

30 Barthes, 'The Death of the Author'.

31 The montage of gaps is discussed in 'Index of Immaterial Architectures: Nordic Light'.

immaterial architectures from within and between the images and words juxtaposed on these pages. The user decides whether architecture is immaterial. But the architect creates conditions in which that decision can be made. Both are creative.

index of immaterial architectures

INTRODUCTION

The 'Index of Immaterial Architectures' has three aims.

First, to consider architectures, architectural materials and architectural producers beyond the familiar limits of the discipline. Although the building and city remain central to architecture, there are now many architectures, all related to the varied experience of the user and interdependent with an understanding of the building and city. In addition to buildings, drawings and texts have for many years been considered as architecture. Onto these one can add certain artworks, everyday spaces and objects at the very least.

The everyday experience of the building is a reference point to compare architecture to other objects and spaces. But even a building is not architecture if an experience primarily associated with another discipline, such as contemplation, dominates other types of experience. The more an experience associated primarily with another discipline excludes other experiences, the less a building is architecture. However, an object or space not usually considered to be architecture, such as an artwork, is architecture if the experience of it is similar to that familiarly expected of the building and city.[1]

Within both the traditional and expanded limits of architecture, architectural matter is not always conventional building fabric. It is whatever architecture is made of, whether condensation, lightning or steel. The rich and diverse materials discussed in the 'Index' locate architecture firmly in the world as a whole, not just the domain of architects. Architects design most buildings of note but architectural invention equal to that of architects is evident elsewhere. In stating that architecture is more than the work of architects, my aim is not to deny the importance of architects in the production of architecture but to see their role in more balanced terms and to acknowledge other architectural producers and other architectures.

Second, to indicate that there are numerous immaterial architectures. The 'Index' is by no means definitive. It is deliberately diverse and describes but one possible vocabulary of immaterial architecture, of which there are many.

Third, to identify architectures in which the immaterial and material are complementary. Each entry in the 'Index' considers a specific material that may in certain conditions be understood as immaterial. As immaterial architecture is grounded in perception, each entry in the 'Index' is a prediction not a guarantee. To ensure its relevance to contemporary architecture, the 'Index' focuses on architectures and materials – some solid, others not – prevalent in the twentieth and twenty-first centuries. Architectures from previous centuries – traditional Japanese and Korean houses,[2] the picturesque[3] and rococo[4] – are included because they are valuable to an understanding of modernist architecture and contemporary practice.

1 Although the experience of a drawing and a text may not be equivalent to that of the building, the drawing and text are architecture because of their importance to the practice of architecture, whether conducted by architects or others.

2 Discussed in 'Index of Immaterial Architectures: Paper'.

3 The picturesque is discussed in 'Index of Immaterial Architectures: Lily', 'Mirror', 'Mirror Glass' and 'Weather'. For a discussion of the sublime and romanticism refer to 'Lightning', 'Television' and 'Weather'.

4 Discussed in 'Index of Immaterial Architectures: Mirror Glass' and 'Plaster'.

ACRYLIC YARN

A Few Grams, a Few Lines

In the 1990s the DIA Center for the Arts was housed in a former warehouse in Chelsea, New York. The DIA focused on temporary exhibitions; a selected artist was given a whole floor – empty except for a few concrete fin walls – in which to construct an exhibit that remained in place for up to a year. In 1997 Fred Sandback installed *Sculpture*, a site-specific work for the second floor. Sandback constructed a number of walls, leaning at different angles, independent of each other and the geometry of the space. Each wall was made only of a continuous line of acrylic yarn marking its edges: along the ceiling, down to the floor, along the floor and up to the ceiling. Within this frame was nothing but air. Weighing just a few grams, an acrylic yarn wall had a presence greater than one of concrete. When two walls crossed, a wall of acrylic yarn sliced a narrow groove through a wall of concrete. Suggesting patterns of movement, the acrylic yarn walls turned the second floor of the DIA into a free-flowing space comparable to the modernist open plan, but with less substance and more effect. Unlike a glass wall that provides only visual porosity, *Sculpture* offered no physical impediment to passage from one side to the other. Visitors could walk straight through an acrylic yarn wall. But they rarely did so. In part, this hesitance relates to an acrylic yarn wall's status as art. But it also indicates that architecture does not necessarily require a strong physical presence. *Sculpture* was a drawing in space and the most delicate collection of architectural elements. Walking through a wall marked only at its edges by a line of acrylic yarn felt like walking through a wall of substance because the idea of a wall was present even though its mass was not.

AIR

Natural Forces

In October 1960 Yves Klein jumped from the roof of 3 Rue de Gentil Bernard in Fontenay-aux-Roses, a suburb of Paris. The resulting image, *Leap into the Void*, is a leap into Klein's subject-matter – space – which he defined as a sensual, spiritual and immaterial expanse in which the body is active and immersed. Accordingly, the experience of space was not 'a passive activity, nor was it considered to be predominantly retinal. It sought to engage all the senses and to liberate the mind, body and imagination', writes Sidra Stich.[1]

1 Stich, p. 9.

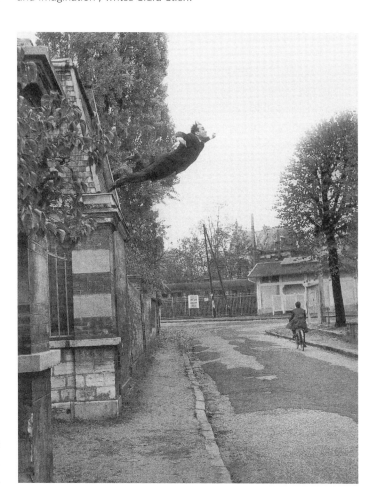

Yves Klein, *Leap into the Void*, 1960. Photograph, Harry Shunk.

Klein's understanding of space was informed by the experience of natural forces, which he incorporated into his work:

> 'Mr Klein' I asked 'if the sky over Nice had been grey, on that day in 1946 when you and Arman and Pascal decided to divide the world between you, would you still have chosen the sky and signed it on its underside as your first monochrome work?' 'No' said Klein 'If the sky had been grey, we would not have been on the beach.'[2]

2 Klein, quoted in Reichardt, unpaginated.

Klein did not merely represent nature; his engagement with natural forces, such as wind and fire, was as direct as possible. Guy Brett writes:

> Our experience of the 'forces of nature' is in so many instances today a graphic one, mediated through seismographs, remote sensors, bubble-chamber photographs, encephalograms and so forth. Artists have in the past sometimes replied by offering up their canvas as a straightforward blank surface to receive the imprint of natural energies, such as Yves Klein's Cosmogonies, one of which was an attempt to capture wind patterns by strapping a still-wet canvas to the roof of his car on a journey from Paris to Nice (a somewhat quixotic gesture), or his fire paintings.[3]

3 Brett, p. 40.

Klein's spatial investigation took many routes. The monochrome paintings, in which space is equated with colour, are the best known. The deep and intense colour of Klein's *Blue Monochrome*, 1960, for example, radiates a space that appears to expand beyond the surface of the painting. In the late 1950s Klein produced large blue monochromes and sponge reliefs for the lobbies of a new theatre at Gelsenkirchen, West Germany. Working with the architect of the theatre, Werner Ruhnau, Klein proposed for the square in front of the building an outdoor café protected by an air roof and, in shallow pools of water, fire walls and fire fountains, which Klein argued were practical in a cold climate. The fire walls, fire fountains and the air roof were not constructed, for financial reasons. However, Stich writes:

> Experiments were performed and models were even made at the Küpperbusch Company in Gelsenkirchen (the firm that engineered the air-conditioning systems for the city theater) . . . Klein and Ruhnau did laboratory research on the air roof both at Küpperbusch and with a climate technician, Matthias Kaeser, in Hamburg. The tests were premised on existing technology in the field of temperature-controlled forced air, such as was developed for the 'climate machines' used instead of entry doors in some department stores.[4]

4 Stich, p. 120.

Another of Klein's proposals, working with the architect Claude Parent, was for coupled fountains of fire and water of equal height and volume. The resulting experience would have been complex. Although of contrasting temperatures, the silvery bursts of fire and water would have looked somewhat similar. For his exhibition at the Museum Haus Lange, Krefeld, in 1961 Klein constructed a fire wall with a grid of fifty Bunsen burner flames. Each flame was flower-shaped, its six petals whipped by the wind. Adjacent to the fire wall was a fire fountain gushing directly from the snowy earth.

Klein did not consider architecture and art to be distinct categories, stating that 'Architecture is space and thus it is everything.'[5] Appropriately, therefore, his first fire paintings were canvases imprinted with burn marks from the Krefeld *Fire Wall and Fountain*. Brett writes:

5 Klein speaking to Professor Max Burchartz, recorded in unpublished notes, 1959, quoted in Stich, p. 122.

> *Immediately after the show Klein was able to work in the testing centre of Gaz de France in Plaine Saint-Denis, outside Paris, using the advanced equipment there, a situation whose dramatic possibilities he exploited to the full. He was both filmed and photographed directing a huge blow-torch in an extravagant transformation of the traditional images of the painter before the canvas.*[6]

6 Brett, p. 41.

In the late 1950s Klein, working with Ruhnau once again, designed the *Architecture of the Air*, of which the fire walls are a part. The *Architecture of the Air* extends themes evident in Klein's monochromes:

> *I was to arrive in my development at an architecture of the air, because only there could I finally produce and stabilize pictorial sensibility in the raw material state. Until this point in still very precise architectonic space, I have been painting monochromes in the most enlightened manner possible; the still very material color sensibility must be reduced to a more pneumatic immaterial sensibility.*[7]

7 Klein, quoted in Perlein and Corà, p. 222.

Locating all services underground, and transforming the climate above by means of air, fire and water, Klein proposed an ecologically conscious but urban architecture without physical boundaries that would enable its users to live comfortably in nature.

Klein's architecture focuses on imprecise boundaries and inconsistent materials in active dialogue with the user. Suggesting a fluidity of space, matter and use, it is the opposite of the stable, functionally defined object often expected of the building. Most buildings make a clear distinction between the unpredictable natural forces outside and the predictable domestic spaces inside. The fireplace is unusual, therefore, in that it is a natural force contained within the building. For so long the focus of

the home – until the advent of television – the fireplace is paradoxical in that, if uncontrolled, it threatens destruction of the home.[8] Burn this house down.

Klein's proposal for air roofs and fire walls can be seen as nature tamed but his intention is more subtle: to locate art, architecture and nature within the single category of space. Ruhnau considered the *Architecture of the Air* to be a continuation of modernist concerns with universal space and transparent buildings.[9] But rather than the clear separation of architecture and nature evident in the Farnsworth House, for example, the *Architecture of the Air* blurs architecture and nature. It is an immaterial architecture made of natural and man-made forces in which 'Air, gas, fire, sound, odors, magnetic forces, electricity, electronics are materials.'[10] Environmentally conscious, working with nature 'without requiring the use of great artificial modifications' and denying the opposition between inside and outside, the *Architecture of the Air* is far removed from the tightly defined seventeenth-century Dutch house that remains the model for the contemporary home.[11] The social implications of the loose spatial order of the *Architecture of the Air* are not explicit and may be as problematic as those of the rigidly ordered home. The *Architecture of the Air* could be developed to consider questions of privacy and multiple occupation but it can also be understood as the individual experience of space: a leap into the void.

[8] With regard to the origins of dwelling Vitruvius and Semper recognize that the fire had a practical purpose – to provide heat and light – but emphasize its social purpose. Vitrivius, p. 38; Semper, 'The Four Elements of Architecture', p. 102.

[9] Stich, p. 121.

[10] Klein, 'The Evolution of Art Towards the Immaterial', p. 44.

[11] Klein, 'The Evolution of Art Towards the Immaterial', p. 44. *Immaterial Dwellings* is another phrase Klein used at the time he developed the *Architecture of the Air*.

AIR CONDITIONING

Russian Doll

1 John McTiernan, dir., *Die Hard*, Fox/Gordon Company/Silver Pictures, 1988.

The film *Die Hard* indicates that the spaces we familiarly inhabit are limited to those that we recognize as inhabitable.[1] The film's premise is both straightforward and unusual. Straightforward in that it is a hijack movie with villains, hostages and a lone hero. Unusual in that the hijack occurs not in a familiar location, such as an aeroplane, but in a less expected one, a corporate office tower in Los Angeles. The hijack site contains two buildings, one within the other like a Russian doll. The larger outer building incorporates the offices, lobbies and reception rooms. The smaller inner one consists of the service spaces: the air ducts, cleaners' cupboards and lift shafts. When the terrorists assume control of the outer building the hero is forced to inhabit the inner one. As in a story for children, a secret entrance leads to a hidden world of unimagined scale and mystery. The hero is able to move around his building because the terrorists only see the outer one, a perception shared also by the office workers, held hostage, who continue to ignore the service spaces and anyone associated with them, such as a cleaner.[2] As the terrorists fail to recognize the inner building they make no attempt to control it. The building within the building only becomes a building when the hero inhabits it. Only through use is each service space transformed into a space within a building: an air supply duct becomes a corridor and a lift shaft becomes a room of variable dimensions. In *Die Hard* a space that is immaterial to one person is material to another.

2 The hero's name, John McClean, indicates his blue-collar status and role in the film, as cleaner and cleanest. *Die Hard* features many social and national stereotypes, alleviated to some degree by the humour of its two principal protagonists: Alan Rickman as a German white-collar terrorist and Bruce Willis as a New York blue-collar policeman.

ALUMINIUM

Marfa

After 1971 Donald Judd concentrated his energies in Marfa, a small Texan town close to the border with Mexico, which led to the establishment of the Chinati Foundation in 1988. The contrasting fortunes of the town and the artist enabled Judd to acquire land and buildings in Marfa, transferring the iconic buildings of an American town – the hotel, bank and military base – from public to private use.[1] Judd appropriated, replicated and intensified the qualities of the town: simple rectilinear forms in large open spaces. Taking the architecture out of a Texan town, Judd turned architecture into art.

1 In the mid-1970s the DIA Center for the Arts, New York, bought 340 acres in Marfa, which it presented to Judd.

Donald Judd, Chinati Foundation, Marfa, Texas, 1988–. Corner of the Architecture Studio at its junction with a low wall framing the gatehouse to the Cobb House and Whyte Building. Photograph, Bob Sheil.

Reworking the artillery sheds on the former military base, Judd installed 100 rectangular aluminium boxes – 48 in the south building and 52 in the north – in three rows on gridded floors. Light enters each shed from continuous windows on the two long elevations and is reflected in the softly polished surfaces of the boxes and floors. The presence and number of visitors affect the character of the interiors; fluctuating shadows are cast as visitors move through the building. Judd calls his work 'specific objects' but 'specific spaces' is an equally accurate description.[2] In the artillery sheds the spaces are as important as the boxes. Each box contains space and is contained in space. The space within each box appears bigger than the box and the space within each building appears bigger than the building because the discordant reflective properties of the interior surfaces form virtual spaces of differing depths. The soft multiple reflections on the boxes and floors, and the interrupting shadows of visitors, make the interior appear fluid and delicate. In the artillery sheds the specific objects make specific spaces, and the immaterial apparent.

2 Judd, quoted in Meyer, 'Marfa', p. 34.

Judd is an artist. But he also designed the building transformations at the Chinati Foundation. For example, to each of the artillery sheds he added two long window-walls and a barrel roof, unseen on the inside. One of the major buildings at the Chinati Foundation is the former Marfa National Bank, in which Judd located the 'Architecture Studio'. In claiming that he produced architecture as well as art, Judd added to his cultural capital.[3] Producing architecture is different, however, from being an architect. The term 'architect' is protected in law but 'architecture' has no such protection. A person can make architecture but not be an architect. Through legal protection of the term, the architect acquires cultural capital. However, Judd would have gained little from acquisition of the title of architect because all his work, including his buildings, acquires its most significant status from his practice as an artist.

3 Bourdieu, pp. 171–183. For a discussion of Bourdieu's theory of cultural capital and its relation to the architect see Rüedi, pp. 30–32.

Judd claimed that he made architecture, but should we believe him? The Chinati Foundation contains buildings, which we familiarly recognize as architecture, and objects, which we familiarly recognize as artworks, but both the buildings and the objects are works of art rather than architecture because of the manner in which they are experienced. Judd only made buildings when he was wealthy enough to be his own client because he wanted the experience of the Chinati Foundation to be conducted on his terms: 'Educated people must have real knowledge and judgement and they must have an influence upon the less educated majority.'[4] In denying the Chinati Foundation an active population, Judd repeats one of the major failings of the art gallery. As a producer of artworks and buildings, the experience Judd expects of visitors is contemplation, which is commonly associated with the reverential appreciation of art in the gallery.

4 Judd, p. 6.

Judd's understanding of art is conservative. The repeated attacks on the autonomy of art since the beginning of the twentieth century have had a twofold agenda. First, to diminish the authority of the artist and the art institution and, second, to transfer some of that authority to the viewer. The Chinati Foundation is both art gallery and artwork. But it need not remain so. Marfa's inhabitants should reclaim the Chinati Foundation, turning art back into architecture.

BAMBOO

Skyscraper

In *Discipline and Punish* Michel Foucault recognizes pervasive social ordering in buildings. David Sibley writes:

> *Thus, the asylum and the prison, rather than being considered exceptional, should be thought of as models which have a wider application in society even though they may assume a more muted form. In particular, pervasiveness should be thought of as a continuum rather than a dichotomous variable. This is the essence of Foucault's argument in* Discipline and Punish.[1]

1 Sibley, *Geographies of Exclusion*, p. 82.

Foucault suggests that the experience of a building depends on the way it is managed as well as designed.[2] Whether a building is authoritarian or democratic is not dependent on form and space alone.

2 Foucault, p. 372.

As the entry point of the European colonial powers into China, Shanghai was divided into a number of quarters each controlled by a nation. The waterfront promenade – the Bund – provides a panorama of European colonial architecture. During the colonial occupation of Shanghai, a sign in the small park at one end of the Bund stated who was excluded: 'No Dogs or Chinese.' The story of this sign, which encapsulates the racist colonization of China, was told to Shanghaiese schoolchildren.[3] Today the sign is absent and two parks occupy the same site. Visitors who know nothing of the city's history experience one. Shanghaiese who know about the sign experience the other. How we understand and experience a space depends on what we know about it through personal and shared experiences and cultural and social affiliations.

3 This story was related to the author by Xiaochun Ai, a Chinese citizen born and educated in Shanghai.

When a building is constructed or cleaned in a European city, a wrapping of translucent plastic is a familiar sight. The appeal of a Christo and Jeanne-Claude *Wrapping* depends to a considerable extent on the aura of what is concealed and the attention given to each *Wrapping* as an artistic event.[4] But in form and material, a *Wrapping* is somewhat similar to the wrapping of a construction site. On a visit to Shanghai, I was surprised to see a bamboo skyscraper, which invoked a rural life within an urban context. But the Chinese architect who accompanied me was uninterested because a skin of bamboo often encloses construction work in China. Pliable plastic is not a permanent building material in Europe and no Chinese skyscraper is made of bamboo. But like a *Wrapping*, pliable plastic and bamboo are

4 Discussed in 'Index of Immaterial Architectures: Fabric'.

fragile and delicate building surfaces that invite subtle and playful uses. I know that beneath the plastic wrapping of a London building site there is a solid structure. But as I know less about the building industry in China I can more easily imagine a skyscraper made of bamboo, not just one temporarily clothed in it. A bamboo skyscraper in Shanghai would be quite different from the same building in London because perception is cultural, and depends on how architecture is understood, inhabited and managed. But, as its boundaries would rarely be solid, the potential of a bamboo skyscraper is social as well as material.

CLOUD

White on White

Designed by Elizabeth Diller and Ricardo Scofidio, the Blur Building, also called the cloud, was a media pavilion constructed for the Swiss Expo 2002 in Yverdon-les-Bains, a small spa town at the southern end of Lake Neuchâtel in the west of Switzerland. Located in the lake, close to the water's edge, the Blur Building sprayed 5,000 litres of filtered lake water a minute through 31,400 nozzles to form an artificial cloud – 100 m long, 60 m wide and 20 m high – that hovered above the lake. A weather station within the building controlled water vapour output in response to climatic changes that affected the size and form of the cloud, such as humidity, air temperature, wind speed and direction. Diller writes:

> *And the cloud is dynamic. It's in a constant play of natural and technological forces. So, on a windy day, it will have a long tail . . . and on a hot, humid day, the mist will tend to expand outwards; while on a day with low humidity, the fog will fall and drift in the direction of the wind; and on a cool day with low humidity, the fog will tend to rise upwards and evaporate. In addition, if air temperature falls below lake temperature, a convection current will lift the fog.* [1]

1 Diller, 'Defining Atmosphere', p. 2.

Before leaving the land, each visitor completed a character profile stored electronically in a hooded 'intelligent' white raincoat. The raincoat provided protection from the wet environment and communicated with the Blur Building's computer system. Visitors reached the cloud via two 100 m long ramped glass-fibre bridges. As the visitor moved towards the cloud his or her experience became progressively white. The white cloud enveloped vision and the white noise of the pulsating fog nozzles muffled sound. Leaving the bridge, the visitor stepped onto a large platform 'about the size of a football field' [2] built on piles set in the lake-bed. As visitors wandered past one another, their coats compared character profiles and blushed in response, changing colour to register either red for desire or green for no interest, the colours standing out in the white environment. Climbing to a higher level, visitors entered the Angel Bar, where they could see clear sky and distant views, and drink waters from around the world. Diller writes: 'Bottled waters, spring water, mineral waters, distilled waters, sparkling waters, as well as rain waters and municipal tap waters from a variety of international cities will be served.' [3] If the Angel Bar had offered filtered water from Lake Neuchâtel visitors could even have drunk the building. Instead, they only needed to hold out their

2 Diller, 'Defining Atmosphere', p. 3.

3 Diller, 'Defining Atmosphere', p. 2.

tongues. As water vapour accumulated on clothing the boundaries between natural environment, building, technology and user blurred. Diller writes:

> *We wanted to synthesize architecture and technology in a way that each would exchange the characteristics of the other, that is to say, de-materialize architecture and to materialize technology. But materialize, not in the sense of hardware, but in the sense of making certain things palpable, that are usually invisible. Like the omissions of certain technologies. So the big project here is the sublime, and the sublime on a level of nature, we're creating artificial nature sublime, but also on the level of technology, where the omissions in this technology, this invisible and fast communication almost beyond our ability to control it, happens. Besides wanting to foil the conventions of heroic Expo and Fair architecture we wanted to delve into the aesthetics of nothing and engage in substance without form.*[4]

4 Diller, 'Defining Atmosphere', pp. 4–5.

Diller + Scofidio, Blur Building, Yverdon-les-Bains, 2002. Interior. Photograph, Elke Zinnecker.

A principal aim of conventional Expo architecture is to provide ordered experience of an image with high visual definition: the passive, collective consumption of a spectacle. Diller + Scofidio did not deny the spectacle, but wished to redefine it by reducing visual definition and allowing undirected movement. Diller writes:

> 'To blur' is to make indistinct, to dim, to shroud, to cloud, to make vague, to obfuscate. Blurred vision is an impairment, it's vision mediated. A blurry image is typically the fault of a mechanical malfunction in a display or reproduction technology. For our visually obsessed, high-resolution, high-definition culture that measures satisfaction in pixels per inch, blur is understood as a loss. [5]

5 Diller, 'Defining Atmosphere', p. 1.

> Basically the movement in this pavilion is completely unregulated. Also we were interested in the relation between attention and mobility. We wanted a range of movement, from aimless wandering, to curious trolling, to grazing, to motivated browsing or shopping, to aggressively focused hunting . . . We wanted to think of a way to socialize the space. Its strongest feature is that it's really about dispersion and it's really very different from the spectacle which is focused, concentrated, on something in particular. This event is entirely dispersed. [6]

6 Diller, 'Defining Atmosphere', pp. 3–4.

For its users, the Blur Building may have been a socially liberating masque or an easily consumed tourist experience. During the Expo, the latter was more likely. In that it is a tourist destination, a spa town such as Yverdon needs to engage with the spectacle to some degree. But it is a rather everyday little town. Between the end of the Expo in October 2002 and the demolition of the Expo buildings in autumn 2003, locals outnumbered visitors and a more active, and questioning, engagement could occur, informed by habitual experience of the building and the surrounding environment.

At Yverdon, a semantic gap existed between the cloud hovering over the lake and its designation as a building. [7] We do not expect a building to drift, flow and blur. Missing from the Blur Building were the precise thresholds and spatial and material stability expected of the building. The Blur Building combined a number of natural and artificial materials but it was made principally of ones that were unpredictable and insubstantial: artificial weather affected by natural weather. To use the Blur Building to the full required an understanding of both architecture and nature, and a desire to question the assumption that they are distinct.

7 For a more detailed discussion of gaps, refer to 'Index of Immaterial Architectures: Nordic Light'.

Unlike the flood tide, fog is more often gently disorientating than destructive. Contrary to the familiar image of Switzerland as a completely mountainous country, a large band of comparatively flat countryside between the Jura to the north-west and the Alps to the south stretches in an arc from Zürich to Geneva. Yverdon is located in

the west of this arc. The low-lying land and profusion of lakes create a foggy climate that fills the landscape for days or even weeks, sometimes creating a sea of fog up to the summit of the Chasseron and the Chasseral, at 1,607 m the highest peaks in the Jura. Because the fog is so pervasive it becomes a part of the everyday environment, slowing movement, diminishing visual depth, flattening sound, and shifting the relationship between interior and exterior. Consequently, local responses to the Blur Building were able to exploit everyday experience of a foggy climate and a steamy spa.

Diller writes that 'we were afraid that this fog would drift to shore and wipe out the Expo, maybe the town as well'.[8] Diller + Scofidio's drawings contrast their cloud with blue skies and blue water. These conditions did occur but more fascinating was the Blur Building within the foggy conditions that regularly appear around Lake Neuchâtel, forming a dialogue between defined boundaries and spatial porosity that was both familiar and stimulating for Yverdon's inhabitants. Replete with blurred sounds and sights when all seemed immaterial, the fog of the natural environment surrounded the fog of the Blur Building, confusing interior and exterior, making the gaps between the building and the fog ever more open to interpretation. At such a moment, the threshold between the building and the fog was reduced to delicate differences in temperature, tone and density of water vapour. Sometimes the fog was denser inside than outside, sometimes the opposite. White on white, cloud on cloud.

The Blur Building had two architects. One was the firm of Diller + Scofidio, the other was the weather, both natural and artificial. The Blur Building was especially open to appropriation because it was useless, unstable and out of its original architect's control.[9] Precisely for these reasons, rather than be demolished, it should have been retained.

[8] Diller, 'Defining Atmosphere', p. 2.

[9] For a more detailed discussion of uselessness in architecture, refer to 'Index of Immaterial Architectures: Fireworks'.

COMPOST

Home Clothing

The domestic environment is a significant contributor to national and global energy consumption. Heating, lighting and servicing the home account for 30 per cent of energy consumption in the UK, for example. The typical response to such a statistic is not a fundamental reassessment of domestic energy consumption but a sealed and insulated interior unresponsive to seasonal variation. Proposing an alternative, Zoë Quick identifies the 1940s as a period when reduced energy consumption, sustainability, recycling and self-help were valued and necessary.[1] With the skill and resourcefulness of the World War II housewife as a model, 'make do and mend' as a motto and a willing grandmother as a consultant, Quick conceives domestic insulation as seasonal clothing rather than permanent building element. Introducing the cycles of gardening and clothing to housing, the Home Clothing prototype is 41 Landrock Road, a draughty Victorian house typical of many a London suburb. Combining skills familiar in the home – DIY, dressmaking and gardening – Quick clothes the home the way we clothe the body. Garments are worn together in layers to form an environmental and ergonomic 'ensemble' specific to the season. Each garment has a different scale and function and a particular role to play in managing domestic energy consumption:

[1] Jonathan Hill and Elizabeth Dow, tutors, Diploma Unit 12, and Oliver Wilton, technical tutor, Bartlett School of Architecture, University College London, 2002.

This means that the exact composition of each 'ensemble' depends on time of year and activities within the house. For example, in winter, the front façade of the house 'wears' a veil with irrigation pipes 'couched' into it, a knitted pullover which holds moisture to feed plant bags which it covers, feathered cosies to provide extra insulation for the plant bags, a muffler made from old socks for cultivating sphagnum moss, and a quilted compost cap. Internally, there is a newspaper lining and a thermal bloomer to keep in heat. Meanwhile, in summer many of these layers are shed, the irrigation veil comes into use and as the roses which climb up the veil come into bloom, they shade the house from summer glare.[2]

[2] Quick, p. 10.

Home Clothing is immaterial in that it is temporal, responsive to changes in the weather season-to-season and day-to-day, and made of materials that are insubstantial and decay, such as air and leaves. Each seasonable ensemble allows minor adjustments equivalent to unbuttoning a jacket or rolling up a sleeve. Two typical garments are thermal bloomers and a quilted compost cap, one inside, the other outside. Placed against the internal face of a window, thermal bloomers trap pockets of still air to slow heat loss from convection: 'The lightweight construction of the bloomers and the fact

that they borrow the structure of the room (similar to clothes, which borrow the structure of the body), means that, like clothes, they can be packed down very small when out of use.'[3] Full of autumn leaves, a quilted compost cap insulates the roof in winter, emitting heat as the compost warms as it decomposes: 'The seasonality of this piece of clothing for the house would extend to spring, when the compost would be returned to the soil, and also summer, when the netting used for the quilt would be reconfigured over a structure of garden canes for use in protecting fruit from insects and birds.'[4]

[3] Quick, p. 8.

[4] Quick, p. 7.

Zoë Quick, Home Clothing, 41 Landrock Road, London, 2002. Detail, hedge cosy. Courtesy of Zoë Quick. 'I used to love watching the transformation of your settee when the time came for its loose covers to be washed . . . This week I've been making a loose cover for the hedge in my front garden. Thanks to the hedge, my loose cover suddenly has thermal properties – it's become part of a set of things like tea-cosies, bed-socks, hot water bottle covers, blankets and quilts.' Letter to Gran, 5 November 2001.

99

Combining DIY, dressmaking and gardening instructions, Home Clothing is presented as a manual, allowing the user to adjust style and fit to suit taste and situation. Whether fabricating a new home garment or repairing an old one, the user is a producer rather than a consumer of goods. Active rather than sedentary, the user can accept less heating and a lower temperature in the home. Labour creates a bond between the user and the home that encourages a culture of repair and re-use, diminishing waste and consumption. The user understands the home not as an isolated capsule but as part of a wider environment, encouraging a community of users who collectively tend their homes, street and neighbourhood.

Zoë Quick, Home Clothing, 41 Landrock Road, London, 2002. Winter façade. Courtesy of Zoë Quick. 'I'd like to imagine that a home might be more tangibly seasonal, and that instead of switching on the heating, we might be able to give our homes the equivalent of a woollen jumper.' Letter to Gran, 10 December 2001.

CONDENSATION

Water Table

In the 1960s Hans Haacke's concern was the sensory experience of natural forces in interaction with man-made systems. *Condensation Cube*, 1963–1965, is a sealed transparent box that creates cycle after cycle of condensation. The inner surfaces of the cube accumulate tiny beads of moisture that slip down to the base as they become heavier. Then, turning into water vapour, moisture rises and collects once again on the surfaces of the cube. As moisture rises and falls, the cube changes from opaque to clear.

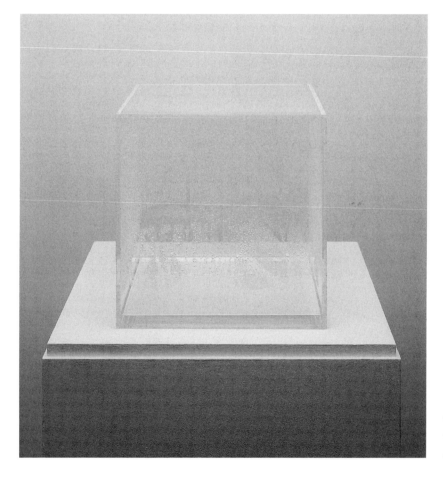

Hans Haacke, *Condensation Cube*, 1963–1965. Courtesy of Lisson Gallery and Hans Haacke.

In 1967 Haacke released a line of white helium-filled balloons in Central Park, New York. The gentle wind and clear blue sky determined the form, direction and composition of the resulting *Sky Line*. In *Narrow White Flow*, 1967–1968, a fan ruffled a long cotton sheet so that it fluttered above the floor. In *Circulation*, 1969, a continuous run of plastic tubing laid casually on the floor in large loops was animated by the liquid circulating within it. In *Earth Art*, a 1969 exhibition at the White Museum, Ithaca, Haacke exhibited *Spray of Ithaca: Falls Freezing and Melting on Rope*. As the title suggests, the work consisted of ice hanging from a stretched cord. At the time Haacke's intention was to:

> . . . *make something which experiences, reacts to its environment, changes, is nonstable . . . make something indeterminate, that always looks different, the shape of which cannot be predicted precisely . . . make something that cannot 'perform' without the assistance of its environment . . . make something sensitive to light and temperature changes, that is subject to air currents and depends, in its functioning, on the forces of gravity . . . make something the spectator handles, an object to be played with and thus animated . . . make something that lives in time and makes the 'spectator' experience time . . . articulate something natural . . .*[1]

1 Haacke, Cologne, January 1965, quoted in Burnham, pp. 112–113.

Haacke, however, came to the conclusion that such work was of limited value because it ignores the extent to which man-made forces dominate and form the natural environment. The theme of his later work is the interdependence of politics and business, and their influence in the art world. Jeffrey Deitch writes:

> *Haacke's focus during the late 1960s was the interaction between natural and human systems. Increasingly he felt that very few 'natural systems' tend in any sense of the word to remain natural. They are increasingly modified by human interests. Gradually he realized that these interests are largely controlled by the military, governmental and corporate concerns. Thus, his art moved in the direction of actively researching the political and economic motives of those in power.*[2]

2 Deitch, p. 105.

At the junction of the two phases of Haacke's output is a 1972 installation at Museum Haus Lange, Krefeld. As it combines the environmental agenda of the earlier work and the socio-political concerns of the later work, *Rhine-Water Purification Plant* offers a rewarding model for architectural practice. In the gallery, river water collected from the nearby Rhine, polluted by industrial and household waste, passed through a series of containers and filters to separate water from pollutants. Clean water flowed into a large low rectangular basin containing goldfish, which stood in front of a picture

window looking onto the museum gardens and wooded landscape beyond. Excess water from the basin flowed into the garden. The bucolic landscape outside looked more natural than the industrial landscape of glass bottles, acrylic containers and plastic tubing inside. But the internal environment was healthier. The water table 'nourishing' the natural landscape contained pollutants from the Rhine. A natural appearance does not necessarily indicate a healthy environment and can be deceptive.

While an artwork can ignore the natural environment, for a building it is unavoidable. As its name indicates, *Rhine-Water Purification Plant* is architecture as well as art. *Condensation Cube* also has clear parallels to architecture. In early morning, condensation may gather on the cold glass surface of a window, to be rubbed away to reveal a view. In 1996 Lucy Read proposed a hotel with fully glazed bedrooms, each comparable to *Condensation Cube*.[3] When a room was unoccupied the glass was clear. At the user's discretion, a bedroom could be sealed from the outside environment. Condensation formed on the glass, changing it from clear to opaque to provide privacy.[4] Rubbing away condensation created a view and a clear section of glass. Drawing architecture on glass, the occupant was both architect and user. The most significant architectural material was condensation, made and manipulated by the user.

[3] Jonathan Hill and Elizabeth Dow, tutors, Diploma Unit 12, Bartlett School of Architecture, University College London.

[4] The sealed environment was comparable to that of a building or car interior with condensation forming on the glass and some air movement between inside and outside.

DUST

63 Microns

A number of entries in the 'Index' – such as weather and graffiti (sgraffito) – are considered the antithesis of architecture rather than its materials. Synonymous with dirt, considerable efforts are made to expel dust from buildings. But it too is an unavoidable part of architecture. Describing dust as 'a little bit of everything on the planet', Hannah Holmes writes that 'Every time you inhale, thousands upon thousands of' dust particles 'swirl into your body. Some lodge in the maze of your nose. Some stick to your throat. Others find sanctuary deep in your lungs. By the time you have read this far, you may have inhaled 150,000 of these worldly specks – if you live in one of the cleanest corners of the planet.'[1] Holmes classifies dust as '63 microns and smaller', which includes human hair at around 100 microns, pollen at 10–100 microns, cement dust at 3–100 microns, fungal spores at 1–5 microns and fresh stardust at 0.1 microns.[2] Dust is unavoidable and it can be an architectural material, not just the undesirable detritus of life. Living with dust may even be poetic in that it is living with 'a little bit of everything on the planet'.[3]

Cousins writes that 'The house has not only to bear the phantasy that it is the support of life, but that it is also, really, the body.'[4] The home is (equated to) the body but dust is the body repressed. In 'one day an adult may lose 50 million scales of skin'[5] and a significant proportion of household dust consists of the users' skin. Distaste of dust, which is most extreme in the home, is a question of physical and psychological cleanliness, and 'repression about the body'.[6] Coming to terms with dust is, therefore, coming to terms with the body and the reality of home-life.

Dust-related allergies and illnesses are common. But attempting to remove all dust is an impossible task with unfortunate consequences as it is both compulsive and ineffective. Cleaning does not just collect dust; it also creates and redistributes it. Holmes writes that 'If you already suffer from asthma or allergies, the last thing you should do is clean up your house dust. Housecleaning has always been an effective method for moving dust from the floor to the air, where you can inhale it.'[7] Even the most obsessive occupant has an invisible 'personal cloud' of dust around them.[8] However often they are cleaned, dust forms so readily that the surfaces of the home are soon faced in layers of dust.

In response to the need to accept and manage dust, Ruth Silver proposes it as a building material, which is collected by a number of everyday devices such as a dust collection hat.[9] As we move habitually around our homes, we directly touch very few

[1] Holmes, p. 5.

[2] Holmes, p. 3.

[3] Living with dust mites is more difficult to understand in such positive terms.

[4] Cousins, 'The First House', p. 37.

[5] Holmes, p. 166.

[6] Cousins, 'The First House', p. 37.

[7] Holmes, p. 167.

[8] Holmes, p. 165.

[9] Jonathan Hill and Elizabeth Dow, tutors, Diploma Unit 12, Bartlett School of Architecture, University College London, 2004.

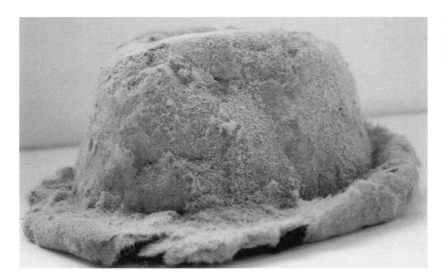

Ruth Silver, Dust collection hat, 2004. Courtesy of Ruth Silver.

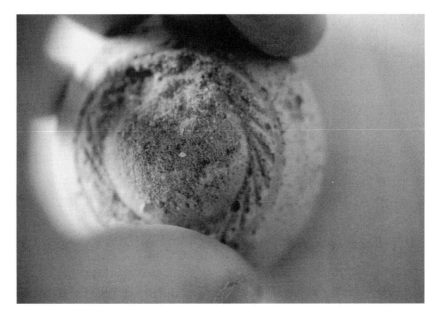

Ruth Silver, Dust door handle, 2004. Courtesy of Ruth Silver.

surfaces. The door handle is a notable exception. From the dust within her home, Silver constructed a dust door handle, cast to match one already there. Touching and turning its soft flaky surface led skin to touch skin, dust to touch dust. As handle and hand rubbed together, further layers of dust were deposited. The user had a number of choices: to wash immediately, wear a glove, leave doors open and accept less

privacy, or live with dust. Used throughout the home, dust door handles would affect all movements. Used once, a dust door handle could make one room more private than others. But the more often a dust door handle is used, the faster it will disappear. Ultimately, a dust door handle will wear away. Dust to dust, like you and me.

FABRIC

Wrapped Reichstag

Wrapping is a familiar and everyday process and a catalyst for imaginative inter-pretation. An object is concealed, made precious and mysterious. Christo first outlined his proposal for 'Wrapped Public Buildings' in a 1961 manifesto. Christo and Jeanne-Claude's numerous wrappings of landscapes, structures and buildings include *The Pont Neuf Wrapped*, Paris, 1985; *Surrounded Islands*, Biscayne Bay, Greater Miami, Florida, 1983; and *Wrapped Reichstag*, Berlin, 1995. The artists have wrapped interiors as well as exteriors. For example, in *Wrapped Floors*, a project for Museum Haus Lange, Krefeld, 1971, a soft cloth covered the floor and brown paper covered the windows. Occasionally a building's interior and exterior are wrapped. In *Wrapped Museum of Contemporary Art*, Chicago, the exterior and interior were clothed in different fabrics, a darker one for the exterior and a lighter one on the floor. However, the *Wrappings* of public structures and buildings such as the Pont Neuf and Reichstag are more provocative because they are experienced in a more complex way than is likely in the art gallery.

Temporary, often lasting just a couple of weeks, a *Wrapping* is produced without public or commercial sponsorship. Instead, the artists sell related drawings and artworks to fund each project. Although a *Wrapping* is not a permanent art commodity it does add to the financial and cultural capital of the artists. However, that the *Wrappings* are too populist and showy for high art is a source of their appeal.

While the conceptual shift from wrapped object to wrapped building is straight-forward, the extra technical and organizational demands are considerable, and the resulting experiences are richer. Each *Wrapping* requires many years of committed teamwork. The tasks undertaken by the artists' team, such as building permissions and technical consultations, are familiar to architects. However, the role of the artists is not directly comparable to that of the architect. Wieland Schmied writes: 'The technical details are given over to professionals – Christo only supervises the various phases of the realization.'[1] The preparations for *Wrapped Reichstag* are typical:

[1] Schmied, p. 11.

The work will be completed in three phases.

The first phase includes all off-site work such as the cutting and sewing of fabric panels and fabrication of the cages and attachment columns. In the second phase, the attachment columns and protective cages will be installed and the rolls of fabric will be moved and positioned on the roof terrace.

With these low-visibility preparations completed, the final phase can be under-taken. The fabric will be unfurled from above and secured in a matter of 4 to 5 days. The shiny-grey metallic fabric will be more voluminous than the building and the folds take the force and direction of the wind, making the building 'breathe' strangely and constantly. The fabric is a fragile material, like clothing or skin, and will have the special beauty of impermanence. [2]

2 Baume, 'Wrapped Reichstag', p. 188.

Preparations for *Wrapped Reichstag* began many years before its construction. The idea was first formulated in the early 1970s and serious work began in 1975. The project was completed in 1995, after the destruction of the Berlin Wall and re-unification of Berlin. Christo's interest in the Reichstag is dependent on its history and function:

I mentioned a parliament building basically because it is the public building. A concert hall can belong to the concert society and a museum to the museum society, but a parliament building belongs to the nation. It is the optimum, because it represents a truly public structure.

*The idea to go to Berlin and to work on the **Reichstag** project was so much more inspirational because of my links with Eastern Europe, and I was in some way expecting that finally I would do a project that could be visible from both East and West Berlin . . . The building is of paramount importance to the German nation and to European history, and it is dramatically related to what Germany is today.* [3]

3 Christo, quoted in Yanagi, p. 23.

A *Wrapping* deliberately blurs the distinction between art and life, through the use of everyday techniques and materials, for example. The artists do not use the same material for each *Wrapping* but vary it according to context. The Pont Neuf was wrapped in light woven nylon while the Reichstag was wrapped in a high-strength synthetic woven fabric tied with dacron rope to meet fire retardation standards. The silvery finish of *Wrapped Reichstag* was chosen 'because the sky of Berlin is always cold blue or grey. I think it will be very beautiful with Berlin's metallic sky.' [4] At the end of each *Wrapping*, the materials are donated to various public bodies and charities for recycling.

4 Christo, quoted in Yanagi, p. 27.

The artists always choose a site that is accessible to the public, who may contribute to the widely publicized negotiations held before permission is granted. An individual can be further involved in a *Wrapping* in a number of ways: as an organizer, con-sultant, constructor or visitor. Although it requires complex organization, a *Wrapping* is an exercise in craft production. Each *Wrapping* is assembled on site in order to show the involvement of people in the production process and to create an object that

invites a physical and emotional response due its inconsistencies and fluctuations. When located outside the gallery, a *Wrapping* is used as well as contemplated, which is rare for a work of public art. 'We don't want to stop the use of the building', states Christo.[5] A *Wrapping* does not simply replace one function with another. Unlike most building refurbishments, it leaves existing uses intact, adding qualities that may stimulate the creative appropriations of users. Nicholas Baume writes that Christo 'has never alienated his subject from its conventional use. A wrapped museum remains open to the public, a wrapped pathway is still for walking, and a wrapped bridge remains open to traffic. Moreover, Christo's projects actively encourage public inter-action.'[6]

5 Christo, quoted in Yanagi, p. 26.

6 Baume, 'Critical Themes', p. 37.

Wrapped Jewish Museum

In confronting Berlin's selective historical amnesia and adopting absence as an artistic strategy, *Wrapped Reichstag* is comparable to the Jewish Museum, designed by Daniel Libeskind and completed in 1998. Libeskind is the appropriate architect of the Jewish Museum because his intellectual position, and the history of the Jews in Berlin, is permeated by a sense of loss. The subject of Libeskind's work is absence, taking things out rather than putting them in, denying the language of familiar architectural elements. The Jewish Museum has no visible entrance. It is reached via an underground passageway leading from the adjacent Baroque main building of the museum. One of the routes beneath the Jewish Museum leads to a high and unheated concrete tower. An unglazed corner opening allows a thin shaft of light to enter the space and, depending upon the wind direction, sounds from the street and playground opposite. Running through the zigzag form of the Jewish Museum is a void that can be looked into but not entered.[7] During the design process, Libeskind considered making the galleries marginally too low to accommodate one particularly large painting he disliked. The architect hoped that the curator's reaction would be to either remove the painting or amputate a section of the offending canvas.[8]

In a number of ways – for example its lack of a conventional and visible entrance – the Jewish Museum resists the day-to-day functioning of a museum. However, so eloquently does it perform the function of a museum – to represent a history – that it opened to the public before its collection was installed. During the course of the Jewish Museum's construction, Libeskind assumed an increasingly public stance, criticizing the regressive and conservative authorities in Berlin.[9] In the Jewish Museum he aims to represent the life of Jews in Berlin before the 1930s, their fate under the Nazis, and their presence in contemporary Berlin. The Jewish Museum is a discourse of

7 My description refers to two visits before the collection was installed.

8 Libeskind, lecture to the School of Architecture, Kingston Polytechnic, 1991.

9 Libeskind, p. 29.

internal rules resistant to function in principle but affirming its particular function. Especially while it had no collection to guide the visitor, the Jewish Museum encouraged the user to be creative, to order and complete its spaces, filling them with an imaginary collection.

Uniform rather than articulated, the fabric that wrapped the Reichstag is comparable to the zinc that wraps the Jewish Museum. The conventional characteristics of a façade are absent from both. Equally seductive, they mirror and reflect the blue-grey sky of Berlin. Zinc is a soft metal. Like fabric, it is folded and lapped for strength. *Wrapped Reichstag* existed for just two weeks and the Jewish Museum is built to last, but both surfaces were chosen because they change over time. Only regular and frequent visits to the Jewish Museum will allow subtle changes in the zinc to be experienced. Shifts in the billowing and rippling surfaces of *Wrapped Reichstag* were more immediate. Continuous, soft and fragile, the surfaces of *Wrapped Reichstag* and the Jewish Museum stimulate awareness of the objects they wrap. Glass is often used as a metaphor for a transparent and democratic political process. Norman Foster's glass dome now surmounts the Reichstag.[10] But Christo's fluid, opaque and uncertain wrapping is a more appropriate image of political developments in Berlin than the sturdy and transparent glass of Foster's refurbishment.

10 Completed in 1999.

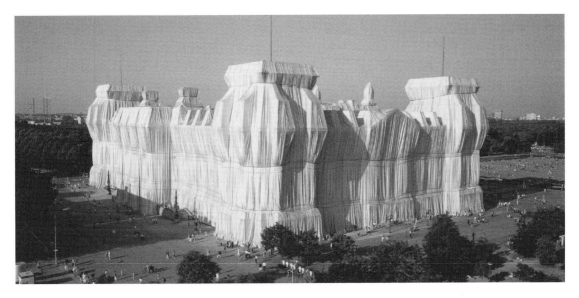

Christo and Jeanne-Claude, *Wrapped Reichstag*, Berlin, 1971–1995. Photograph, Wolfgang Volz. Courtesy of Christo and Jeanne-Claude, VOLZ/LAIF/KATZ.

Daniel Libeskind, Jewish Museum, Berlin, 1998. Photograph, Jonathan Hill.

Bernard Tschumi, Fireworks at Parc de la Villette, 1991. Courtesy of Bernard Tschumi Architects.

FIREWORKS

Useless Architecture

Functionalism advocates 'the general philosophical notion that an object which fulfils its function properly is automatically beautiful', implying that the degree of satisfaction derived from an object is in proportion to its efficiency for a task.[1] As a critique of functionalism, Bernard Tschumi suggests that pleasure is derived especially from two types of misuse.[2] One is uselessness, which contradicts societal expectations of usefulness in terms both of specific buildings and spaces and of architecture as a whole.[3] The other is disjunction, the intentional or accidental appropriation of a space for a use for which it was not intended.[4]

Tschumi's positive reference to the uselessness of architecture recalls Roland Barthes' equally positive description of the uselessness of the text.[5] The correlation of uselessness to pleasure is not new. It is found in the appreciation of the autonomous artwork and the drifting movement of the flâneur. Tschumi offers a further example:

> Built exclusively for delight, gardens are like the earliest experiments in that part of architecture that is so difficult to express with words or drawings: pleasure and eroticism. Whether 'romantic' or 'classical', gardens merge the sensual pleasure of space with the pleasure of reason, in a most 'useless' manner.[6]

Tschumi argues that the most extreme misuse negates 'the form that society expects of it'.[7] As architecture is coupled with utility and permanence, he argues for the celebration of the useless and ephemeral: 'The greatest architecture of all is the fireworker's; it perfectly shows the gratuitous consumption of pleasure.'[8] In defence of uselessness Tschumi writes:

> Hegel concluded in the affirmative, architecture was a sort of 'artistic supplement' added on to the simple building. But the difficulty of such an argument appears when one tries to conceive of a building that escapes the utility of space, a building which would have no other purpose but 'architecture'.[9]

Tschumi accepts Hegel's distinction between building and architecture as a challenge: 'As opposed to building, making architecture is not unlike burning matches without a purpose.'[10] In 1982 Tschumi won the competition to construct Parc de la Villette in Paris, one of the Grands Projets initiated by President Mitterrand. Nine years later he

1 Collins, p. 218.

2 Tschumi, *Cinégramme Folie*, p. 26.

3 Tschumi, 'The Pleasure of Architecture', p. 51.

4 Tschumi, 'Index of Architecture', pp. 105–6; Tschumi, *Event-Cities*, p. 13; Tschumi, 'Spaces and Events', pp. 95–96. Tschumi rejects functionalism but to designate a space as useless or disjunctive is an attempt to suggest, if not determine, future use. Uselessness and disjunction are unlike determinism in that the architect accepts that his or her idea of the use of a space may differ from its actual use.

5 The title of Tschumi's article 'The Pleasure of Architecture' refers to Barthes' book *The Pleasure of the Text*.

6 Tschumi, 'The Pleasure of Architecture', p. 51.

7 Tschumi, 'The Architectural Paradox:', p. 26.

8 Tschumi, 'Fireworks', 1974, extract from 'A Space: A Thousand Words', quoted in Tschumi, 'The Architectural Paradox', p. 26.

9 Tschumi, 'The Architectural Paradox', p. 15.

10 Tschumi, 'The Pleasure of Architecture', p. 52.

choreographed a fireworks display in the completed park, combining two of the pleasurable and useless architectures he identifies.

11 Martin, pp. 64–65.

Tschumi and Barthes link uselessness to pleasure and a resistance to the market.[11] Quoting Adorno's request to 'produce a delight that cannot be sold or bought, that has no exchange value and cannot be integrated in the production cycle', Tschumi says that uselessness resists the cycles of production and consumption, which usefulness

12 Tschumi, 'The Architectural

Paradox', p. 26.

affirms.[12] He argues that parks and fireworks are pleasurable, useless and outside the production cycle. A useless factory contradicts societal expectations. But does a useless park or firework? And what does useless mean in this context? A park is a site of production and consumption but of social behaviour rather than objects. Signs and actions are commodities just as much as kettles and cars. To resist the cycles of production and consumption, a building or park would have to negate all the roles expected of it. Certain products, such as fireworks, are highly profitable, commanding a price far above their production costs precisely because they are produced for pleasure. An architecture that is perceived as immaterial and short-lived is not necessarily worthless.

Whether conceived as an artwork, building or spectacle, the immaterial architectures in this book are discussed as spaces to be used. Their potential depends on their ability to seem both immaterial and relevant to everyday experience, which, at first glance, does not apply to a firework display. Semper, however, suggests that such an event is valuable to everyday experience precisely because it is not an everyday occurrence. It offers an intense experience, and an intense experience of architecture, because it is short-lived. Semper contends that the principal purpose of architecture is social. However, he differentiates between domestic and monumental architecture:

13 Semper, 'Style in the Technical

and Tectonic Arts or Practical

Aesthetics', p. 255.

the 'prototype that was the dwelling was carried forward into monumental form'.[13] The means of this transformation remains the delicate woven surface but at a scale larger than the domestic: 'the festival apparatus, the improvised scaffolding with all the special splendour and frills that indicate more precisely the occasion for the festivity

14 Semper, 'Style in the Technical

and Tectonic Arts or Practical

Aesthetics', p. 255.

and the glorification of the day'.[14] Harry Francis Mallgrave remarks that 'Semper's theory and practice can sometimes be construed as a desire to return to the artifice of the masque', of which fireworks are commonly a part.[15] Indicating that social codes

15 Mallgrave, 'Introduction', p. 2.

are not natural and universal but artificial and local, the masque appropriates and transforms familiar spaces, allowing the appearance, character and behaviour of its protagonists to change as well. In the masque, spectators can also be actors. Fireworks are often contemplated as a spectacle but, especially when the spectators are also the choreographers, fireworks may encourage a level of social and festive interaction that is often absent in the cinema, theatre or street.

FLUORESCENT LIGHT

Maximalism

The Serpentine Gallery is located in Kensington Gardens, central London, in a building not originally intended for the display of art. Until quite recently, the Serpentine was unusually informal; visitors entered straight from the park into a small building with only a few rooms, all facing onto Kensington Gardens. As it lacked adequate security and a sophisticated temperature and humidity control system, the Serpentine was unable to exhibit some artworks, especially those on loan from other galleries. In the 1990s the building was refurbished to counter this deficiency. A hermetic environment and austere entrance hall were introduced, undermining the informal connection between the park and gallery. Although diminished, the Serpentine's relationship with its urban parkland setting remains one of its principal pleasures.

In autumn 2001 the Serpentine hosted an exhibition of the work of Dan Flavin. Between 1963 and his death in 1996, Flavin created light installations made only of 'commercially available fluorescent tubes in ten colours (blue, green, pink, red, yellow, ultraviolet, and four whites) and five shapes (one circular and four straight fixtures of eight, six, four and two-foot lengths)'.[1] Artists' concern for the minimum means of expression can be traced back to paintings such as Kasimir Malevich's *White on White*, 1918, and readymades such as Marcel Duchamp's *Fountain*, 1917. But minimal art as an art movement originated in New York and Los Angeles in the 1960s. James Meyer writes:

> *Primarily sculpture, Minimal art tends to consist of single or repeated forms. Industrially produced or built by skilled workers following the artist's instructions, it removes any trace of emotion or intuitive decision-making, in stark contrast to Abstract Expressionist painting and sculpture that preceded it in the 1940s and 1950s. Minimal work does not allude to anything beyond its literal presence, or its existence in the physical world.*[2]

Michael Govan writes, however, that 'Dan Flavin came to reject the idea of Minimal art that he was credited with having helped to invent . . . Flavin joked that he preferred to call it "maximalism", emphasising his art's bold effect over its economy of means.'[3] To describe Flavin's artworks as minimal art is to suggest that his prime concern was the material rather than experience, but the opposite is true. To describe Mies' buildings as minimal architecture is equally deceptive. Both emphasize 'the bold effect over its economy of means'.[4]

1 Govan, p. 5.

2 Meyer, 'Survey', p. 15.

3 Govan, p. 5.

4 Discussed in 'Index of Immaterial Architectures: Milky-White Glass' and 'Mirror Glass'.

In Flavin's Serpentine exhibition one of the rooms housed *untitled (to you, Heiner, with admiration and affection)*, 1973, a low wall of horizontal and vertical green fluorescent tubes in white frames, which divided the room in half along its longer dimension. Visitors looked over the wall and through the full-height glass windows to the park beyond. The artwork seemed to suffuse the park with a pinkish light similar to a 1950s tinted postcard, except that this image fluttered in the wind. Moving to another room, the pinkish tint remained on the retina for a few moments, slowly fading to be replaced by new colours. At the Serpentine the immaterial appeared as the light of a fluorescent tube, in lingering colour on the retina, and as a colour-tinted parkland, cast back to the 1950s.

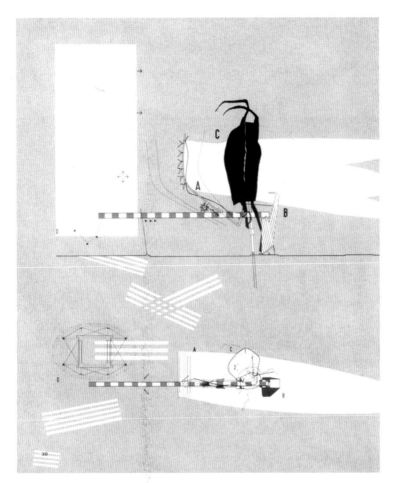

Peter Wilson, Ninja House,
1988. Section and plan.
Courtesy of Bolles + Wilson.
A Filter 1: Mechanical mask;
B Filter 2: Necessary
equipment (stair, WC,
cupboard); C The Glove;
D Tower of Winds.
1 Cone of minimum
electronic interference—an
electronic shadow;
2 Sleeping mat;
3 Rock garden.

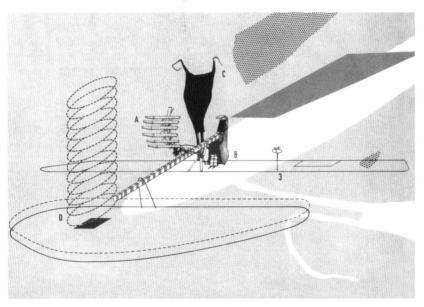

Peter Wilson, Ninja House,
1988. Isometric. Courtesy
of Bolles + Wilson.
A Filter 1: Mechanical mask;
B Filter 2: Necessary
equipment (stair, WC,
cupboard); C The Glove;
D Tower of Winds.
1 Cone of minimum
electronic interference—an
electronic shadow;
2 Sleeping mat;
3 Rock garden.

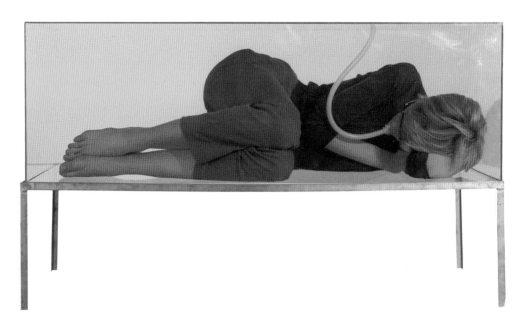

Dunne + Raby, Faraday Chair, 1998. Courtesy of Dunne + Raby.

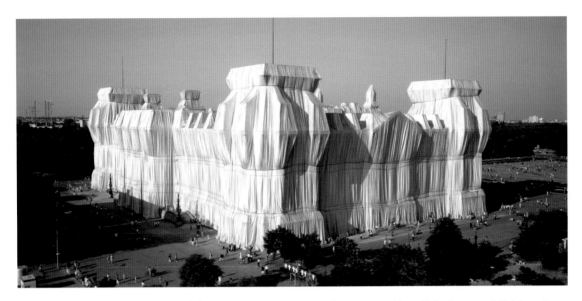

Christo and Jeanne-Claude, *Wrapped Reichstag*, Berlin, 1971–1995. Photograph, Wolfgang Volz. Courtesy of Christo and Jeanne-Claude, VOLZ/LAIF/KATZ.

Daniel Libeskind, Jewish Museum, Berlin, 1998. Photograph, Jonathan Hill.

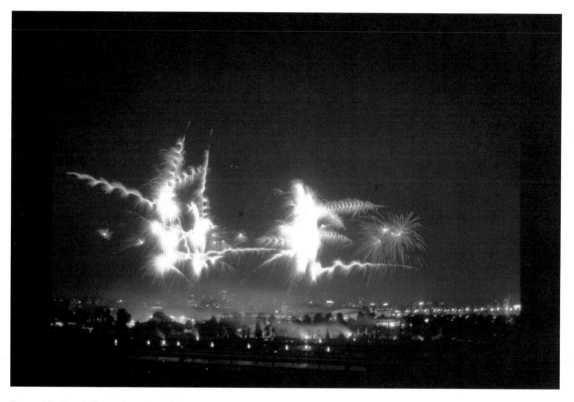

Bernard Tschumi, Fireworks at Parc de la Villette, 1991. Courtesy of Bernard Tschumi Architects.

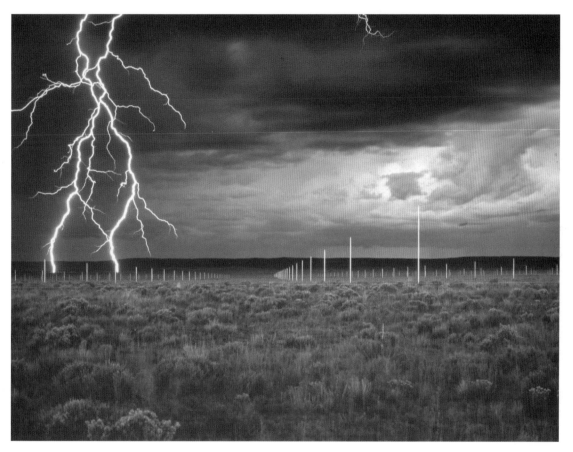

Walter De Maria, *The Lightning Field*, 1977, Quemado, New Mexico. Photograph, John Cliett. Courtesy of DIA Art Foundation.

William Kent, Rousham,
1737–1741. Cold Bath and
Watery Walk. Photograph,
Nat Chard.

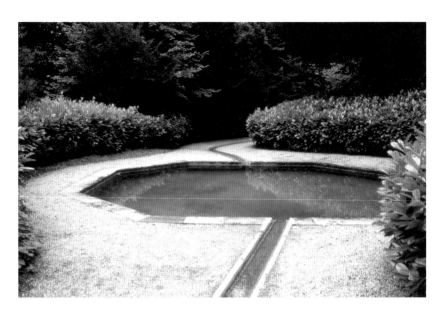

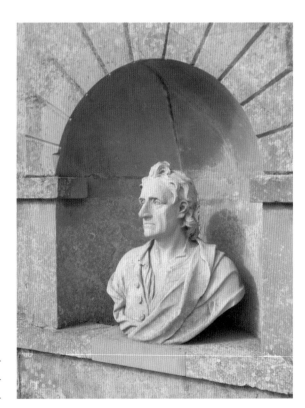

William Kent, Elysian Fields, Stowe, late 1730s.
The bust of John Locke in the Temple of British Worthies.
Photograph, Jonathan Hill.

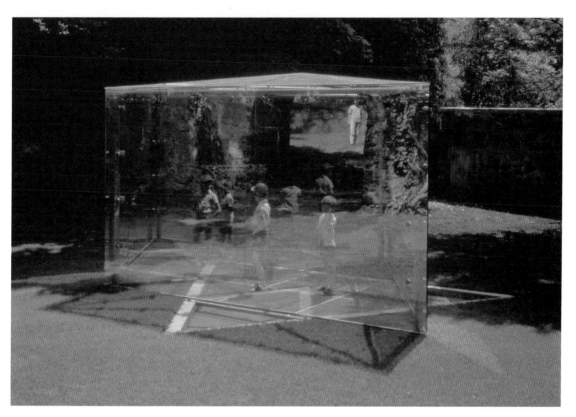

Dan Graham, *Star of David Pavilion for Schloss Buchberg*, 1988–1996. Courtesy of Lisson Gallery and Dan Graham.

Andrew Holmes and Mark Fisher, Saffron
Valley, Croydon, 1993. Blue road collage.
Courtesy of Andrew Holmes and Mark
Fisher.

Andrew Holmes and Mark Fisher, Saffron Valley, Croydon, 1993.
Crocus line collage. Courtesy of Andrew Holmes and Mark Fisher.

FROSTED LIGHT

Pilot and Prisoner

In drawing and building, light is equated with space[1] and is a frequent subject of architectural investigations.[2] But architects may also assume that the purpose of light is to reveal the beauty of form. James Turrell's conception of space as a tangible continuum recalls one of the more prevalent modernist conceptions of space but attention to form is absent in a Turrell 'light work'.[3] Turrell's concern is not the presence of form in light but the presence of light as space: 'Generally we light surface, and light is used to reveal things. The idea of revealing light itself is rarely even thought of. Architecture turns out to be a different thing than maybe we think it should be.'[4]

For Turrell, light is revelatory but not religious.[5] He identifies two very different experiences as catalysts to his investigation. As a pilot, Turrell was immersed in light. As a prisoner, he was immersed in dark.

> I have a whole book of illusions that happen to pilots – especially, say, in a turn, and where there are changes in terrain that may not be read as changes in terrain, and . . . may set up an illusionary quality.[6]

> As a result of things I said as a draft counselor during the Vietnam war, I spent time in the penitentiary, and to avoid being assaulted or raped, I would do things that got me into solitary . . . At first, as a punishment, they make it extremely dark, totally dark, so that you can't see anything. However, the strange thing that I found out was that there never is no light. Even when all the light is gone, you can sense light. In order to get away from a sense of claustrophobia or the extremeness of punishment, the mind manufactures a bigger space and it doesn't take long for this to happen.[7]

Turrell creates light works for inside and outside the gallery. Often just naturally lit, the external light works are responsive to the changing conditions of the sky. But the sense of light as space is strongest in light works inside the gallery, which are either lit artificially or by a combination of artificial and natural light. Turrell uses standard construction techniques and components – stud walls and commercial light fittings – as a means to an end not an end themselves. No attention is drawn to artifice: 'Well, it's very simple. It all comes from seventy-five and sixty-watt frosted light bulbs. It's straightaway light that you have everywhere else.'[8]

1 Evans, *The Projective Cast*, p. 109.

2 For further discussion, refer to 'Index of Immaterial Architectures: Fluorescent Light', 'Milky-White Glass', 'Night Light' and 'Nordic Light'.

3 Forty writes that 'there were broadly three different senses in which "space" was used by architects and critics in the 1920s: space as enclosure; space as continuum; and space as extension of the body'. Forty, *Words and Buildings*, pp. 265–266.

4 Turrell, in Andrews and Bruce, '1992 Interview with James Turrell', p. 51. Turrell underestimates the importance of light as space in modernist architecture but his work is notable for the degree to which it diminishes form.

5 Turrell, in Jacques, p. 63.

6 Turrell, in Andrews and Bruce, '1982 Interview with James Turrell', p. 38.

7 Turrell, in Jacques, p. 57.

8 Turrell, in Andrews and Bruce, '1982 Interview with James Turrell', p. 38.

Light, which is often associated with the immaterial alone, is understood as immaterial and material: 'I feel my work is using the material of light to affect the medium of perception. I'm using light in its material aspect . . . I try to take light and materialize it in its physical aspects so you can feel it – feel the physicality; feel the response to temperature and its presence in space, not on a wall.'[9] Entering *Rayzor, 1968*,[10] is like being immersed in a mist or cloud with the horizon absent.[11] Time and space, distance and depth, are confused. Just as the body feels suspended, so too is there 'a slight suspension of . . . time'.[12] For Turrell the resulting disorientation is positive. First, because it focuses awareness on perception itself: 'So I'm interested in the capacity to just perceive one perceiving.'[13] Second, because the visitor needs to let go of his or her assumptions and discover new ways to navigate: 'Talk to any instrument pilot and you know damn well you've had to do that to gain that license.'[14] Third, because it engenders unsettling but playful interactions between a community of occupants as they shuffle and bump into each other. A light work is a rewarding model for *Immaterial Architecture* because it uses everyday and inexpensive components and materials to create a material enclosure that is experienced as immaterial and an immaterial space that is experienced as material.

9 Turrell, quoted in Andrews, 'The Light Passing', p. 12.

10 *Rayzor* uses a combination of fluorescent and natural light.

11 Turrell, in Andrews and Bruce, '1982 Interview with James Turrell', p. 38.

12 Turrell, in Andrews and Bruce, '1982 Interview with James Turrell', p. 39.

13 Turrell, in Andrews and Bruce, '1992 Interview with James Turrell', p. 48.

14 Turrell, in Andrews and Bruce, '1982 Interview with James Turrell', p. 38.

LIGHTNING

The Lightning Field

Connecting Klein's *Architecture of the Air* to the work of Walter De Maria is a concern for the emotional response to natural forces. But De Maria understands nature as magisterial and sublime, not grounded in the familiar.[1] Edmund Burke's highly influential *Philosophical Enquiry into the Origin of our Ideas of the Sublime and Beautiful* was first published in 1757. Burke's description of the natural sublime was not new; Joseph Adamson's *Pleasures of the Imagination*, published in 1712, was but one influence. Burke's achievement was to compile the sublime and the beautiful into a system that provides a coherent argument for the sublime. While the sublime is magnificent, the beautiful is merely pleasant. The sublime is evoked by a desolate and expansive landscape subject to the uncertain drama of natural forces. Particular to an experience rather than an object, the pleasure of the sublime is first threatening and then reassuring as comprehension increases and fear diminishes:

> *Whatever is fitted in any sort to excite the ideas of pain, and danger, that is to say, whatever is in any sort terrible, or is conversant about terrible objects, or operates in a manner analogous to terror, is a source of the sublime; that is, it is productive of the strongest emotion which the mind is capable of feeling . . . When danger or pain presses too nearly, they are incapable of giving any delight, and are simply terrible; but at certain distances, and certain modifications, they may be, and they are delightful, as we everyday experience.*[2]

From Burke developed the principle that the arts should attempt to replicate not natural forms but sublime experience.

In 1968 De Maria drew two mile-long white chalk lines in the Mojave Desert, California. The use of land and line in *Mile Long Drawing* is a precursor to an artwork De Maria completed nine years later. Located in New Mexico, 2,195 m above sea level, *The Lightning Field*, 1977, is a grid of 400 polished stainless steel poles spaced 67 m apart. With sixteen poles running north–south and twenty-five running east–west, *The Lightning Field* is 1 km wide and 1.6 km long. As the pointed tips of the poles are all the same height above sea-level, the distance from tip to ground varies slightly according to the contours of the site, averaging 6.5 m. De Maria writes: 'The land is not the setting for the work but a part of the work.'[3] Other parts are the sky and lightning.

1 Tiberghien, p. 224; Beardsley, p. 62.

2 Burke, p. 36.

3 De Maria, p. 58.

The experience of *The Lightning Field* is informed by a number of factors that influence the visitor's sense of time and space. These include the long journey to the site, the isolation of a few people amongst the vastness of the earth and sky, the changing quality of the daylight and night-sky, the wait for a specific event to occur, and the overnight stay in a cabin adjacent to the site. De Maria writes:

> *It is intended that the work be viewed alone, or in the company of a very small number*
> *of people, over at least a 24-hour period.*
> *The light is as important as the lightning.*
> *The period of primary lightning activity is from late May through early September.*
> *There are approximately 60 days per year when thunder and lightning activity can be*
> *witnessed from* The Lightning Field.
> *The invisible is real.*
> *The observed ratio of lightning storms which pass over the sculpture has been*
> *approximately 3 per 30 days during the lightning season.*[4]

4 De Maria, p. 58.

An environmental artwork challenges the art market in that, in contrast to a tangible and movable commodity, it has limited material presence and exists for but a short time. To avoid the art market and the art gallery, land art is rooted to a site. As a work of environmental art and land art, *The Lightning Field* employs both strategies: it is immaterial, temporal and site-specific. However, the artist's challenge to the commodification of art is a recurring artistic theme that may itself be commodifed. *The Lightning Field* is very much a part of the art world. The contemplation and awe that De Maria expects of visitors extends the status and aura of the artwork to a new site, which in its isolation takes the individual experience of art to an extreme. The DIA Center for the Arts, New York, supervises visits and many people have seen photographs of *The Lightning Field* even if they have not been there. As Gilles Tiberghien observes: 'Although at first, the Land Art artists fled the museums and galleries, claiming a desire to escape the market system, this was only to return to these spaces – albeit through another door – to exhibit photographs and various other documentation related to their works.'[5] The allegiances and associations of *The Lightning Field* are those of art. As the superiority of ideas over matter underpins the status of art in western society, the denial of matter in conceptual and environmental art affirms art as much as questions it.

5 Tiberghien, p. 235.

Although *The Lightning Field* was conceived as art it can be understood and experienced as architecture. Like Klein's *Architecture of the Air, The Lightning Field* is an architecture that combines natural forces and the minimum of conventional architectural materials. Standing outside *The Lightning Field* many days of the year,

the dominant experience is likely to be that most associated with the artwork: contemplation. But when an electric storm rumbles overhead and strikes the poles, viewing *The Lightning Field* from inside or beside the cabin will conform to Burke's definition of the sublime, which depends on the viewer's safe distance from threatening nature.

The experience of the interior is more subtle, and contemplation and the sublime but two of its parts. The grid of poles defines a delicate architectural space in which everyday activities can occur if the DIA does not prevent them. Between October and April, when the interior is comparatively safe, experience of *The Lightning Field* may combine contemplation, use and the sublime, in the knowledge that lightning is mostly distant. But between May and September *The Lightning Field* provides a potentially dangerous experience. Burke describes the sublime as rugged and wild and the beautiful as soft and homely.[6] But what happens when a visitor is at home in *The Lightning Field*? Using a minimum of materials De Maria has unwittingly created a building with a roof of lightning for the brave or foolhardy to occupy. The Lightning House as well as *The Lightning Field*.

6 Burke also suggests that the sublime is masculine and the beautiful is feminine. Whyte, p. 72.

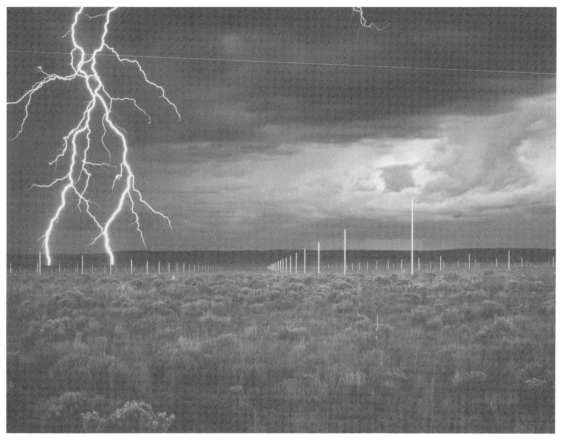

Walter De Maria, *The Lightning Field*, 1977, Quemado, New Mexico. Photograph, John Cliett. Courtesy of DIA Art Foundation.

LILY

The Natural Light of Reason

Conflicts crucial to the eighteenth century are evident in picturesque garden design, between the promotion of objective reason and exploration of subjective experience.[1] Established by an act of parliament in 1753, the British Museum is a project typical of the Enlightenment, which favoured the collection, analysis and ordering of information according to a logical system, in conjunction with the development of new scientific disciplines such as archaeology and ethnography. Neil MacGregor, its present director, writes that the British Museum's purpose is 'to get the whole world in one building'.[2]

The term 'Enlightenment' derives from the 'natural light of reason'. Beginning in the late seventeenth century, the Enlightenment was founded on the assumption that man and nature are subject to the same laws of reason, can be understood by reason and progress by reason. Coupling nature to reason was a means to order both nature and human nature. Laugier, the key theorist of Enlightenment architecture, identifies architecture's origins and principles in nature, which he considers to be synonymous with reason.[3] The primitive hut is a prototypical temple of classical antiquity, perfect because it follows the simple reason of nature.

Enlightenment theory was applied to the eighteenth-century English landscape. Parliamentary land enclosures transformed open land into a Cartesian geometry of regular fields defined by hedges and walls.[4] Within the resulting large estates, picturesque gardens proliferated. A classical temple in an undulating landscape recalls the 'natural' order of the primitive hut in its environment, which Laugier applies to the city:

> The picturesque can be found in the pattern of a parterre as much as the composition
> of a painting. Let us carry out this idea and use the design of our parks as plan
> for our towns . . . Above all, let us avoid excessive regularity and excessive symmetry
> . . . a multitude of regular parts brings about a certain impression of irregularity and
> disorder which suits great cities so well.[5]

The 'disorder' of the picturesque is mere 'impression'. Laying an idea of nature onto the garden and the city makes both seem natural. Tafuri writes:

> When in 1753 Laugier enunciated his theories of urban design, officially initiating
> Enlightenment architectural theory, his words revealed a twofold inspiration. On the

[1] For further discussion of the picturesque, and its relations to the sublime, romanticism and modernism, refer to 'Index of Immaterial Architectures: Lightning', 'Mirror', Mirror Glass', 'Television' and 'Weather'. For further discussion of modernism and the rococo refer to 'Mirror Glass' and 'Plaster'.

[2] MacGregor, in Jury.

[3] Laugier, p. 12.

[4] Descartes is an important figure of the early Enlightenment.

[5] Laugier, pp. 128–129.

William Kent, Rousham, 1737–1741. Cold Bath and Watery Walk. Photograph, Nat Chard.

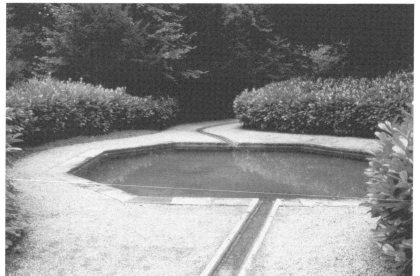

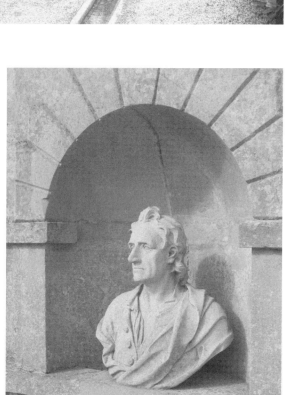

William Kent, Elysian Fields, Stowe, late 1730s. The bust of John Locke in the Temple of British Worthies. Photograph, Jonathan Hill.

one hand, that of reducing the city itself to a natural phenomenon. On the other, that of going beyond any a priori idea of urban organization by applying to the city the formal dimensions of the picturesque.[6]

6 Tafuri, *Architecture and Utopia*, pp. 3–4. Tafuri refers to Laugier, *An Essay on Architecture*.

Norman Davies and Roy Porter note the importance to Enlightenment theory of English empiricism, which promoted reason but made it specific rather than abstract.[7] Associating illumination with understanding, the Enlightenment gave particular importance to visual contemplation. Porter writes that 'Locke's *Essay concerning Human Understanding* (1690) was paradigmatic for a host of later texts which explained cognition through visual metaphors, the mind as a *camera obscura*.'[8] But eighteenth-century empiricism did not depend on vision alone. It valued memory, movement and repeated experience as tools to develop ideas, all appropriate to the picturesque garden. The design and appreciation of gardens developed alongside the increasing value given to personal experience in the eighteenth century. At Stowe, the grandest eighteenth-century English garden, the painter, architect, stage and garden designer William Kent added the Elysian Fields in the late 1730s, of which the 'Temple of British Worthies' is a principal element. Each of its twelve niches contains a bust with an inscription and pediment above. The inscription to Locke, who inspired the Elysian Fields,[9] reads:

7 Davies, p. 598; Porter, *Enlightenment*, p. 9.

8 Porter, *Enlightenment*, p. 46.

9 John Dixon Hunt and Peter Willis write that one of Locke's 'essays in *The Tatler* (No. 123) even seems to have provided the programme of images and their associated ideas for Stowe's Elysian Fields'. Hunt and Willis, 'Introduction', p. 37.

Who best of all Philosophers,
understood the powers of the human mind:
the nature, end, and bounds of civil government;
and with equal courage and sagacity, refused
the slavish systems of usurped authority
over the rights, the consciences, or the reason of mankind.

Leaping the Fence

In 'The History of the Modern Taste in Gardening', 1771, Horace Walpole remarks that it was Kent who first 'leaped the fence, and saw that all nature was a garden'.[10] The garden at Rousham, which Kent designed between 1737 and 1741, is one of the earliest and most influential picturesque gardens, the product of a number of creative translations into 'English'.[11] Borrowing from classical antiquity, Renaissance imaginings of classical antiquity, and seventeenth-century paintings of a mythical classical antiquity, Kent designed according to the 'genius loci' – genius of the place – a concept with classical origins important to the picturesque. Hunt writes:

10 Walpole, p. 313.

11 A garden designed by Charles Bridgeman in the 1720s was already in place, which Kent transformed and expanded.

Allusions to the new garden's Italian models – to the ruined Temple of Fortune at ancient Praeneste or to a sculptural group in the grounds of the Renaissance Villa de-Este – were offered along with cultural changes that the act of translation had wrought upon the classical originals. Further, throughout the relatively small garden Kent emphasized both the old and the new, classical and Gothick, often side by side; by these juxtapositions our attention is drawn to the new English location of classical ideas and forms.[12]

12 Hunt, *Gardens and the Picturesque*, p. 11.

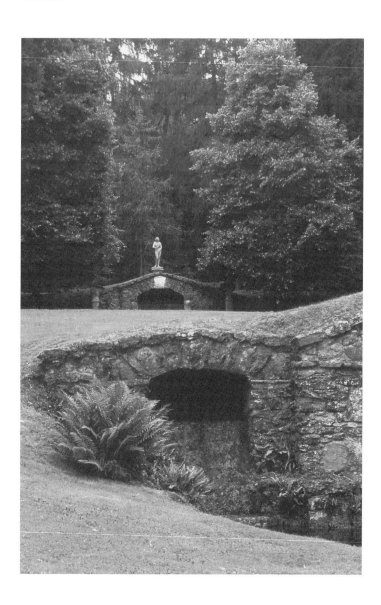

William Kent, Rousham, 1737–1741. Vale of Venus. Photograph, Nat Chard.

In eighteenth-century England the genius of the place was made as much as found, the fusion of new ideas, forms and spaces with those already in place, which were themselves the result of earlier migrations. Republican Rome offered eighteenth-century England a semblance of authority and a model to emulate and surpass. The 'natural' landscape garden was associated with liberal democracy and a constitutional rather than absolute monarchy: 'Many in the eighteenth century claimed that the landscape garden was an English invention – like liberty, with which it was often compared.'[13] In comparison to the geometric French garden, which provided a visual setting for large ceremonial and social gatherings, the English garden was there to be discovered not seen at once. But whose liberty does it represent?

[13] Robinson, p. 60.

> It is no coincidence that two of the distinctive features of Rousham are the ridge (giving
> a 'commanding height' over the countryside) and the haha, the first derived from
> military tactics and the second from military architecture. It is not fortuitous either that
> fortifications (the castellated seat) and images of heroic militarism (the gladiator, the
> arch, Hercules, Marcus Aurelius and Caesar), however stylised, proliferate.[14]

[14] Pugh, pp. 57–58.

In the picturesque garden, no one is seen to work and nothing is produced. Work is doubly denied because the garden must appear natural. For the landed class, pleasure is the garden's purpose, distant from undesirable conflict. The labour of others, who tend the gardens, is rendered invisible.

William Kent, Rousham,
1737–1741. Watery Walk.
Photograph, Nat Chard.

15 van Eck, p. 247.

16 Only since the mid-nineteenth century has the term 'landscape architecture' referred to the design of landscapes rather than the depiction of buildings and landscapes in paintings. The term 'landscape architect' derives from the same period.

17 Hunt, *The Picturesque Garden in Europe*, p. 34.

18 Irénée Scalbert notes, however, that 'What held true for the picturesque – that the reality of nature was a picture – was fundamentally alien to Claude, for whom (as his biographers have testified) the reality of a picture was nature.' Scalbert, p. 26.

19 Hunt and Willis, 'Introduction', p. 11.

20 Hunt writes that 'Continental theorists were as confident about the high status of the art of landscape gardening as many were diffident or unconcerned about making any strict connection with painting.' Hunt, *The Picturesque Garden in Europe*, p. 100.

21 Whately quoted in Hunt, *The Picturesque Garden in Europe*, p. 62. Whately uses the Old English term landskip. Its original meaning was a picture of the land not the land itself.

Garden Picture

The original meaning of the Italian term 'pittoresco' is a method of laying on paint in broad, bold and irregular strokes to depict not a detailed copy of nature but something closer to the experience of nature.[15] The term 'picturesque' refers to garden design influenced by landscapes represented in paintings.[16] Like most advocates of the picturesque, Kent was influenced by the seventeenth-century painter Claude Lorrain, even imitating his drawing style.[17] Kent owned paintings by Claude, as well as others by Nicolas Poussin and Salvator Rosa. Composed into fore-, middle- and background, Claude depicted a pastoral Arcadia of classical temples, undulating landscapes and relaxed inhabitation,[18] which evoked the simple, rural life praised by Virgil and Horace in classical antiquity.[19] Together, artistic and literary references increased awareness of the pleasures of the picturesque garden.

For eighteenth-century English advocates of the picturesque, the status of garden design as an art depended on its relations with landscape painting.[20] However, the relevance of the painting to the garden was much discussed and conclusions were inconsistent. Landscapes depicted in paintings influenced picturesque garden design but the garden was not equivalent to the painting. Thomas Whately, author of the respected *Observations on Modern Gardening*, published in 1770, states that 'Gardening . . . is as superior to landskip painting, as a reality is to a representation', adding that paintings are 'studies, not models' for gardens.[21]

William Kent, Rousham, 1737–1741. Cold Bath. Photograph, Nat Chard.

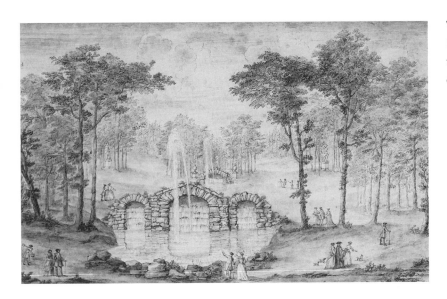

William Kent, Rousham,
1737–1741. Drawing of
the Vale of Venus. Courtesy
of C. Cottrell-Dormer.

The picturesque garden is not experienced like the painting, which absorbs the viewer but holds him or her at a distance. Instead, the visitor is immersed and active within the garden. Vision is considered not in isolation but in relation to the other senses. The garden is experienced not in a single concentrated moment but in motion, over time and with all the senses. Even when the garden visitor is static, movement is implicit because any single view is understood in relation to other potential views and is but one part of a complex and changeable whole, which is subject to time, climate and occupation. No geometric and ideal rules directed the architect of the eighteenth-century picturesque garden, which was designed the way it was experienced, by a figure moving across a landscape: 'The spot from whence the view is taken is in a fixed state to the painter, but the gardener surveys his scenery while in motion', writes Humphry Repton in 1794.[22] The product mirrored the process as eighteenth-century gardens were designed through perspectives, understood collectively rather than singly, as often as plans. Valuing the subjective experiences of the user and the architect, and with less regard for orthogonal drawings, eighteenth-century garden design was a significant departure in the practice of the architect.

22 Repton quoted in Bois, p. 43;
from Humphry Repton, *The Art of
Landscape Gardening*, 1794.

Garden Story

The early picturesque garden was embedded with meanings and conceived as a place of study in the classical tradition. Stourhead, the garden most obviously inspired by

23 Henry Hoare began the garden at Stourhead in 1740.

Claude, is also the most didactic.[23] The lake at its centre indicates that the principal views – across the lake and on a circuit – are those of a detached observer appropriate to the Age of Reason. Rousham was intended for learned visitors able to uncover and understand the references and meanings encoded in its design. Edmund Spenser's *The Faerie Queene* – an edition of which Kent illustrated – was a pivotal inspiration. Hunt writes: 'And for the properly equipped and learned mind this encounter with Venus among the glades of Rousham would bring back with suitable propriety Spenser's discussions of courtesy and its connections with the countryside.'[24]

24 Hunt, *Gardens and the Picturesque*, p. 86.

Henry Hoare, Stourhead, 1743–. View across the lake towards the Temple of Apollo. Photograph, Jonathan Hill.

As the century progressed, the garden as a picture that tells a story was less appreciated, due in part to changes in patronage and the increasing value given to subjective experience. Recalling the broad and irregular brush strokes of 'pittoresco', the late eighteenth-century picturesque was concerned more with effects than meanings. Whately distinguishes between the emblematic, which requires careful analysis and understanding, and the expressive, which emphasizes immediate and intuitive experience, and which he favours.[25] Designed to cultivate knowledge and imagination, Rousham is emblematic and expressive, however. Occupant and garden interact with each other. Although it is assumed that the garden was designed with a clockwise route in mind,[26] no narrative need be followed for the garden to be enjoyed: 'Rather it is the juxtapositions already noticed, ancient and modern, classical and gothick, natural and artificial, foreign and English, that constitute its "subject".'[27] Scale, complexity, topography, multiple allusions and seasonal variations encourage action, imagination and subjective journeys: 'the interlocutor does not simply receive the messages, but he is asked to complete them, even to change their meaning while they are being deciphered'.[28] In the eighteenth century, the picturesque referred both to the composition of the view and the response of the viewer. Today, wandering unhindered the reader can construct the story anew. But even if we know neither *The Faerie Queene* nor the garden's other references, recognition that they exist adds intrigue and discovery to the experience.

Garden Building

Kent was the principal exponent of Palladianism, which transferred the principles of the sixteenth-century Venetian architect Andrea Palladio to England. Supported by three patrons, Kent spent ten years studying art, architecture and gardens in Rome and Venice, returning to England in 1719 at the age of 34. Through geometry and proportion, Palladio's villas refer to the immaterial but they also engage and celebrate everyday life. They are mostly working farms in the tradition of the modest classical villa and country estate, evoking the pleasures of rural life and the harmony of man and nature. The Villa Emo, Fanzolo di Vedelago, 1565, consists of a central pedimented block flanked on each side by an arcaded farm building terminated by a dovecote. The central ramped stairs provide entrance to the principal rooms and a surface for threshing grain.

Affirming its interest in Palladio, the English Enlightenment considered the farm to be a suitable model for man's careful management of nature.[29] But by comparison to Palladio's designs, Palladian houses such as Kent's Holkham Hall, 1730,

[25] Whately, p. 38.

[26] Hal Moggridge remarks that the construction foreman and head gardener John MacClarey mentions such a route in a letter of either 1750 or 1760. Moggridge, p. 191.

[27] Hunt, *William Kent*, p. 86.

[28] Tafuri, *Theories and Histories of Architecture*, p. 82.

[29] Porter, *Enlightenment*, p. 306.

Andrea Palladio, Villa Emo, Fanzolo di Vedelago, 1565. The central block and ramped stairs for threshing grain. Photograph, Jonathan Hill.

are too large for their setting and distant from agriculture, apart from views onto a few grazing cattle.[30] Rousham has a scale and relationship with the land more appropriate to Palladio. House, garden and farmland are adjacent to each other. Kent made only limited additions to the existing house. His major contribution was the garden, which overlaps with agriculture at one point.[31] Located at the south-west tip of the garden, the Gothic seat – seen from the house across a field – is nicknamed the 'Cow Castle' because it shelters cattle as well as people.[32] In many picturesque gardens the focus is inward, private and escapist.[33] But at Rousham many of the views, and the gaze of the principal sculptures,[34] point outward across farmland, towards focal points in the countryside.[35] Such views can be seen in terms of military surveillance, as Simon Pugh suggests. But a view can work two ways not just one. Offering views inwards and outwards, the house, garden and farmland at Rousham are visible to each other.

Palladio influenced the picturesque but his forms are not picturesque. For example, the Villa Rotunda, Vicenza, 1570, is seemingly symmetrical across its axes and a different garden design is seen from each of its four elevations.[36] Such a composition is too regular to be described as picturesque. But, often unnoticed, one axis is slightly wider than the other. James S. Ackerman writes that 'Palladio thought of strict uniformity as literally unnatural; this his neo-Classical admirers never understood.'[37] Neither the English Palladian house nor garden pavilion is picturesque on its own, however. They are picturesque as part of a larger composition.

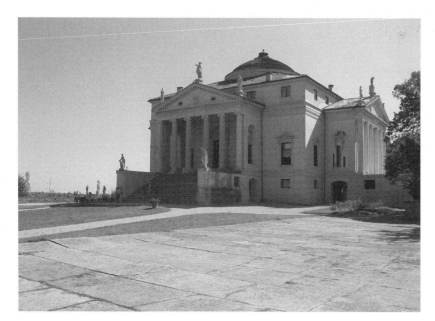

Andrea Palladio, Villa Rotunda, Vicenza, 1570. Photograph, Jonathan Hill.

30 Scully, *Architecture*, p. 332.

31 The farm is not adjacent to the garden, however.

32 Hunt, *Gardens and the Picturesque*, p. 12. In harmony with Kent's conception, Rousham's owner General Dormer introduced long-horned cattle to the paddock adjacent to the garden. Mowl, p. 110, fig. 3b.

33 For example, at Stourhead and Stowe most views are inward.

34 Noted by Mavis Batey of the Garden Historical Society. Moggridge, p. 188.

35 Little of the farmland viewed from the gardens has ever been the property of Rousham's owners. Moggridge, p. 188.

36 The Villa Rotunda was conceived as a country residence not a working farm.

37 Ackerman, p. 164.

Palladio conceived the villa as a body in the landscape. From this classical tradition, the temples occupying the eighteenth-century garden were understood as bodies in a rather different landscape. As a transformation of the picturesque tradition, rather than the building as a body in the garden, I understand the building as the garden and vice versa. The Palladio villa is a matrix of interconnected rooms that allows its occupants to determine alternative routes and varied configurations of open and

William Kent, Rousham, 1737–1741. Apollo at the end of the Long Walk. Photograph, Jonathan Hill.

closed spaces.[38] Very few rooms have a specific function. With reference to the Palazzo Antonini, Udine, 1556, Evans writes: 'The peculiarity of this one is that lavatories were brought within the main building. In pairs they flank the square anteroom at the very centre of the plan (ventilated from above). They, too, could be used as thoroughfares.'[39]

Rousham is not a regular grid, the familiar definition of a matrix. Although they lack specific functions, its 'rooms' are particular rather than consistent; its plan is meandering rather than rectilinear. But, an irregular matrix, Rousham is equivalent to the Palladio villa because both are picturesque in the movements they encourage. Compact and intimate – squeezed along a twisting slope leading down to the River Cherwell – Rousham offers little obvious hierarchy, endlessly varied routes and exquisite rooms that open one into the other.[40] So easily does Rousham absorb visitors that it often appears spacious and empty,[41] particularly appropriate to society today in which desire for privacy is greater than in either the sixteenth or eighteenth centuries.

Barcelona Garden

Proclaiming a faith in reason comparable to that of the Enlightenment, the early modernist villa or *unité* was conceived as a neo-Platonic form set in ideal nature. But most early modernists preferred nature to be a picture viewed from inside rather than a landscape to be explored outside. To connect modernism to the picturesque, Caroline Constant and Dan Graham select the Barcelona Pavilion.[42]

> The term 'pavilion' was first associated with garden structures for temporary shelter in the late seventeenth century, such buildings provided the architectural leitmotif of the English landscape garden, which emerged in the following century as a vehicle of the new sensibility.[43]

In the eighteenth-century picturesque garden, regular forms are held within an irregular landscape. Each has its own scale. Mies defines nature and architecture as separate parts 'of a larger whole.'[44] But the Pavilion fuses regular form and irregular landscape into one. Neither has a specific scale. A garden and a building, the Pavilion is modernist and picturesque.

Unlike the Farnsworth House, for example, the Pavilion does not frame the views to a landscape beyond. As in many picturesque gardens, the gaze is inward. Constant writes:

[38] Evans, 'Figures, Doors and Passages', p. 88.

[39] Evans, 'Figures, Doors and Passages', p. 63.

[40] The spaces and objects at Rousham are specific and evocative. The Praeneste Terrace, Dying Gladiator, Octagon Pond, Upper Cascade with Venus and Cupids, Upper Ponds, Watery Walk, Cold Bath, Temple of Echo, Gothic Seat, Palladian Doorway, Statue of Apollo, Long Walk, Lower Cascade and Pyramid, for example.

[41] The absence of a shop and café, with nothing to be bought and consumed, also helps.

[42] Graham is discussed in 'Index of Immaterial Architectures: Mirror Glass'.

[43] Constant, p. 46, with reference to *The Compact Edition of the Oxford English Dictionary*, Oxford: Oxford University Press, 1971, p. 572.

[44] Mies in Norberg-Schulz, 'A Talk with Mies van der Rohe', p. 339.

Ludwig Mies van der Rohe,
Barcelona Pavilion,
1929–1930. Interior.
Photograph, Jonathan Hill.

Early plans indicate Mies's explicit use of Picturesque devices. He distributed three pedestals for statues throughout the Pavilion, each positioned to provide a focal point at the end of a major viewing axis. The sequence is analogous to the eighteenth-century pictorial circuit – a series of points at which a view is contrived to arrest the progress of the viewer.[45]

45 Constant, p. 47.

46 Constant, p. 47.

In the final design Mies reduced the sculptures to one. 'By eliminating these sculptural focal points, he rejected pictorial means', writes Constant.[46] This claim is unconvincing, however. Views are framed across water and along vistas. Surfaces rather than sculptures – a wall of red onyx or green alpine marble – punctuate journeys around the Pavilion.

Neither the Pavilion nor the picturesque garden has a function. Both are useless except as displays of power, which deny productive labour and social turmoil, and instruments of self-reflection, which respond to rising concern for the individual and subjective experience. The picturesque pre-empted modernist concerns for the ambiguous object open to creative interpretation, which locates the immaterial in

subjective experiences rather than mental abstractions.[47] Eighteenth-century fascination for the illusions of parallax – the perceived differences in an object's position when seen from different locations – was important to the development of ambiguity in modernist architecture, which promoted discontinuity, montage, and a temporal conception of space.[48] Broken and incomplete, ruins are familiar in the picturesque landscape because they indicate both loss and potential. They locate the visitor within a history, evoke memories and stimulate the imagination and emotions. The ruin is a fragment, an essential element of montage. In the late eighteenth century, mirroring the transfer from emblematic to expressive gardens, ruins were associated with general feelings rather than specific meanings, as is the case in the Pavilion, which provides visual perspectives as a guide to movement but no narrative.

Evans equates modernism with attempts to order social behaviour and limit the unpredictability of everyday life. But he describes the matrix of rooms in a Renaissance villa as an open plan, a term commonly applied to modernist architecture derided for its association with visual and social transparency.[49] Evans suggests a different interpretation of the open plan. Neither the Renaissance nor modernist villa is always open. Rather they are open to change. Spatial interconnectivity and lack of functional definition are evident in the Palladio villa, Rousham and Pavilion, unlike most examples of the modernist open plan that I criticize in this book.[50] The Palladio villa is most receptive to adaptation because rooms and routes can be either open or closed. Rousham has no doors but the garden's size, dense planting and weaving topography allow the visitor to be either public or private. Although smaller, and more open to view, the Pavilion offers the visitor similar options. The open plan is a quality of use as much as form.

Barcelona Artwork

On the one hand, the Pavilion is a picturesque garden experienced in meandering movements with all the senses. On the other, it is an artwork intended for the concentrated gaze of contemplation, as the architects of the 1986 reconstruction intend:[51]

> It is necessary to go there, to walk amidst and see the startling contrast between the building and its surroundings, to let your gaze be drawn into the calligraphy of the patterned marble and its kaleidoscopic figures, to feel yourself enmeshed in a system of planes in stone, glass and water that envelops and moves you through space, and contemplate the hard, emphatic play of Kolbe's bronze dancer over water.[52]

47 Discussed in 'Chapter 2: Hunting the Shadow'.

48 Bois, p. 41; Collins, p. 26. Citing Scully, Bois describes Piranesi as a further precedent for the modernist conception of space. Bois, pp. 44–50; Scully, *Modern Architecture*, p. 10.

49 Evans refers to the 1518–1519 design for a villa in Rome by Raphael and Antonio da Sangallo. Only a part, later to be called the Villa Madama, was built.

50 For example, in 'Chapter 1: House and Home'.

51 Ignasi de Solà Morales, Christian Cirici and Fernando Ramos.

52 Solà Morales, Cirici and Ramos, p. 39.

The Pavilion is an architectural icon, not only because it is seductive and much copied, but also because it has most often been perceived in conditions similar to that of the artwork. Between 1929 and 1930 it was an exhibition building to be viewed; between 1930 and 1986 it was known through photographs; and since 1986 the reconstruction's status as an historical monument has discouraged everyday use. Both exhibit and gallery, the reconstruction reinforces the status of the architect as an artist and implies that contemplation is the experience most appropriate to the building.

The 1929 Pavilion was designed to respond to seasonal changes. Water lilies, often found in the picturesque garden, were planted in the larger of the two pools and two large flags, the German and Spanish, fluttered in the wind on tall masts in front of the Pavilion. But the water lilies and flags are absent from the 1986 Pavilion because they would introduce life, climate and decay, all incompatible with the experience of a contemplative artwork.

In contemplation, the viewer is detached from his or her surroundings and absorbed in a static object observed at a distance. Although the 1929 Pavilion incorporated seasonal elements, the contemplative gaze was undoubtedly one of Mies' design concerns. The Pavilion's tinted glass surfaces are reminiscent of the coloured overlays applied to the Claude glass and the camera, both aids to contemplation. A convex mirror, either round or oval, named after Claude but never used by him, the Claude glass alters nature according to picturesque conventions.[53] In a Thomas Gainsborough sketch, drawn around 1750, a seated artist holds the Claude glass in his left hand and sketches with his right. The artist looks at the mirror not the wider landscape. Whately describes the painting as a study for the garden. As it became famous as a set of photographs, which Mies doctored to remove items he disliked, the opposite is true for the 1929 Pavilion. The building was a study for the photograph. Today, visitors to the 1986 Pavilion contemplate and record views that replicate the 1929 photographs, which the official photographs of the reconstruction further mimic.[54] The reconstruction's purpose is to reproduce the photograph as much as the building, both as objects of contemplation.

To be art, the artwork must remain useless. But in the garden useless is useful and synonymous with potential. The decision of the user not the architect, use can change from one day to the next. Whether the 1986 Pavilion is experienced as a garden or as an artwork is dependent on the user. But the history of the Pavilion and the reverence of its visitors and managers bring its status as an artwork to the fore. It is impossible to imagine the Pavilion's managers repeating the invitation of Rousham's owners: 'Bring a picnic, wear comfortable shoes and it is yours for the day.'[55]

53 The late eighteenth-century picturesque especially favoured the Claude glass.

54 The photographer is Eloi Bonjoch. Solà Morales, Cirici and Ramos, pp. 40–67.

55 Printed in the leaflet provided at the entrance to the garden.

MESH

Honest to a Fault

Edged by a six-lane road, surrounded by nondescript buildings, and built on a concrete deck over railway tracks in front of Barcelona-Sants railway station, Plaça Sants is a large square completed in 1983 to the design of Albert Viaplana and Helio Piñón.[1] The architects write: 'At the outset we were desolate. Anyone who knows the place we had to work on will understand.'[2] A smooth concrete surface 'in the manner of a road as broad as it was long' covers the whole square.[3] Furthest from the station, a square mesh canopy rests on a grid of sixteen slender steel columns, each higher than a four-storey building. In the same materials but lower, longer, narrower and gently undulating, another canopy traverses the centre-line of Plaça Sants. Each canopy casts a soft shadow that provides little protection from the sun and less from the rain. Apart from the low canopy no routes or paths cross the square. Under the canopies are linked tables and benches on which people face outwards, away from the table. Along one edge of the square a curving line of low timber benches provides no protection from the adjacent six-lane road, its noise and pollution. In one corner of the square sit three curved mesh screens with no obvious purpose. In another corner two converging lines of 3 m high poles occasionally spout water. The architects write that 'the walking figure was left with no alternative but to stay still'.[4] But whether it is hot or cold, sunny or raining, no visitor would wish to stay still in Plaça Sants.

Unlike a building a square need not house a function.[5] It is an antidote to a busy and productive city. A square is useless in the sense that it has no tangible product. But a square is useful in other ways. It is a place for play, contemplation and social interaction. Plaça Sants contains more architecture than many squares but it is more useless than most because it does not provide all that is expected of a square.

Fireworks and gardens, two useless architectures identified by Tschumi, are joyous and socially useful.[6] Plaça Sants offers a different understanding of uselessness, one informed by the architects' response to its context. Since the industrial revolution, repulsion towards the city is a familiar theme in art, literature and architecture. Implying that usefulness is not always an appropriate and honest architectural ambition, and that an architectural project should not function when the city around it does not, Viaplana and Piñón worked with, rather than against, the desolation the site evokes. To achieve some pleasure in a place as desolate as Plaça Sants, they concluded that architecture must be more useless not less: 'In spite of everything, desolation was now bearable.'[7] Some of the users seem to agree. Their actions are appropriate, playful

1 The square is also called Plaça dels Països Catalans.

2 Viaplana and Piñón, quoted in Bohigas, Buchanan and Lampugnani, p. 175.

3 Viaplana and Piñón, quoted in Bohigas, Buchanan and Lampugnani, p. 175.

4 Viaplana and Piñón, quoted in Bohigas, Buchanan and Lampugnani, p. 175.

5 However, a building may be designed for no specific function.

6 Discussed in 'Index of Immaterial Architectures: Fireworks'.

7 Viaplana and Piñón, quoted in Bohigas, Buchanan and Lampugnani, p. 175.

Albert Viaplana and Helio
Piñón, Plaça Sants,
Barcelona, 1983.
View across the square.
Photograph, Jonathan Hill.

and inventive responses to the uselessness of squares in general and Plaça Sants in particular, which is known especially for its skateboarders. On one of my visits, instead of using one of the square's undulating curves, skateboarders played on a section of a concrete kerb that they had detached and placed in the middle of the square. On top of a mesh canopy, high above the ground, were a single trainer and a number of traffic cones.

Albert Viaplana and Helio Piñón, Plaça Sants, Barcelona, 1983. Mesh canopy with traffic cone. Photograph, Jonathan Hill.

MILKY-WHITE GLASS

Charcoal-Black Steel

In 1938 Mies was appointed Director of the School of Architecture at Armour Institute of Technology, Chicago, later renamed Illinois Institute of Technology. In 1940 he began to design the IIT campus, completing Crown Hall, the architecture and design building, in 1956. The ground floor is a single space without internal supports. The four elevations are glass set in a steel structure. The lower glass panels are 2 m high and sand-blasted milky-white. Above, and at the entrances, the glass is clear.[1] The lower milky-white glass casts soft shadows, conceals the immediate external environment, and draws the eye in two directions. First, towards the clear glass above and sky beyond and, second, into the light-infused interior. The milky-white glass below and clear glass above combine to diminish awareness of the building's mass, focusing attention instead on space. For Mies, as for many a modernist architect, light cast through glass was a means to reveal and experience space.[2] Seeing in past architectures a life-constraining materiality, Mies' intention was to make the material immaterial and the immaterial tangible: 'And what finally is beauty? Certainly nothing that can be calculated or measured. It is always something imponderable, something that lies between things.'[3] According to Forty:

> *Mies's aim seems to have been to make an architecture that would, through the subject's encounter with it, bring to consciousness the 'modern spirit'; in particular, this was to be achieved by the freedom of movement, and the opportunity, as Mies put it 'to seize life,' unrestricted by mass and matter . . . For Mies, 'space' was without question the pure essence of architecture – but not of the architecture of all times, only that representative of the 'modern.'[4]*

Although he considered it to be the liberating essence of modern architecture, Mies' understanding of space as a protective membrane between interior and exterior was less dynamic than that of modernists such as Moholy-Nagy who concentrated more on the architectural implications of the space–time continuum.[5] Crown Hall implies a less frenetic pace, like its distant views and soft shadows of milk or mist.

In 1951 Mies completed two apartment buildings at 860 Lake Shore Drive, Chicago, each with a black steel structure, clear floor-to-ceiling glazing and pale internal blinds. The glass at the base of each tower is sand-blasted milky-white once again.

1 The glass elevations are faced internally with Venetian blinds, which were not in use when I visited even though the weather was sunny.

2 Mies' concern for the dematerialization of architecture was long-held. A similar desire was evident in the work of other early twentieth-century architects. For example, the members of the Crystal Chain such as Bruno Taut, who were well known to Mies. Weston, pp. 52–53.

3 Mies van der Rohe, 'Build Beautifully'.

4 Forty, *Words and Buildings*, p. 268.

5 Moholy-Nagy also referred to space as an extension of the body and knew of the protective membrane theory of Ebeling, a colleague at the Bauhaus. Discussed in 'Chapter 1: House and Home' and 'Chapter 2: Hunting the Shadow'.

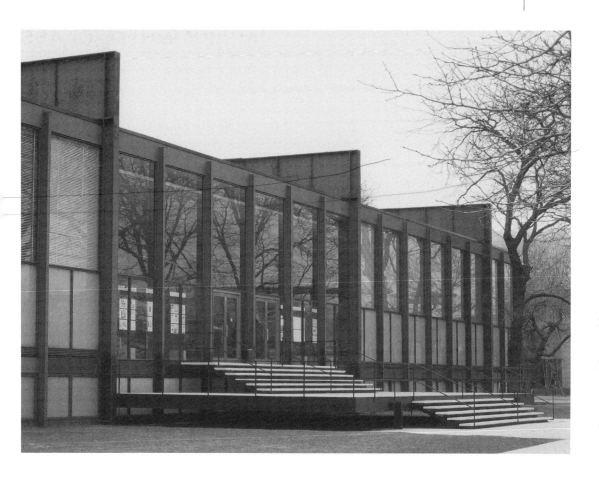

Photographs of 860 Lake Shore Drive tend to confirm the solid rationality often associated with Mies' architecture.[6] However, the buildings are very different from their photographs, which describe only the visual qualities of architecture, not those that are spatial and sensory in other ways. Sometimes it is assumed that Mies' noted aphorisms 'less is more' and 'almost nothing' refer to structural efficiency alone.[7] But at 860 Lake Shore Drive it is clear that they refer to the immaterial. Prioritizing the experiential and spatial over the material, Mies' intention was to achieve 'the greatest effect using the meagerest of means'.[8] The surfaces in the Barcelona Pavilion are clearly cut from natural materials. The fissures and lines in the marble, onyx and travertine tie the Pavilion to the physical world. At 860 Lake Shore Drive the surfaces are pure colour, charcoal-black or milky-white. The black steel defies shadows that would make it solid, and the milky-white glass renders the base of the building weightless. Evans writes:

Ludwig Mies van der Rohe, Crown Hall, Illinois Institute of Technology, Chicago, 1956. Photograph, Igor Marjanovic.

6 Evans, 'Mies van der Rohe's Paradoxical Symmetries', p. 244.

7 Mies commonly used two aphorisms, one spoken in English, 'less is more', the other in German, 'beinahe Nichts', meaning 'almost

nothing'. Vittorio E. Savi and Josep M. Montaner write that the provenance of 'less is more' is uncertain but 'Mies attributes it to his master Peter Behrens'. Savi and Montaner, p. 12.

8 Mies, quoted in Savi and Montaner, p. 12. Discussed in 'Index of Immaterial Architectures: Fluorescent Light'.

9 Evans, 'Mies van der Rohe's Paradoxical Symmetries', pp. 245–246.

10 Freed, quoted in Diamonstein, p. 93.

Look at the Lake Shore Drive Apartments (1948–51) where . . . every effort was made to deny that structure has anything to do with weight, heaviness, crushing, distension, or bending. The towers do not stand there. They hang . . . So the result is not the exhilarating levitation of an object (a familiar effect), but a dreamy disorientation of the observer. [9]

The day I visited 860 Lake Shore Drive the fog slipped in from Lake Michigan, rendering the two towers even less material, the space between them even more tangible. Speaking about his education at Crown Hall in the 1950s, James Ingo Freed writes: 'At that time, we were made to feel the tangibility of space, we could swim in it; like a fish swims in water.' [10]

MIRROR

Temple Island

Michael Webb was born in Henley-on-Thames, a small but prosperous town 35 miles west of London. Henley is noted for its annual rowing regatta, which alongside Wimbledon and Ascot is one of the principal social events of the English summer. Founded in 1859 and held in the first week of July, Henley Royal Regatta is associated with privilege as much as sport.

Small islands dot the broad stretch of the Thames close to Henley. Beyond the town is Temple Island, on which a fishing lodge with cupola, colonnade and plinth was built to the design of James Wyatt in 1771. Framed by the trees, sky and water, the temple was built to punctuate the view of the river from Fawley Court. The regatta course starts adjacent to Temple Island and finishes close to the bridge in the centre of town. As his father was accountant to the regatta, Webb watched from the privileged position of the Stewards Enclosure. A 1987 exhibition at the Architectural Association and subsequent publication, Webb's *Temple Island* is redolent of a nostalgic childhood moment 'late one golden afternoon'.[1] In conversation with Stephanie Brandt, he remarks:

> If you, as an architect, devote yourself to a dear landscape, known to you since early childhood, how can you suggest anything that changes it any material way? The point about a nostalgic place is that by changing it you destroy it. You don't, for example, put a new building on it.[2]

> But since architects possess this malignant wish to 'intervene', as they say . . . the intervention in the landscape of Henley Regatta must remain in the imagination; and, as a result, need therefore no longer be constrained by matters of cost, bulk or even gravity.[3]

Fittingly, therefore, apart from 'the little temple built as a fishing lodge on an island in the river',[4] Webb's 'ingredients to fuel the imagination' include nothing that is solid, permanent and familiarly architectural:

> . . . around 5.30pm on a hot cloudless day at the conclusion of the races, when the sunlight dances off the surface of the river and when the shadows lengthen.[5]

1 Webb, p. 26.

2 Michael Webb, in conversation with Stephanie Brandt, 6 January 2004.

3 Michael Webb, in conversation with Stephanie Brandt, 15 January 2004.

4 Michael Webb, in conversation with Stephanie Brandt, 15 January 2004.

5 Michael Webb, in conversation with Stephanie Brandt, 15 January 2004.

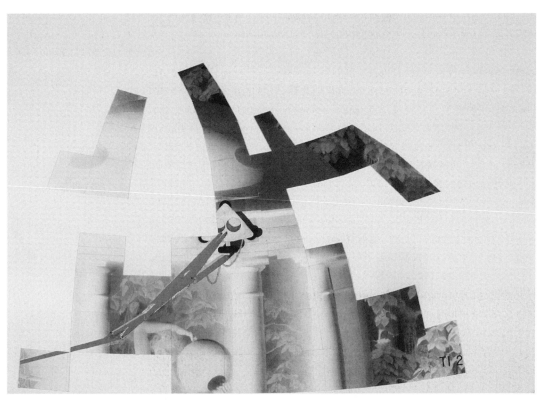

Michael Webb, Temple Island, 1987, redrawn in 2005 for *Immaterial Architecture*. Survey Drawing of the Existing Temple: Elevation of a Perspective Projection. Depicted are some component tessellations of a spherical Image Plane in which the Observer is a mobile floodlight illuminating the cupola of the temple. Courtesy of Michael Webb.

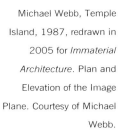

Michael Webb, Temple Island, 1987, redrawn in 2005 for *Immaterial Architecture*. Plan and Elevation of the Image Plane. Courtesy of Michael Webb.

. . . the implied 2D grid of the lines of course markers . . . that in a photograph resemble one of those pictures intended to explain perspective foreshortening.[6]

6 Michael Webb, in conversation with Stephanie Brandt, 15 January 2004.

The ephemeral atmosphere of a specific time and place is the fuel to Webb's imagination. Never fully revealed or explained *Temple Island* is equally elusive. In drawings and words the reader is given precise data and vague hints. A submersible carries a tripper 'floating down the regatta course towards the temple during the running of the Grand Challenge'.[7] The submersible may potentially allow a new temple – a creation and recreation that recalls Wyatt two hundred years before – to appear in certain conditions, fleetingly aligned in four periscopes. But we can never be sure. We cannot understand an object 'as it is' because the way we perceive affects what we perceive. Webb does not present a coherent and comprehensive description because there is not one definitive temple. As fleeting and fragmentary as memory and perception, *Temple Island* is incomplete and unfinished, knowingly.

7 Webb, p. 26.

Michael Webb, Temple Island, 1987. Early perspective of regatta course, looking towards Temple Island from the FINISH. Courtesy of Michael Webb and Archigram Archive.

Temple Island recalls another unfinished publication, Franz Kafka's *The Castle*, which follows K, a visiting land surveyor, around the village that surrounds the castle. K passes from one person to another in search of information that will allow him to enter the castle and gain permission to reside in the village. But as K's search is unsuccessful, the author need have no more knowledge of the castle than the reader: 'The castle hill was hidden, veiled in mist and darkness, nor was there even a glimmer of light to show that a castle was there.'**8** My hunch is that *Temple Island* is also a mystery to Webb, and he likes it that way. We do not know the temple, just as we never discover the castle. The focus of both narratives is not an object but what

8 Kafka, p. 9.

04 2/P

04 I/P

Michael Webb, Temple Island, 1987. Early perspective of the regatta course viewed by an overhead observer, who sees only what the tripper at T1 sees, thus objects in the landscape cast negative or 'white' shadows. Courtesy of Michael Webb and Archigram Archive.

we imagine it to be. They provide many questions and few answers so that author and reader alike are creative author-readers, each of us constructing another castle and another temple.

Webb is a member of Archigram, known for its confidence in architecture animated by technology. But from Webb's early Archigram projects to *Temple Island* is a journey from object to subject. In his earlier work the object is active. In *Temple Island* the subject is active. Webb writes that 'The object is interesting . . . only in that it may generate feelings of excitement, calm, indifference, boredom.'[9] The object is the means not the end.

Webb's opening line in *Temple Island* pre-empts the criticism of his peers: 'Doesn't much look like Archigram' – 'Looks more like the eighteenth-century than the twenty-first (!)'[10] *Temple Island* draws on ideas of the romantic and picturesque movements. It recalls the romantic exploration of nature as a metaphor for exploration of the self. Webb remarks that 'the actual temple and adjacent regatta course is for me the subject of certain chronic mental wanderings'.[11] Webb's many references to the weather are typical of romantic art and literature, in which weather is an important constituent of place.[12] Like the picturesque, *Temple Island* shows concern for empirical science and offers creative translations of earlier architectures. Its focus is a ruin, common to many a picturesque garden and redolent of loss and the passage of time. Although the landscape it depicts is gentle, *Temple Island* is especially indebted to the late eighteenth-century picturesque. In contrast to the direct and unmediated experience of nature promoted by romanticism, the late eighteenth-century picturesque was best observed through the Claude glass.[13] Rarely used in a garden, its purpose was to make found nature more picturesque. William Gilpin, a noted advocate of the late eighteenth-century picturesque, even described the merits of using the Claude glass at speed, while riding in his chaise.[14] Offering a fleeting glimpse of a nostalgic landscape, the submersible is to the chaise as the periscope is to the Claude glass.

[9] Webb, quoted in Woods, p. 54.

[10] Webb, p. 1.

[11] Webb, p. 26.

[12] Discussed in 'Index of Immaterial Architectures: Weather'.

[13] Discussed in 'Index of Immaterial Architectures: Lily'.

[14] Hunt, *Gardens and the Picturesque*, pp. 178–179.

MIRROR GLASS

On Reflection

A location in a gallery is but one way that an object acquires the status of art. As important are curatorial practices, the art market, and the aura of the artwork and the artist, which define an object as art whether it is located inside or outside the gallery. Art practices outside the gallery, such as environmental art and land art, are often characterized as an attempt to contend the commodity status of art and engage forms of experience that invite a critical and active dialogue between the artist, artwork and viewer. But environmental art and land art rely on the familiar mechanisms of the art world and are often experienced in contemplation. Public art is more often urban rather than rural. But, located outside the gallery, it shares some of the concerns and dilemmas of environmental art and land art. It too is sometimes produced under the assumption that the subject–object relations within the gallery should be replicated outside. As it is made by one individual and contemplated by another, private art is a good description of most art, whether in the gallery or in nature.[1] A desolate desert and hermetic gallery are equally suited to contemplation. A congested street is not. Public art is often an uneasy hybrid of private art and public architecture: an object to be contemplated in an environment unsuitable for contemplation.

In 1991, with the architects Modjeh Baratloo and Clifton Balch, Dan Graham completed *Rooftop Urban Park Project* at the DIA Center for the Arts in Chelsea, New York. Originally a temporary exhibit expected to remain for three years, *Rooftop Urban Park Project* was retained due to its critical success.[2] To reach it the visitor enters the DIA and proceeds to the roof. *Rooftop Urban Park Project* has two parts: *Video Salon*, in a small existing rooftop room, and *Two-Way Mirror Cylinder Inside Cube*, a new pavilion outside. The two adjacent parts indicate that Graham's earlier video work and later pavilions have a common theme: self-perception fragmented in time and space.

Two-Way Mirror Cylinder Inside Cube is situated in the private space of the DIA and the (visual) public space of New York. The park implied in *Rooftop Urban Park Project* is not just the roof of the DIA but the roof of the city. Consisting of a cylinder within a cube, both walled in two-way mirror glass and placed on a timber plinth, the pavilion is an entrance lobby to gaze on the city of corporate modernism through its own distorting architecture. The pavilion immerses the viewer in shifting reflections and overlapping views of the city, viewer and others. Attention focuses on its effects not its substance, which appears to dissolve from view. The notable memories of my visits – one in summer, the other in winter – are threefold. First, the inside of the

1 If the artist uses assistants, their efforts are rarely announced.

2 Although DIA, Chelsea, closed for renovations in 2003, my description is written in the present tense as if *Rooftop Urban Park Project* is still *in situ* and accessible.

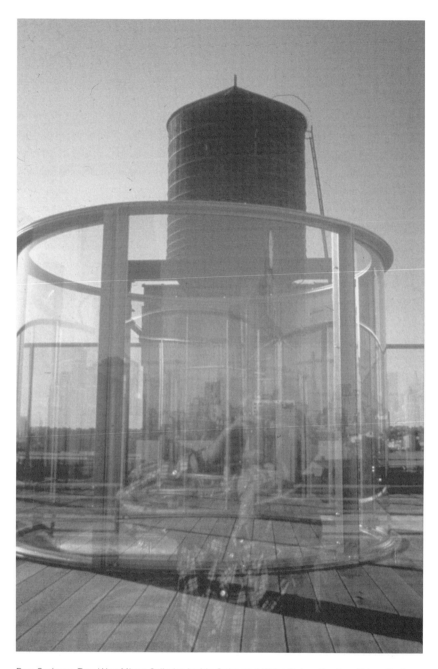

Dan Graham, *Two-Way Mirror Cylinder Inside Cube and Video Salon, Rooftop Urban Park Project*, DIA Center for the Arts, New York, 1991. Courtesy of Lisson Gallery and Dan Graham.

cylinder, disorientating and fragile like the inside of a soap bubble, especially when the curved hinged door slowly closes. Second, blurred urban panoramas flickering on the surface of the cylinder as light levels adjust. Third, views forward and backward merging on the surface of the cube. Other visitors will have comparable experiences but each visit to the pavilion is different due to the actions and number of people present, the time of day and season. Weather conditions – such as the direction of the sun and character of the sky – adjust the transparency and reflectivity of the pavilion's surfaces and, thus, the relationship of cylinder to cube, interior to exterior.

Graham's pavilions refer to one of the principal concerns of modernist architecture: transparency. Anthony Vidler writes:

> Modernity has been haunted, as we know very well, by a myth of transparency: transparency of the self to nature, of the self to the other, of all selves to society, and all of this represented, if not constructed, from Jeremy Bentham to Le Corbusier, by a universal transparency of building materials, spatial penetration, and the ubiquitous flow of air, light and physical movement.[3]

3 Vidler, *The Architectural Uncanny*, p. 144.

Visually transparent, the modernist façade implies that the workings within are equally transparent and accessible. But the transparency of modernist buildings is deceptive, as Graham recognizes. In *Rock My Religion*, next to a photograph of Mies' 1958 Seagram building, New York, he writes:

> Yet the glass's literal transparency not only falsely objectified reality, it was a paradoxical camouflage. For while the actual function of the occupying corporation might have been to concentrate its self-contained power and to control by secreting information, its architectural façade gave the impression of absolute openness. The transparency was visual only: glass separated the visual world from the verbal, insulating outsiders from the focus of decision-making and from the invisible, but real, links between company operations and society.[4]

4 Graham, *Rock My Religion*, p. 227.

The façade of the Seagram is reflective as often as it is transparent, however. At night, with the lights on, the interior is revealed. In daytime, if the interior light level is low, the glass is reflective. And between these two conditions the façade reveals and reflects to varying degrees, as Mies was aware: 'My experiments with a glass model helped me along the way and I soon recognized that by employing glass, it is not an effect of light and shadow one wants to achieve but a rich interplay of light reflections.'[5] Mies also exploited the reflectivity of materials other than glass. For example, nearly all the surfaces in the Barcelona Pavilion are reflective to varying degrees: clear glass, opaque

5 Mies, quoted in Neumeyer, p. 240. Published without a title as Ludwig Mies van der Rohe, *Frühlicht*, 1, no. 4, 1922, pp. 122–124.

glass, chrome, water in the two pools, yellow travertine, red onyx and green alpine marble. As self-perception is the theme of his work, Graham's understanding of Mies' architecture is positive as well as negative, and informs the many pavilions he has created.

In addition to the corporate towers of post-war modernism, Graham's references include English picturesque gardens[6] and the rococo Amalienburg hunting lodge[7] from the eighteenth century, and the Barcelona Pavilion, Farnsworth House and minimal art object from the twentieth:

> Minimal Art and post-Bauhaus architecture . . . compare in their abstract materialism and their formal reductive methodology. They share a belief in 'objective' form and in an internal self-articulation of the formal structure in apparent isolation from symbolic (and representational) codes of meaning.[8]

> Mies' best-known temporary pavilion, the Barcelona Pavilion, can be seen as a twentieth-century variation of the allegorical (and narrative) eighteenth-century 'English Garden' pavilion. The spectator is led through the narrative walk by reflected virtual images of himself and other parts of the pavilion seen in surfaces of polished marble and other modern materials.[9]

> One of my beginning points was the Amalienburg pavilion in the formal garden of Munich's Nymphenburg Palace. It contained a hall of mirrors which related the King to the mythology of the sun god. The silver mirrors and their ornamentation of artificial foliage were transformed into gold in the presence of the king by the opening of the windows by day, and the use of golden candlelight by night. The two-way mirror glazed corporate towers in the 1970s were often gold-coloured, symbolizing the god-like potency of the corporation . . . In the ecologically conscious 1980s the office building's façade became silver two-way mirror, reflecting the sky and creating the impression of a good relation between building and environment.[10]

Connecting Graham's pavilions to these references is an understanding of immaterial architecture as a means to consider the perception of the self in relation to others. Graham writes: 'The first pavilions are also philosophical or socio-psychological models referencing the spectator's ego and visual perception process relative to the 'other' spectators or audience.'[11] The pavilions are both art and architecture, as he acknowledges:[12] 'All architects I know want to be artists and all artists I know want to be architects, it's a virus.'[13] Rooftop Urban Park Project is a public artwork that encourages contemplation to be public as well as personal. It contradicts the familiar

6 For further discussion of the picturesque, refer to 'Index of Immaterial Architectures: Lily', 'Mirror' and 'Weather'.

7 Designed by François de Cuvilliés and constructed between 1734 and 1740 in the gardens of the Nymphenburg Palace near Munich. Discussed in 'Index of Immaterial Architectures: Plaster'.

8 Graham, 'Art in Relation to Architecture/Architecture in Relation to Art', p. 228.

9 Graham, in Graham and Hatton, p. 19.

10 Graham, in Graham and Hatton, p. 19.

11 Graham, in Graham and Hatton, p. 7.

12 Graham, in Graham and Hatton, p. 7.

13 Graham, 15 February 2003, in 'More or Less Mies: Reflections in Twenty-first Century Architecture and Art', a conference conceived and organized by Jonathan Hill, held at the Whitechapel Gallery, London, 15 and 22 February 2003, in conjunction with the Bartlett School of Architecture, University College London.

form of contemplation, which rejects anything and anybody that intrudes on individual experience. *Rooftop Urban Park Project* is a building in which fluctuations in perception, occupation and climate are both its subject and integrated into its fabric.

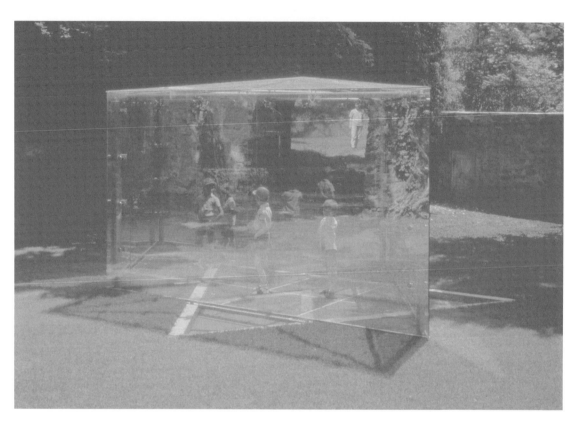

Dan Graham, *Star of David Pavilion for Schloss Buchberg*, 1988–1996. Courtesy of Lisson Gallery and Dan Graham.

Andrew Holmes and Mark Fisher, Saffron Valley, Croydon, 1993. Blue road collage. Courtesy of Andrew Holmes and Mark Fisher.

Andrew Holmes and Mark Fisher, Saffron Valley, Croydon, 1993. Crocus line collage. Courtesy of Andrew Holmes and Mark Fisher.

NIGHT LIGHT

Saffron Valley

In 1993 fifteen architectural practices were invited to propose ideas for the regeneration of Croydon, a bland satellite town south of London with a fittingly dull reputation.[1] Croydon is primarily known for cheap office space and a government building that processes foreign nationals resident in the London area, which with presumably unintentional irony is named Lunar House and located far from central London.[2] Most of the practices proposed either new buildings or the transformation of existing ones. Their logic was circular and self-promotional; as architects design buildings, the best way to improve a town is to build new buildings. Architects argue that building design is a skill at which they are particularly adept, and their fees are often calculated as a percentage of construction costs. Even a particularly skilful and deservedly famous architect may not be paid significantly more than other architects. For architects, therefore, building size is synonymous with financial reward. Artists, who are not paid a percentage of construction costs and can charge according to their fame, have less need to produce works of scale and mass.

The proposal by Andrew Holmes and Mark Fisher – Saffron Valley – included no demolition and no new buildings, however.[3] Instead, their principal suggestion was only that new light bulbs – emitting a rich blue light – should be inserted in all street lamps in Croydon 'to connect the commuter city with the memory of Archbishop Whitgift's trout streams'.[4] Rivers of blue light would run through the town, their intensity varying through the night. Their second proposition added the bulb of a plant to that of a lamp. A line of white crocus bulbs would point towards a TV satellite, connecting the memory of Croydon as a valley of saffron to the presence of Croydon as a city of information. The only proposal to deal with the whole town, Saffron Valley was also the simplest. With limited means Holmes and Fisher offered Croydon a poetic solution to its poor environment and dull image. Saffron Valley was also the most contextual proposition, making a virtue of the miles of roads and roundabouts that at present identify Croydon as a replica of the car-bound North American city.

Saffron Valley indicates that a significant urban transformation does not necessarily require new buildings and can be created through the most delicate and immaterial of means. It is a convincing validation of Mies' aphorisms 'almost nothing' and 'less is more'.[5] In Saffron Valley, as in Mies' architecture, space is equated with light, which is historically associated with revelation. Tabor writes:

1 'Croydon: the Future', organized by the Architecture Foundation and the London Borough of Croydon.

2 Lunar House is the largest Public Enquiry Office (PEO) in the UK, open to foreign nationals who wish to apply for a visa extension without leaving the UK. No appointment is necessary. Readiness to queue is, however.

3 Croydon's name derives from the Anglo-Saxon 'croeas deanas', meaning 'the valley of the crocuses'. The spice saffron is derived from the stamens of the saffron crocus, *Crocus sativus*.

4 Melhuish.

5 Discussed in 'Index of Immaterial Architectures: Milky-White Glass'.

> Scholastic metaphysics classified light as substance, an 'embodied spirit,' which distributes light to God's creation . . . Scholasticism was far from pristine or icon-oclastic, but it had a strong subjective aspect which valued communion more highly than the reading of words and images: revelation more highly than information. And light was the main vehicle of revelation: St Bernard of Clairvaux described union with God as 'immersion in the infinite ocean of eternal light and luminous eternity' . . . So the Gothic cathedral was designed to be literally divine, as immaterial and as luminous as possible.[6]

6 Tabor, pp. 226–227.

Today, we view light with different eyes. But Croydon would benefit from its renewed presence. Man-made, and the opposite of a distant Godly light, the luminous blue sensual flows of Croydon would be revelatory in other ways, identifying and nourishing the earth-bound beauty of an everyday urban night-life.

NORDIC LIGHT

Venetian Light

In 1962 the Pavilion of the Nordic Nations, designed by Sverre Fehn, opened in the gardens of the Venice Biennale. Serving Finland, Norway and Sweden, the Nordic Pavilion is located between the American and Danish pavilions and next to a small hill. It is a single rectangular room. The north and west walls, respectively adjacent to the hill and the American Pavilion, are concrete; those to the south and east are sliding glass. The roof consists of two layers of deep and slender concrete beams closely spaced. The lower structural layer extends from the north wall to double beams on the south elevation, which rest on the broad double column at the south-east corner of the Pavilion. The upper layer is aligned east–west.

To indicate the Pavilion's affiliation to the Nordic nations, Fehn focused on the interdependence of nature, architecture and art in Nordic culture. Especially in summer, the high Venetian sun creates a sharp and warm light with strong shadows that emphasize the solidity and mass of buildings. In contrast, the typical Nordic light is diffuse and cool with soft shadows that flatten and diminish matter. As a symbol of Nordic culture, the Nordic Pavilion creates a Nordic light. The two layers of concrete

Sverre Fehn, Pavilion of the Nordic Nations, Venice Biennale, 1962. East façade. Photograph, Jonathan Hill.

Sverre Fehn, Pavilion of the Nordic Nations, Venice Biennale, 1962. Roof detail. Photograph, Jonathan Hill.

beams exclude direct sunlight and create a light that is soft and diffuse, transforming Venetian light into Nordic light.

Often associated with the immaterial, light is also a material of architecture. In the Pavilion it is but one of a number of natural materials. Large trees are abundant throughout the Biennale gardens. Rather than remove ones that coincide with the Pavilion, Fehn built around them. Gaps in the roof beams allow the trees to grow unhindered, and the two wings of the double corner column bifurcate at 45 degrees to frame a particularly large tree.

Water, more than anything else, is the context in Venice, whether in the canals, lagoon, mist or rain. Built in a marshy landscape, the sea is the source of Venice's wealth. First, through the development of sea-bound trade and, second, as a destination for tourists drawn to the beauty of a watery city. Evidence and experience of decay, which indicate the passage of time and fragility of life, are key to Venice's appeal. The rising sea is the principal agent of the city's decay and romanticism. On the roof of the Pavilion, clear fibreglass panels prevent rain from entering the interior. But in a rainstorm, water trickles down the trees and into the interior. Extending beyond

the glass walls – left open in summer – the concrete floor is flush with the gardens that surround it, diminishing the threshold between inside and outside, which is marked not by a physical barrier but by a shift from Venetian light to Nordic light. A photograph of the Pavilion before the installation of the sliding glass walls shows the concrete floor shiny and washed with water after a rainstorm, indicating the symbolic and literal interaction of architecture and nature that is characteristic of Nordic culture and Venice, especially in moments of peril and beauty.

Elements formed of man-made materials – slender concrete beams, clear fibreglass panels, glass walls and smooth concrete surfaces – make the Pavilion appear unusually light and weightless. The Pavilion's other important materials – Nordic light, trees and rain – are natural. Together they diminish the solidity and materiality of the Pavilion, blur the boundary between nature and architecture, and invite casual movements that undermine the aura of art, which the other national pavilions tend to affirm. The conjunction of solid matter,[1] fluid matter[2] and immaterial space[3] seems to draw the Pavilion away from the material and towards the immaterial.

1 Concrete, glass, fibreglass and trees.

2 Water.

3 Light.

Montage of Gaps

Bürger writes that 'The organic work of art seeks to make unrecognisable the fact that it has been made.'[4] In the organic work of art the individual parts are subordinate to, and in harmony with, the overall composition, while in the non-organic work of art, the parts, arrangement and context are distinct and non-hierarchical. Although many of its most important architectural materials are natural, the Pavilion is not an organic work of art. Instead, it is comparable to Bürger's description of the non-organic work of art. Proclaiming its artificiality and indicating that the natural is itself cultural, the non-organic work of art invites a knowing and active response from the viewer, who 'participates with the "author" in the creation of the work'.[5]

4 Bürger, p. 72.

5 Newman, p. 45.

Bürger states that the non-organic work of art is characteristic of the early twentieth-century artistic avant-garde: 'To this extent, montage may be considered the fundamental principle of avant-gardist art.'[6] Montage is familiarly understood to consist of distinct material fragments brought together in a new site: the montage of fragments. But the Pavilion is a montage unlike that of the early twentieth-century artistic avant-garde. Rather than a montage of fragments, it is a montage of gaps, which requires the interplay of three elements – site, fragments and gaps – each as important as the other.[7] A gap is an opening, maybe for just a moment, between seemingly more substantial conditions. Indicating that something is either unnoticed or missing, a gap is especially open to varied interpretation. Signifying incompletion, a gap invites the

6 Bürger, p. 72.

7 For a more detailed discussion of the montage of gaps, refer to Hill, *Actions of Architecture*, pp. 109–128.

user to imagine what is there and, thus, to complete the image. But as no interpretation is correct, each user can make the image anew. In the Pavilion the gaps are spatial, sensual and semantic. The spatial gap seems both empty and latent, waiting to be filled and transformed by experience. The sensual gap occurs when either a number of senses contradict each other or one is depleted. The semantic gap occurs when, for example, certain characteristics expected of a building or building fragment are absent or undermined. In the Pavilion a sensual gap is evident in the depletion of Venetian light to create Nordic light.[8] Other gaps – spatial, sensual and semantic – occur due to the absence of a clearly defined threshold between building and garden, apart from differences in light, and the presence of external elements inside as well as outside, such as trees and weather. Blurring interior and exterior, Fehn creates a semantic gap between the Pavilion and the term 'building'.

Montage is applicable to architecture because the experience of the building depends upon a complex reading of many conditions understood over time. For the reasons I outline in 'Chapter 2: Hunting the Shadow' the often didactic montage of fragments associated with the early twentieth-century artistic avant-garde is an unsatisfactory model for architecture.[9] The Pavilion implies a theory of montage not based on shock and, therefore, suitable to the habitual experience of architecture.[10] The montage of gaps is a development of ambiguous montage associated with picturesque gardens and some modernist architecture.[11] It is especially appropriate to user creativity because buildings are experienced not all at once and as a whole, but piece by piece in moments separated by gaps in climate, use, space and time, to mention but a few examples. The aim of the montage of gaps is not to grab attention and then sink to acceptability. But to have a more gradual influence, remaining unresolved so that it is available for endless revisions and appropriations, to be remade anew by each user. Even more than in the montage of fragments, in the montage of gaps authority is shared between the producer and the user.

8 For a discussion of the juxtaposition of sounds and sights, refer to 'Index of Immaterial Architectures: Silence'.

9 The montage of fragments can be ambiguous but it is more often didactic and shocking.

10 As a gallery, the Pavilion is not visited as regularly as some other building types but most visitors are likely to experience it a number of times on visits to different exhibitions.

11 Ambiguous montage is discussed in 'Chapter 2: Hunting the Shadow'.

OAK TREE

Fountain

In 1974 a visitor to the Rowan Gallery in London would have found a room empty except for a glass of water placed in the centre of a glass bathroom shelf mounted nine feet above the floor.[1] Accompanying the exhibit was a leaflet detailing an interview with the artist of *An Oak Tree*, Michael Craig-Martin:

> Q: To begin with, could you describe this work?
> A: Yes, of course. What I've done is change a glass of water into a full-grown oak tree without altering the accidents of the glass of water.
> Q: The accidents?
> A: Yes. The colour, feel, weight, size . . .
> Q: Do you mean that the glass of water is a symbol of an oak tree?
> A: No. It's not a symbol. I've changed the physical substance of the glass of water into that of an oak tree.
> Q: It looks like a glass of water . . .
> A: Of course it does. I didn't change its appearance. But it's not a glass of water. It's an oak tree.[2]

Lynne Cooke writes:

> Critics were quick to link the underlying concept to the act of transubstantiation which takes place in the Mass when the bread and wine become the body and blood of Christ, a reading with which the artist does in general concur. But in one sense at least, reference to transubstantiation offered only partial explanation. More important was the fact that in this work Craig-Martin asserted his belief in the impossibility of art that is purely materialist. Paradoxically, this was done via a strictly materialist approach . . . What is crucial to this work is the question of belief – both the power of art to construct reality and the question of how this belief comes into being.[3]

An Oak Tree is a fruit of one of the longest and most influential traditions in modern art. In 1917 Marcel Duchamp exhibited *Fountain*, a mass-produced urinal which he signed 'R. Mutt'. *Fountain* is often categorized as a revolutionary artistic gesture. In renaming, signing and placing an everyday object in a gallery, Duchamp questioned the autonomy of art, as well as the nature of individual creation and the economic

1 Michael Craig-Martin, *An Oak Tree*, 1973.

2 Craig-Martin, plate 18, p. 60.

3 Cooke, pp. 11–12.

circulation of artworks on the concept of originality. But *Fountain* is also an iconic moment in twentieth-century art which affirms the uniqueness of the artist and the artwork. Raising the status of a urinal to that of art, *Fountain* furthers the principle that art and artistic originality are products of the artist's intellect. Art is the idea not the object, it states. A urinal is an artwork because the artist says so. A urinal is a *Fountain* because the artist says so.

In that it is made of mass-produced materials – tap water and glass – *An Oak Tree* is reminiscent of *Fountain*. *An Oak Tree* draws attention to the continuing importance of the aura of the art, and the role of the gallery and the artist in its affirmation. Prioritizing conception over perception, Craig-Martin claims that he can change one object into another: 'It is not a glass of water anymore. I have changed its actual substance.'[4] *An Oak Tree* addresses the act of faith required of the art viewer. Without any visible material transformation, a glass of water is *An Oak Tree* if the viewer accepts the word of its creator. So what is the role of the viewer? To agree or disagree? Or to use Craig-Martin as a catalyst, maybe to rename a glass of water a horse chestnut or conceive a rowan tree in an oak gallery.

For some visitors to the Rowan Gallery, it is likely that an oak tree and a glass of water existed in the same space and time, one according to conception, the other according to perception. A comparable process occurs in architecture, sometimes without the involvement of the architect, who has less command over interpretations than the artist. Designing a building that is intentionally inappropriate for its function,[5] or naming a building according to a function for which it was not designed, does not change one object into another.[6] Rather it allows two to coexist, each with different images and associations, to which the user may add others. When eighteenth-century houses house an architecture school, the physicality and idea of 'house' rub against those of 'architecture school'.[7] Adjusting Cooke's words to refer to architecture rather than art, the 'Index of Immaterial Architectures' affirms 'the impossibility of architecture that is purely materialist. Paradoxically, this is done via a strictly materialist approach.' Rather than prioritizing conception, however, the 'Index' investigates immaterial architectures that are informed by a dialogue between conception and perception.

4 Craig-Martin, plate 18, p. 60.

5 Peter Eisenman, House VI, Cornwall, Connecticut, 1976, for example.

6 Language, either in contradiction to use or in conjunction with use, is one of the principal ways in which the immaterial works in architecture.

7 Architectural Association School of Architecture, London.

OIL

20:50

Richard Wilson's *20:50* was first installed in 1987 in Matt's Gallery, London. Later it was housed in the Saatchi Gallery, a former industrial building in Boundary Road, London, which was simply divided into a sequence of large rooms with steel roof trusses, white walls and minimal detailing familiar in a contemporary art gallery.[1] In Boundary Road *20:50* was located away from the main gallery entrance in a rectangular room with white walls, a glazed roof and only one entrance. The first experience of *20:50*, before the visitor saw the artwork, was the smell of sump oil, unexpected in an art gallery but familiar in an industrial building. To reach *20:50* the visitor passed along a short corridor that concealed Wilson's artwork from the other spaces of the gallery. On reaching *20:50* the smell of sump oil contradicted the sight of a horizontal mirrored surface at waist-height, which filled the room and reflected the glazed roof above. The visitor moved towards the centre of *20:50* along a walkway that sloped down and narrowed gently. Cut into the mirrored surface at an oblique angle, the walkway had a steel floor and sides, their upper edges flush with the mirrored surface. As the walkway narrowed, the visitor moved closer to the mirrored surface and, if he or she had not already done so, realized that it was formed of sump oil set within a steel container so full that only surface tension prevented the oil from spilling over. The powerful smell of oil contradicted the visual experience of the artwork and revealed the true nature of the mirrored surface. Enjoying watching the visitors, the gallery guards recounted stories of people who failed to understand the materiality of the mirrored surface. A woman placed her handbag on what she believed to be a solid surface only to see it sink, and a man peered so inquisitively he lowered his face too far. Oil dripped off his nose. Such experiences can be understood in two ways. First, they recall Benjamin's comment that in contemplation 'A man who concentrates before a work of art is absorbed by it. He enters into this work of art the way legend tells of the Chinese painter when he viewed his finished painting.'[2] But, second, as in both instances concentration was broken by touch, they can be understood as attempts to use *20:50* as well as contemplate it.

 20:50 is an artwork. Usually the art gallery maintains a clear distinction between the space of the artwork and the space of the viewer. However, the best known photograph of *20:50*, when it was installed at Matt's Gallery, is a rare record of an inhabited artwork, suggesting that *20:50* is only complete when occupied.[3] The single figure stands still and does nothing that can be understood in terms of utility. But there

[1] *20:50* was until recently installed in the relocated Saatchi Gallery in the former County Hall on London's South Bank.

[2] Benjamin, 'The Work of Art', p. 239.

[3] The figure is Richard Wilson.

are many ways to occupy buildings and the figure's experience need not be contemplation alone. *20:50* is architecture in that it offers a complex sensory experience that cannot be understood at a distance. The steel walkway is unambiguous. But another principal element, the mirrored surface, is a liquid that appears solid at first, contradicting the most immaterial element of *20:50*: the smell of sump oil. To comprehend *20:50* the visitor must occupy it.

PAPER

Paper Architecture

The traditional Japanese house is a matrix of interconnected rooms divided by fusuma, sliding screens with latticed wooden frames used externally and internally.[1] Few spaces are mono-functional – function is more often temporal and defined by the user – and the threshold between inside and outside is defined by an action, removing shoes, as much as by physical fabric. The fusuma allow the relationships between rooms undefined by function and the more fixed spaces of cooking, dining and gardening to shift according to the occupation of the house and time of day. Furniture is mostly lightweight and movable. For example, beds are only brought out when in use; the rest of the time they are folded away.

1 Rabeneck, Sheppard and Town, p. 84.

Jun´ichiró Tanizaki, however, ascribes the particular quality of Japanese architecture not just to the sliding screen but to the paper in which it is faced:

> Paper, I understand, was invented by the Chinese; but Western paper is to us no more than something to be used, while the texture of Chinese paper and Japanese paper gives us a certain feeling of warmth, of calm and repose. Even the same white could as well be one color for Western paper and another for our own. Western paper turns away the light, while our paper seems to take it in, to envelop in gently, like the soft surface of a soft snowfall.[2]

2 Tanizaki, pp. 9–10.

Deep eaves protect the interior from direct sunlight, ensuring that soft shadows are cast through paper:

> The light from the garden steals in but dimly through paper-panelled doors, and it is precisely this indirect light that makes for us the charm of a room. We do our rooms in neutral colors so that the sad, fragile, dying rays can sink into absolute repose . . . And from these delicate differences in the hue of the walls, the shadows in each room take on a tinge peculiarly their own.[3]

3 Tanizaki, pp. 18–19.

Tanizaki concludes 'that the beauty of a Japanese room depends on a variation of shadows, heavy shadows against light shadows – it has nothing else'.[4] As Guy Brett notes, 'The paradox of referring to "everything" by "nothing" has been a key recourse in eastern philosophy and religion.'[5]

4 Tanizaki, p. 18.

5 Brett, p. 11.

paper

6 Gropius, *Apollo in the Democracy*, p. 120.

7 Corrin, p. 33.

The traditional Japanese house, which Gropius praises for its flexibility, is a precedent for the modernist open plan.[6] Japanese architecture was better known to early modernists but traditional Korean architecture has some similar qualities. Lisa G. Corrin writes that 'In a typical Korean house the apertures are removable sliding doors that separate interior spaces so that uses can be constantly altered. Even the furniture is portable.'[7] The modernist open plan incorporates the sliding walls and flowing spaces of traditional Japanese and Korean houses, but misinterprets and hardens their spatial, social and environmental porosity. In the modernist open plan, a specific function is often tied to a specific space. The sliding internal wall is substantial enough to create privacy between adjacent spaces, and the glass external wall is a defensive barrier, isolating interior from exterior, so that the occupant is unaffected by the unpredictable natural environment.

In traditional Japanese and Korean houses internal and external walls are delicate and porous; in Japan the internal temperature is maintained by a stove, and in Korea by under-floor heating. As windows are faced in opaque rice paper, oiled to become waterproof, the user's perception of the exterior involves all the senses rather than the primarily visual connection between inside and outside that is apparent through the glass wall of the modernist open plan. Do-Ho Suh, an artist who grew up in a traditional Korean house, writes that 'Korean architecture is very porous. While you are sitting or sleeping in the room, you can hear everything inside and outside. You feel like

Yangban Class House constructed by King Sunjo, Changdeokgung Palace, Seoul, 1828. Window faced in rice paper. Photograph, Jonathan Hill.

you are in the middle of nature.'[8] In traditional Japanese and Korean houses, paper provides a porous boundary that blurs architecture and nature, allowing one to infiltrate the other, so that the user must live with seasonal fluctuations: 'Winter was held to offer an experience of difficult but rewarding beauty.'[9]

In 'Chapter 2: Hunting the Shadow' I note that paper – the space of drawing – is crucial to the status of the architect and architectural design. But as an architectural material, paper is unfamiliar in western architecture for two reasons. First, as it is understood as immaterial, paper cannot be easily recognized as material. Second, a wall or window of paper offers a soft boundary compatible with holistic perception more often associated with eastern than western society. It is neither sensible nor possible to directly transfer the architecture of one society to another because meaning is dependent on context. Social cohesion in Japan and Korea, informed by the prevalence of Confucian values, ensures that a social boundary need not necessarily be physical. But learning from Japanese and Korean paper architecture may encourage western architecture's obsession with immaterial drawing and material building to be further questioned and confused.

8 Suh, in Corrin, p. 33.

9 Drexler, p. 41.

PLASTER

Rococo Revolution

Once, when I noted my fascination for the rococo to an architect friend, her reply was 'oh you mean cake decoration'. Often described as feminine, rococo architecture is dismissed as an inconsequential frippery. For eighteenth-century architects who 'rediscovered the beauty of perennial Platonism and sought relief in the stern, timeless beauty of elementary geometric forms . . . Rococo capriciousness was associated with moral lassitude and a lack of honesty', an opinion shared by many architects today.[1]

1 Harries, *The Ethical Function of Architecture*, p. 301.

Hans Sedlmayr and Hermann Bauer, however, identify a number of innovations in rococo architecture, including the ennoblement of the low, an earthly and sensual rather than metaphysical light, and walls that appear soft and delicate due to their lack of colour, curved form and hidden structure. They write: 'In this turnover, which brought the "low" to the top and simultaneously ennobled it, the rococo was a revolution in the true meaning of the word. It is one of the great European revolutions in that chain of revolutions which once begun cannot be stopped.'[2] In two further paragraphs, Sedlmayr and Bauer wonderfully evoke the gentle luminosity of the rococo:

2 Sedlmayr and Bauer, p. 238.

> It is necessary to attempt to explain the unity of rococo through its conception of light, for each true style has a specific relation to light. Rococo light is a transfigured, but earthly, sensuous light. The three physical means contributing to it are French windows, the whiteness of the rooms and mirrors, as well as the particular sheen given to ordinary materials. French windows are characterized not only by a greater amount of light and tall, slender openings which come close to Gothic proportions, but primarily by the fact that they admit light to the room upward from the floor . . . Light streaming in along the floor is a particularly earthy light that is transfigured by the mirrorlike smoothness of the parquet floors.
>
> No less an innovation was the adaptation of the interior to the predominantly white color of the walls. This white was, in a way, materialized light that had become color . . . After 1725–30, in the rococo proper, the white color was often replaced by light-hued tones containing a great deal of white (light blue, light yellow, pink, reseda etc.). In the decoration of furniture white was combined with a finely distributed gold (or silver) and became materialized shimmer. White was the lightest of colors, gold the material of light, and the mirrors were both shimmer and illusion, increasing the effect of luminosity, and subtracting all remaining weight from the confines of the room. Further, the mirror transfigured the light, making it intangible and fantastic, yet

without robbing it of its earthly character. In the large mirrors, which often filled whole walls, the interior fused with the exterior, and the earthly light attained the highest degree of luminosity . . . Many materials with particularly light-catching surfaces contributed to the luminosity of the mirror: the brilliantly polished parquets; the varnish of the furniture: the shiny iridescent silks or softly glowing velvets, used for both upholstery and dress; the milk-white gleam of the porcelain, mother-of-pearl and lacquer and the moonlike shimmer of lead sculpture.[3]

3 Sedlmayr and Bauer, pp. 239–240.

Reflective Architecture

The pinnacle of rococo architecture is the Amalienburg, a small hunting lodge for Electress Maria Amalia, which was designed by François de Cuvilliés and constructed between 1734 and 1740 in the gardens of the Nymphenburg Palace near Munich. The Amalienburg's restrained exterior and exuberant interior are characteristic of rococo architecture, which differentiates spaces according to their function. Sedlmayr and Bauer write:

Convenance, or suitability, required a differentiation of structures and rooms (according to their purpose) . . . The sharp distinction between exterior and interior in the rococo kept faith with this principle. It would not have been suitable to decorate the exterior like the interior. The particular purpose of each room determined its form, size, proportions, and particularly its dimensions, character, and the themes of its decoration.[4]

4 Sedlmayr and Bauer, p. 243.

Rococo architecture promotes comfort and play but acknowledges the transience of life as well as pleasure. Christian Norberg-Schulz writes that 'The Rococo, thus, shows the empirical interest in sensation, but transforms scientific observation into the enjoyment of sensuous stimuli – visual, auditory, gustatory, olfactory, and, last but not least, erotic – which became a justification for life.'[5] Norberg-Schulz concludes that 'Rather than illustrating nature's grand design' rococo 'expresses its transitory and perishable aspects'.[6]

5 Norberg-Schulz, *Late Baroque and Rococo Architecture*, p. 13.

6 Norberg-Schulz, *Late Baroque and Rococo Architecture*, p. 13.

The Amalienburg sits in a clearing in meandering woods to one side of the formal parterres that originate from the Nymphenburg Palace. At its centre is a clearing within a clearing, a circular salon of floor-to-ceiling mirrors and French windows facing each other across the axis that runs through the building. The salon seems to expand beyond its actual dimensions. Nature is reflected in mirrors, observed through windows and, in delicate, silvery, swirling plasterwork, depicted in metamorphosis, full and abundant but at the edge of winterly decay. Architecture, nature and depicted nature fuse and

François de
Cuvilliés, Amalienburg,
Nymphenburg Palace,
Munich, 1734–1740.
Interior. Photograph,
Victoria Watson.

fluctuate according to the seasons and weather. Reflected in mirrors, the occupants enter this world and observe themselves within it. Graham writes:

> Amalienburg was located in a wooded sector of the formal garden and served as a guest-lodge for visiting royalty who wished to 'hunt.' It contains a ten-sided hall of mirrors (Spiegelsaal) with open corridors at two ends. The formal aesthetic of the Spiegelsaal connected the king to the mythology of artificial nature upon which Nymphenburg's formal garden was based. It related the exterior to the interior, sunlight to the material qualities of mirrors and windows, daylight to the artificial light of nighttime. Each of its four windows was orientated to a cardinal direction: each marked the starting-point of a footpath that continued into the woods towards the north, south, east and west. The sun rose and shone directly through the eastern window. Wreaths of artificial foliage, which were mirrored in forms embossed in silver above the mirrors of the hall, created a tunnel through which the rising sun passed each morning, while the sun set along the path to the west, which was directly aligned with the west window.
>
> The sun's light turned the silvered mirrors, and hence the entire room, into gold. The king, in essence, symbolized the sun, and the transformation of silver into gold was the alchemy from which his rule derived its potency. Cuvilliés' pavilion was designed so that a spectator looking through any one of the windows would see

François de Cuvilliés, Amalienburg, Nymphenburg Palace, Munich, 1734–1740. Interior. Photograph, Victoria Watson.

7 Graham, *Architecture*, pp. 27–28.

8 Discussed in 'Index of Immaterial Architectures: Milky-White Glass'.

9 For a discussion of modernism and its relations to the picturesque, refer to 'Index of Immaterial Architectures: Lily', 'Mirror' and 'Mirror Glass'.

10 Laugier dismissed the rococo as fanciful. But the picturesque, which he promoted, was readily absorbed into eighteenth-century German garden design because its concerns – irregularity, temporality and the pleasures of nature – are also characteristic of the rococo, which was already established in Germany. Laugier, p. 56.

11 Cuvilliés and Mies diverge, however, in their conception of the relations between architecture and nature. Through reflection and replication, nature is brought within the Amalienburg. But at 860 Lake Shore Drive and Crown Hall, architecture and nature are kept apart. Reflected upward from the floor, the Amalienburg's earthly light affirms the rococo's absorption in the tangible pleasures of life. At 860 Lake Shore Drive and Crown Hall the diffuse light below and stronger light above, cast through opaque and clear glass, suggest ascetic retreat. Tempering this interpretation somewhat, Mies states that architecture free of matter allows its occupants to more fully seize life. Refer to 'Index of Immaterial Architectures: Milky-White Glass' and 'Mirror Glass'.

reflected, from the mirrors to the left and right side of the window, the view from two of the other windows. This would be the view of the king, the invisible centre of all directions and perspectives.[7]

Although they are separated by over two hundred years, visits to Cuvilliés' Amalienburg and Mies' Barcelona Pavilion, 860 Lake Shore Drive and Crown Hall[8] suggest that these buildings share certain characteristics and aspirations.[9] This conclusion, and connections between the rococo and picturesque, explain the Amalienburg's inclusion in the 'Index of Immaterial Architectures', which in most instances concentrates on the twentieth and twenty-first centuries.[10] The Amalienburg's windows, mirrors and milky-white walls equate to the Pavilion's reflective surfaces and the clear and milky-white glass of Lake Shore Drive and Crown Hall, focusing attention on perception of the self, others and nature, and the relations that bind them together.[11] With doors and windows of timber and glass, masonry walls decorated internally with plaster and mirror, and ceilings of timber, lath and plaster, the Amalienburg is made of solid, physical materials that are experienced as immaterial. Cuvilliés constructed an immaterial architecture – silky, pale and reflective – to consider life not metaphysics.

RUST

Dust

One Sunday in 1992 we caught a slow train to Igualada, a small town on the outskirts of Barcelona. Arriving at the station, the town was empty. So we walked. Beyond a run-down and partially constructed industrial estate, at the top of a steep slope, we reached the cemetery designed by Enric Miralles and Carme Pinós. But nothing was there. So we walked forward and down. As if through our movements, the cemetery grew around us. After 50 metres, concrete burial niches surrounded us and another interpretation was at hand. We had been lowered into the earth. Mirroring the decaying body, the cemetery is designed to weather. The body turns to dust and the cemetery to rust. On steel gabions, lamps and plaques and cast-iron mausoleum doors, rust forms a velvety surface.

A cemetery is a city of the dead. A boundary wall encircles the traditional Catalan cemetery, isolating death from life. But a cemetery is also a social space for the living. As more of the dead collect within a cemetery, so do more of the living. Miralles and Pinós 'intended the cemetery to be closer to those still alive than to the dead'.[1] The delivery of goods to the industrial estate overlaps with the delivery of coffins to the cemetery. The sounds of the warehouse merge with those of the cemetery, which has no obvious boundary. Visitors enter directly from the street. As more bodies are buried, the cemetery will expand along the zigzag path that leads down the slope. But the path goes nowhere. Or, as Christianity assumes that the soul is immaterial, nowhere in this world. At the time of our visit the chapel was unfinished and occupied by a forest of thin, irregular branches supporting shuttering to the concrete roof, so tightly spaced that only spirits could pass between them. The cemetery is the end of town and the end of life. The fate or fortune of any architect who designs a cemetery is to lie there. Enric Miralles arrived far too early.

[1] Zabalbeacscoa, p. 17.

SGRAFFITO

Ornament is Not a Crime

Sgraffito means scratchwork in Italian. First, a layer of coloured plaster is applied to a wall. Onto this is added a layer of white plaster, on which a design is drawn. While it is still wet the upper layer is selectively scratched away to reveal the lower one. Known in Italy and Germany since the fourteenth century, the tradition is strong in Switzerland, especially the mountainous canton of Graubünden in the east of the country.[1] In part, the popularity of sgraffito is attributed to Swiss mercenaries who, returning from military service to Italian states during the Renaissance, wanted to construct their houses on similar lines to the palazzos they had observed. But, as finances and local skills were limited, a version of a Renaissance palazzo was drawn on a façade rather than built. Sgraffito – a practice classified as low in architectural terms – recalls the aspiration to produce architecture that is devoid of matter and recognized as high art. Architecture exists where matter is absent, scratched away.

The term 'graffiti' derives from sgraffito. But rather than a layer removed, graffiti places one layer over another, to obscure what lies beneath. Graffiti is additive rather than reductive, except in the sense that the upper layer reduces the communicative ability of the lower one. Graffiti and sgraffito further differ in the manner in which they are applied. Sgraffito is applied according to an owner's wishes but it can still have the subversive intent associated with graffiti. Graffiti is understood as one person's uninvited and unwanted reaction to the property of another. But, as it derives from sgraffito, graffiti can be applied in two ways. One is without permission. The other is commissioned. Both can be subversive.

Graffiti and sgraffito ornament a building. For much of the twentieth century, modernist architects denied that their buildings were in any way ornamented. Notably, in 'Ornament and Crime', first published in 1908, Loos denounces ornament, graffiti and, by reference to tattoos, sgraffito:

The evolution of culture is synonymous with the removal of ornament from objects of daily use.[2]

One can measure the culture of a country by the degree to which its lavatory walls are daubed. With children it is a natural phenomenon; their first artistic expression is to scrawl on the walls erotic symbols. But what is natural to the Papuan and the child is a symptom of degeneration in the modern man.[3]

1 Mack, p. 22.

2 Loos, 'Ornament and Crime', p. 100.

3 Loos, 'Ornament and Crime', p. 100.

The modern man who tattoos himself is a criminal or a degenerate . . . If a tattooed
person dies at liberty, it is only that he died a few years before he committed a murder.[4]

4 Loos, 'Ornament and Crime', p. 100.

In 1896, in 'The Principle of Cladding', Loos accepts Semper's assumption that architecture originates in the surface dressing not the structure to which it is applied.[5] Loos states that surface should differ from structure because each material has its own formal language,[6] a principle again evolved from Semper.[7] According to Loos, materials should express nothing but themselves. Consequently, he rejects ornaments. Associating ornamentation with all that he considers negative, Loos promotes appreciation of the intrinsic qualities of unadorned materials, a principle familiar in modernism. The onyx wall at the centre of Mies' Barcelona Pavilion is a noted example. Loos assumes that a surface is not an ornament if it is independent of the structure and applied without transformation. But ornamentation is not absent from modernism. Often the material is itself the ornament.[8]

5 Loos, 'The Principle of Cladding', pp. 66–67.

6 Loos, 'The Principle of Cladding', p. 66.

7 Discussed in 'Conclusion: Immaterial–Material'.

In the 1960s and 1970s, debates on semiotics and mass communication undermined modernism's denial of ornament. Once architecture's role as a sign was accepted, ornamentation became a subject of design discussions once again, if still not acceptable to many architects. When an architect wishes to conceal ornament's presence, other terms are used in its place, such as detail.

8 However, citing Loos' 'Ornament und Erziehung' (Ornament and Education), published in 1924, Wigley argues that Loos did not oppose all ornament and supported disciplined and restrained ornament. Wigley, *White Walls, Designer Dresses*, p. 111.

Jacques Herzog and Pierre de Meuron readily admit that their interest in ornament is a direct critique of Loos' unadorned modernism.[9] As architect of the main building and first dean of the architecture school at the ETH (Federal Institute of Technology) in Zürich, where Herzog and de Meuron studied, Semper's ideas were readily available. In contrast to Loos, Herzog & de Meuron find in Semper an advocate of adornment.[10] Notably, Semper argued for the revival of sgraffito.[11]

9 Pierre de Meuron remarked as such at the opening of the Eberswalde Polytechnic Library in April 1999. Mack, p. 38.

10 Asman, 'Ornament and Motion', pp. 396–397.

11 Mack, p. 23.

Often Herzog & de Meuron adjust sgraffito to contemporary technologies. But in 1991 they won a competition for housing, a hotel and shops at Sils-Cuncas in the upper Engadine valley, Graubünden, adjacent to the entry station to the cable car that rises up the Furtschellas mountain. The architects proposed a number of abstract, rectangular blocks with sgraffito sentences cut into their plaster surfaces. Unfortunately, the local population rejected their proposal.

In 1993 Herzog & de Meuron completed a production and storage building for Ricola-Europe SA at Mulhouse. Karl Blossfeldt's 1920s photograph of a plant leaf was printed onto the polycarbonate panels that face the entrance wall and canopy. Although flat, Blossfeldt's image has the soft, grainy contours of an imprint or fossil, both of interest to Herzog & de Meuron and related to sgraffito in that they depict through absence rather than presence. Weather and nature provide character and differentiation to the black side-walls of the factory. When wet, the walls are reflective. When dry,

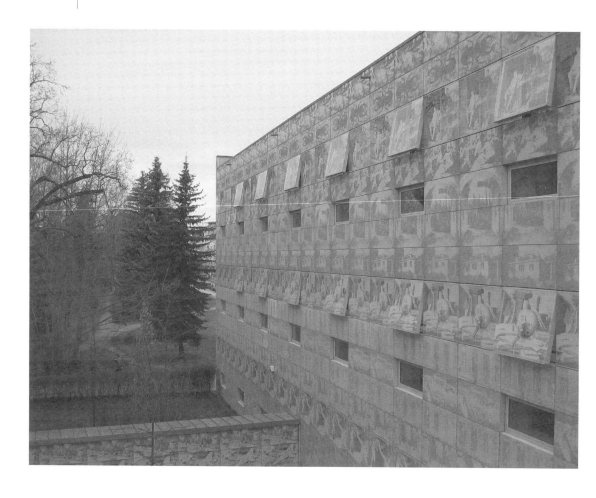

Herzog & de Meuron, Eberswalde Polytechnic Library, 1999. Exterior. Photograph, Lina Lahiri.

they are massive. As the roof is without gutters, melting snow and rain flow off the roof and down the walls, staining the concrete, and encouraging the growth of algae and moss in a manner reminiscent of graffiti and sgraffito accumulated over time.

In 1994 Herzog & de Meuron began to design the Eberswalde Polytechnic Library, north-east of Berlin. Knowing of Thomas Ruff's archive of over 2,500 newspaper photographs collected since 1981, Herzog & de Meuron invited him to work on the library façade. Rectangular in plan, and three storeys high, the building is faced in concrete and glass panels. Onto each panel is printed a newspaper photograph selected by Ruff. The same image is repeated horizontally sixty-six times, forming bands that wrap around the building. Applying an image to glass is simply achieved by silk-screen printing, and analogous to commissioned graffiti. Applying an image to concrete is a more complex hybrid of sgraffito and graffiti. Gerhard Mack writes:

The photographs are transferred onto a special plastic film by means of a silk-screen process, using a cure-retardant instead of ink. The printed film is then placed into the formwork (taking care to avoid any slippage) and concrete poured over it. The amount of retardant used controls the degree to which the surface of the concrete sets. When the panel is taken out of the formwork, and carefully washed with water and brushes, the concrete that has lain in contact with the retardant remains liquid and is rinsed away, leaving darker, rougher areas of exposed grey aggregate. [12]

12 Mack, p. 22.

To encourage debate on the relationship between the building's exterior and interior, Ruff selected photographs that refer to Germany's recent history and the library's purpose, contents, use and location. Many of the photographs are iconic images known to the inhabitants of Eberswalde. One, taken on the day the Berlin Wall was built, 17 June 1961, shows both the wall's construction and an escape attempt. Another depicts the demise of Nazi Germany's women's relay team at the 1936 Berlin Olympics. In response to local criticism, the first image was adjusted, the second rejected. Although commissioned, Ruff's sgraffito–graffiti is subversive and disruptive, a tool for public debate. However, Ruff's principal concern is not the photograph as a means of mass communication: 'Without text, the picture is only a picture and not information. You can't pigeonhole it. It is suspended in a vacuum.' [13] Valeria Liebermann writes: 'For

13 Ruff, in Ursprung, 'I Make My Picture on the Surface', p. 163.

Herzog & de Meuron, Eberswalde Polytechnic Library, 1999. Detail of concrete panel. Photograph, Lina Lahiri.

14 Liebermann, p. 59.

him every photograph is, in the first instance, simply a surface that operates somewhat like a mirror – the viewer usually only sees that which corresponds to his or her own experiences and ideas, and often fails to recognize the photographer's contribution.'[14] Like the newspaper photographer, and unlike the photographer exhibiting as an artist, the architect's contribution is often unrecognized. Buildings are usually experienced without knowledge of the architect's intentions.

Typical of a newspaper, the selected photographs are black and white. But, applied to concrete and glass, they have less definition and contrast than the originals. They are grey and grey rather than black and white. Soft and pale, they make an austere, bulky form less defined and weighty. At first glance, with photographs applied to both, it appears that glass and concrete are treated the same. But the application techniques subtly differ. An image on glass is quite different from one on concrete. Something is seen beyond glass but nothing is seen through concrete. Looking through glass, two pictures fuse into one, and the viewer may question whether it is possible to simply

15 Mack, p. 50.

say that one is reality and the other is representation.[15] Each is subjective. In Ruff's *Portrait of Eberswalde Library*, 1999, a photograph of two people on a laden scooter is montaged onto a photograph of the library. Like the building, the people are blue-grey and semi-transparent. As one is seen through the other, the building and the people appear ghostly, caught between the material and the immaterial.

Herzog & de Meuron ornament buildings with photographs to question architecture and photography. Herzog & de Meuron want their buildings to make unsatisfying photographs, to defy the camera: 'On-site experience of the building, direct confrontation with it, is essential. Our architecture is always based on the one-to-one experience.

16 Herzog and de Meuron, in

Ursprung, Herzog and de Meuron,

p. 82.

In fact, that is architecture's only chance of survival.'[16] Although they emphasize the tangible experience of buildings, matter is but a means to an end: 'the immaterial, mental processes of understanding, learning, and developing always have priority'.[17]

17 Herzog and de Meuron, 'Just

Waste', p. 74.

SILENCE

4' 33"

The early twentieth-century artistic avant-garde incorporated material fragments into an artwork, diminishing the boundary between art and life. Douglas Kahn notes that a comparable process occurred in music: 'The strategy that had propelled music into an avant-garde practice in the first place was the progressive incorporation of extra-musical sounds into the circumscribed sounds of music.'[1] Notably, in mid-century, John Cage 'proposed that any sound can be used in music; there need not be even any intention to make music for there to *be* music, only the willingness to attune to aural phenomena. In other words, sounds no longer required any authorial or intentional organization, nor anyone to organize them – just someone to listen', writes Kahn.[2] In 1952 Cage created *4' 33"*, four minutes thirty-three seconds of 'silence' that focused attention on the music of incidental sounds in a performance environment, whether a creak or a cough. In 4' 33", authorship is shared between the composer, audience and space. Silence is equally powerful in everyday life. The depletion of one sense heightens awareness of all the senses and the surrounding environment. I once heard half-a-dozen Swiss attempt to define their nation in a single event. They concluded that an absence, rather than a presence, best represents Switzerland, where bus doors close silently.

Our sense of place depends upon what we do not hear and see, as well as the sounds and sights around us. Everyday experience is replete with juxtapositions of the senses. For instance the sight of an aeroplane and the smell of sawdust.[3] The user perceives the gap between the sight and the smell, recognizes the absence of the corresponding smell and sight, such as the smell of the aeroplane and the sight of sawdust, and forms a mental image of the sensations present. In this instance a wooden plane is one possibility.[4]

The suppression and then release of a single sense, such as sound, is a strategy familiar in a horror film. Stanley Kubrick's *The Shining* opens with an overhead shot, the camera following a car on a long drive into the mountains.[5] The destination of the vehicle, carrying a mother, father and child, is a large hotel open to visitors only in the warmer months. The father, a writer, is to be its winter caretaker. On the family's arrival, the staff scurry around. Their departure is sudden, resulting not just in less sound but more silence. In an instant the size of the spaces and the silence of the hotel loom large and threatening, as though one was a register of the other. As is often the case in film, silence is linked to malevolence and previously insignificant and

1 Kahn, p. 102. Kahn refers to 'Art of Noises', the 1913 manifesto of Luigi Russolo, an Italian Futurist.

2 Kahn, p. 102.

3 Ai, p. 89.

4 For a discussion of the juxtaposition of the senses, refer to 'Index of Immaterial Architectures: Nordic Light'.

5 Stanley Kubrick, dir., *The Shining*, Warner, UK, 1980.

familiar sounds assume importance. At low level, the camera follows the child's tricycle on a solitary journey around the hotel. The presence of the one fluctuating sound, the wheels of the tricycle as they travel over the varied floor surfaces of the hotel corridors, is deafeningly loud and full of foreboding because of the absence of other sounds. The most disturbing parts of the child's journey occur where there is least sound, when the wheels cross the smoothest sections of the floor, implying that a sudden event, and sound or sight, will fill the void. The viewer, thus, finds or creates the horror in his or her mind rather than on the screen. The purpose of the horror film is to shock but the recurring suppression and then release of a single sense, evident in the tricycle's habitual journey, is applicable to the experience of the building because it is repeated throughout the film, inducing lingering and fluctuating tension rather than instantaneous shock.

Sound is immaterial in that it cannot be seen except through its consequences, such as the vibrations on a surface. Sound is material, however, in that it can be heard. Silence is immaterial visually and aurally. But, through absence, it focuses increased attention on the senses and materials present. Absence of material is not the same as absence of meaning.

SOUND

Building Place

Immersed in the visual, architects think a lot about the look of a building and little about how it sounds. While architects and others spend considerable efforts on the design of the visual environment, the aural environment receives less attention. Max Neuhaus writes that 'the sounds of our man-made sound environment are usually simply byproducts – the results of not caring whether something makes a sound or not, and, if it does, not caring what sound it makes'.[1]

After studying at the Manhattan School of Music, Neuhaus became a percussion soloist noted for his interpretation of contemporary music. In the mid-1960s he created his first 'sound installation' and he decided to end his musical career a few years later. A Neuhaus sound installation is site-specific, against which other sounds are heard to shift and flex. Often it is constant and without a predetermined time duration. One of his best-known works, *Times Square, New York*, was active from 1977 to 1992 and revived at the turn of the millennium under the administration of the DIA Center for the Arts, New York. Located on a pedestrian traffic island, the sounds of the installation emanate from under the pavement to overlap with those of the city. Each sound installation can only be experienced on site. None are recorded but many are drawn. Drawings for *Times Square, New York* indicate that it was conceived as a rectangular volume of sound with precise edges. However, a Neuhaus drawing is not intended as an accurate representation of a sound installation, avoiding many of the confusions of the architectural drawing.

Invited in 2000 to speak at the Bartlett School of Architecture, University College London, Neuhaus proposed, instead of a lecture, a format appropriate to his work: a conversation with two other speakers. For Neuhaus, a sound installation is a conversation rather than a lecture: 'In fact, for me the work only exists in the mind of each individual perceiver. It's manifested in the imaginations and perceptions of its visitors, and that's its only existence . . . I'm fascinated by the variations, the fact that most people perceive these works completely differently.'[2]

Although sound is his medium, Neuhaus creates a sound installation with full awareness of the other senses: 'The ear does things which the eye can't do; the eye does things which the ear can't do. In addition, visual and aural perception are complementary systems. It is not a question of one being better than the other; they fit together.'[3] Neuhaus recognizes that our perception of the aural is often less conscious than our perception of the visual, especially in the urban environment. But his intention is to make a place that is tangible if not physical:[4]

1 Neuhaus, p. 3.

2 Neuhaus, in 'A Conversation between Max Neuhaus, Paul Robbrecht and Yehuda Safran', Fondation pour l'Architecture, Brussels, 1997.

3 Neuhaus, p. 1.

4 Neuhaus, in 'A Conversation between Max Neuhaus, Jonathan Hill and Yehuda Safran', Bartlett School of Architecture, University College London, 2000.

I've always thought of my work as immaterial because you can't see or touch it. On the other hand, I describe the process of making one as building a place. I don't change a space visibly in any way, as the sources of sound are never seen. But what I have finally realised is that my work is not immaterial at all. It's the place itself which becomes the material dimension of the work. But you still can't photograph it, and you can't record it. [5]

5 Neuhaus, in 'A Conversation between Max Neuhaus, Paul Robbrecht and Yehuda Safran'.

6 Neuhaus, in 'A Conversation between Max Neuhaus, Paul Robbrecht and Yehuda Safran'.

Neuhaus claims that his work is material rather than immaterial because he wishes to emphasize its purpose – to build a place – rather than its means. He states that 'the sound isn't the work . . . I use sound as a means to generate a perception of place'. [6] But it is equally appropriate to describe a Neuhaus sound installation as both immaterial and material. A sound installation is immaterial in that you cannot see or touch it. But the sense of place it generates is material. A sound can be as tangible as an object.

STEEL

Break Down

And yet the truth of the matter, as Marx sees it, is that everything that bourgeois society builds is built to be torn down. 'All that is solid' – from the clothes on our backs to the looms and mills that weave them, to the men and women who work the machines, to the houses and neighbourhoods the workers live in, to the firms and corporations that exploit the workers, to the towns and cities that embrace them all – all these are made to be broken tomorrow, smashed or shredded or pulverised or dissolved, so they can be recycled or replaced next week, and the whole process can go on again and again, hopefully forever, in ever more profitable forms.

The pathos of all bourgeois monuments is that their material strength and solidity actually count for nothing and carry no weight at all, that they are blown away like frail reeds by the very forces of capitalist development that they celebrate. Even the most beautiful and impressive bourgeois buildings and public works are disposable, capitalized for fast depreciation and planned to be obsolete, closer in their social functions to tents and encampments than to 'Egyptian pyramids, Roman aqueducts, Gothic Cathedrals.'[1]

1 Berman, p. 99, referring to Marx and Engels, p. 476.

In *All That is Solid Melts Into Air: The Experience of Modernity*, Marshall Berman recognizes that the expanding cycle of materialization and dematerialization – modernization – is familiarly associated with capitalism. Berman argues, however, that the assumption that modernization can only be negative and capitalist 'leaves out all the affirmative and life-sustaining force that in the greatest modernists is always interwoven with assault and revolt'.[2] In Berman's alternative interpretation, modernization is linked to both modernism and Marxism.[3]

2 Berman, p. 30.

3 Tafuri links modernization to modernism but not Marxism. Tafuri, p. 16.

Since the beginning of the twentieth century, the artistic avant-garde has been associated with a critique of the commodification of art and life. In 2001 Michael Landy's *Break Down* materialized in a former department store at the Marble Arch end of London's Oxford Street.[4] Lists of Landy's seven thousand possessions covered the walls of the ground floor foyer. At its centre, half-a-dozen workers manned various machines. Over a two-week period, all Landy's possessions were dismantled and broken down into their constituent materials – such as green plastic and grey rubber – and placed in large refuse bags in the shop window. Behind a guide rope encircling the workers and machines, visitors watched. The accompanying pamphlet – designed to look like a sale notice – indicated that the exhibition title referred to both the physical

4 *Break Down* was organized by Artangel.

dismantling of Landy's possessions and the mental state of someone who initiates such a process. The pamphlet implied that *Break Down*, as a commentary on consumer culture, was cathartic for the author and maybe the audience. However, it is also indicative of the state of contemporary art that an artist feels the need to create such a spectacle now that so many, previously unexpected, actions are familiar in the art world. A critique of commodification, *Break Down* is also its opposite. In destroying all his physical possessions, Landy enhanced another, more valuable, possession: his status as an artist. A commodity need not be physical. The cultural capital of an artist is itself a commodity.[5]

5 Bourdieu, pp. 171–183.

Break Down is an artwork and Cedric Price's Inter-Action Centre is a building but it is appropriate to compare one to the other because both deploy dematerialization as a means to consider the roles of the author and the viewer/user. *Break Down* is disingenuous in comparison to Inter-Action, built in London between 1972 and 1977, and demolished in 2000. Price resisted calls for Inter-Action to be listed and, thus, protected. He accepted demolition as a reasonable and unsurprising event appropriate for a building no longer deemed useful. *Break Down* affirmed rather than questioned

Cedric Price and Ed Berman, Inter-Action Centre, London, 1977. Photograph, Adrian Forty.

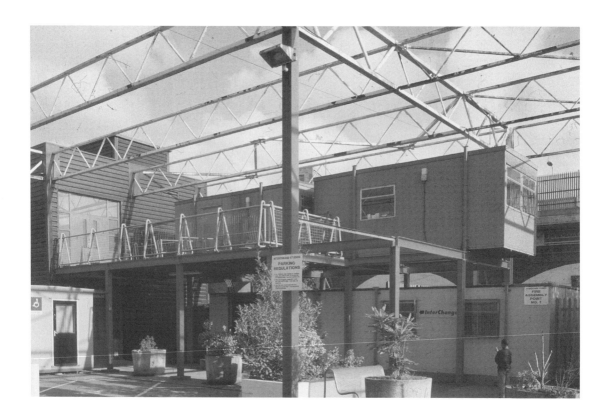

its site. Shopping for art, the visitor was merely a passive observer to a spectacle. Authority and authorship remained in the hands of the artist. In contrasl, the user was active in the transformation of Inter-Action, which the architect did not attempt to control: 'In allowing for change, flexibility, it is essential that the variation provided does not impose a discipline which may only be valid at the time of design.'[6] Providing a conceptual and physical (steel) frame, Price accepted that Inter-Action would acquire elements he did not design, an attitude untypical of architects, who are more often absorbed in the creation of a constant and consistent object. Price further acknowledged that for meaningful transformation to occur the user must have both the authority and knowledge to change a space, and need only modest technical skills comparable to those of a DIY enthusiast.

After the demolitions of *Break Down* and Inter-Action, material fragments remained, to be recycled. Now the artwork and building exist primarily as immaterial ideas. *Break Down* promotes the idea that the artist is paramount. Inter-Action furthers the idea that the architect and the user share authorship. Involving users in design and construction does not necessarily produce better architecture. But neither does working with users automatically lead to the enfeeblement of the architect, as Inter-Action convincingly indicates.

6 Price, 'Activity and Change'.

TELEVISION

Urban Sublime

1 For further discussion of the sublime, refer to 'Index of Immaterial Architectures: Lightning'.

Traditionally, the sublime is evoked by nature.[1] However, especially since the industrial revolution, the rapidly expanding city personifies a terrifying and thrilling presence, evoking an urban sublime that Leon Chew depicts in photographs of Chicago, Las Vegas and Tokyo. Chew photographs urban valleys, flatlands, crags and cliffs. But unlike the Surrealists, who conceived the city as petrified nature to experience it anew without history and preconceptions, Chew depicts the city as architectural and natural.

The horizon bisects each photograph into two nearly equal halves. Even in *Landscape 003* – the interior of a Chicago car park – the ground plane draws the

Leon Chew, *Landscape 003*, 2002. Courtesy of Leon Chew.

viewer towards the horizon and the distant 'sky', the focus of natural forces in the
sublime. In the other photographs, often a glowing sky is on the cusp of transformation.
Only in *Evangelic* is the sky black and static, appropriate to Las Vegas, a city that
disregards natural light and feeds on the artificial. In *Landscape 001*, the ventilation
grills in the ground plane mirror the curtain walled façades of the corporate towers
beyond, and the forces depicted are natural and local. The Chicago air is full of water
vapour slipping in from Lake Michigan, rendering the buildings less weighty and
material. Elsewhere, Chew depicts forces that are artificial and generic, electromagnetic
weather rather than natural weather.

Modernist architecture is often associated with a quest for visual transparency but
the reflective possibilities of glass are as important in Mies' architecture.[2] In *Evangelic*
and *Shibuya 2am*, only a television reflected in a glass curtain wall indicates that the
night-time urban landscape is viewed from an interior. Countering the precise
thresholds of the seventeenth-century Dutch house, the symbol of the contemporary
home is cast into the city, to appear as a monumental image floating above the horizon.
Television in general and this television in particular are both of the city and of the

[2] Discussed in 'Index of Immaterial
Architectures: Milky-White Glass' and
'Mirror Glass'.

Leon Chew, *Shibuya 2am*, 2002. Courtesy of Leon Chew.

Leon Chew, *Evangelic*, 2002. Courtesy of Leon Chew.

interior, reflecting the permeability of the contemporary home. The reflected image in *Shibuya 2am* seems to cast the private and intimate actions of a couple onto the city. In *Evangelic*, a public figure, a television evangelist – equivalent to a modern-day flood tide – offers respite from the moral ambiguity of good fortune.[3] Seen through the lens of the unseen photographer, Chew's photographs are notably empty of people and full of the electromagnetic forces of the urban sublime. Increasingly the contemporary home has but one occupant. The sublime is best experienced alone.

3 Schama, pp. 47–49.

WEATHER

Weather and Weathering

As this book opens with a discussion of the home and the threat – literal and imagined – posed by the weather, it is appropriate that it ends with homes in which weather is a principal material and weathering a principal process. Weather and weathering are metaphors for the outside pouring into architecture, blurring its boundaries, disturbing its contents. 'Weather' is the final entry in the 'Index' but not its conclusion. Instead, the 'Index' as a whole concludes this book and introduces a potential vocabulary of immaterial architecture.[1]

1 In conjunction with 'Conclusion: Immaterial–Material'.

Yellow or Black

Buildings are usually built to resist the weather but sometimes weather's consequences are described in positive terms. Attention to the effects of weather and weathering is a recurring architectural tradition developed principally from romanticism, the sublime and picturesque,[2] which held particular fascination for the genius of the place in all its manifestations and ruins as indicators of the passage of time.[3] The eighteenth-century concern for weathering and wearing was not completely new, however. Richard Weston writes:

2 For a discussion of the sublime, refer to 'Index of Immaterial Architectures: Lightning'.

3 Whately, p. 305.

> It would be an exaggeration to suggest that the theory of the Picturesque marked the emergence of a wholly new sensibility in Europe – Leonardo da Vinci, after all, had commended the random stains on walls to the attention of painters – but it gave new coherence to previously unstructured ideas . . . In the process, it challenged the hegemony of the Classical theory of beauty – which preferred smoothness to roughness, precision to vagueness – and acted as a stimulus to new attitudes to the past.[4]

4 Weston, p. 121.

5 Da Vinci, p. 201.

6 Da Vinci, p. 222.

7 Uvedale Price places the picturesque between the beautiful and the sublime, able to combine the two. Price, 'From An Essay on the Picturesque', p. 354. The sublime was an influence on romanticism.

Da Vinci credits Sandro Botticelli for noticing that 'various inventions are to be seen' in a building stain.[5] But da Vinci recognizes similar potential in weather: 'I have in the past seen in clouds and walls stains which have inspired me to beautiful inventions of many things.'[6]

Romanticism, which developed towards the end of the eighteenth century, did not represent a decisive departure from picturesque strategies such as fragmentation and reflection.[7] But it questioned the attention given to the formal and visual to the

detriment of other concerns in the late eighteenth-century picturesque, typified by the popularity of the Claude glass.[8] Romanticism equated the direct and unmediated exploration of nature with self-exploration. Wild landscapes not gardens were favoured, focusing attention on weather as a means to fully appreciate the qualities of a place and a person. Hunt writes that J.M.W. Turner's 'notebooks especially reveal how careful he was to record landscape subjects from different points of view or in different weathers, times of day, or even the moods in which he painted, for only in this way does a particular place yield its fullest genius'.[9] Interested in uncovering meanings encoded in a place, Turner's response was critical as well as personal. Many of Turner's paintings focus on changes in the weather and human response to those changes. Describing his 1842 painting *Snow Storm – Steam-Boat off a Harbour's Mouth making Signals in Shallow Water, and going by the Lead. The Author was in this Storm on the Night the Ariel left Harwich*, he states: 'I did not paint it to be understood, but I wished to show what such a scene was like: I got the sailors to lash me to the mast to observe it; I was lashed for four hours, and I did not expect to escape, but I felt bound to record it if I did. But no one has any business to like the picture.'[10] Although romanticism often associated industrialization with a loss of individuality, Turner's depiction of weather extended to the city. Responding to the atmospheric pollution in nineteenth-century London, the largest industrial city in the world, he depicted the effects of its heady haze of smog and fog.

In 1849, John Ruskin, a noted advocate of Turner, wrote: 'For, indeed, the greatest glory of a building is not in its stones, or its gold. Its glory is in its Age . . . it is in that golden stain of time, that we are to look for the real light, and colour, and preciousness of architecture.'[11] Ruskin reserved praise for ageing due to the effects of use and weather rather than the appearance of ageing, as in the newly fabricated picturesque ruin, and regretted the effects of industrialization. In 1877, delighting in the effects of time on buildings and influenced by Ruskin, William Morris founded the Society for the Protection of Ancient Buildings on the premise that, instead of returning a building to its original state, each layer of history should be retained. Unfortunately, rather than acknowledging the passage of time, conservation policy may lead to the denial of change. The façades of Bedford Square, begun in 1774 on the Duke of Bedford's London estate under the supervision of his agent, Robert Palmer, are faced in yellow London stock bricks. A material is a major constituent of place. So too is the way it weathers and ages. Layers of soot now render the brick black, for which it is known and noted. When, in the cleaner air of late twentieth-century London, builders removed the dirt to reveal the yellow beneath, conservation authorities demanded that the façade be coated black once again, praising a layer of dirt over a mass of brick. To contemporary eyes, black suits an austere Georgian façade better than yellow.

8 For a discussion of the Claude glass, refer to 'Index of Immaterial Architectures: Lily' and 'Mirror'.

9 Hunt, *Gardens and the Picturesque*, p. 237.

10 Quoted in Andrews, *Landscape in Western Art*, p. 177. Malcolm Andrews, however, questions Turner's account as 'The *Ariel* was a Dover, not a Harwich, paddle steamer, and Turner, as far as is known, had not been to that part of East Anglia for many years . . . given that Turner was in his late 50s at this time, one may be reasonably sceptical about his capacity to withstand the elements for as long as claimed.'

11 Ruskin, Ch. VI, X, p. 177.

Weather Architecture

Conversant with his praise for the effects of use and weather, conservation is one of Ruskin's themes. Another, with more positive consequences, is the symbiosis of architecture and nature, which counters the assumption that weather is either a problem or a resource:

> The idea of self-denial for the sake of posterity, of practising present economy for the sake of debtors yet unborn, of planting forests that our descendants may live under their shade, or of raising cities for future nations to inhabit, never, I suppose, takes place among publicly recognised motives of exertion. Yet these are not the less of our duties; nor is our part fitly sustained upon the earth, unless the range of our intended and deliberate usefulness include, not only the companions but the successors of our pilgrimage. God has lent us the earth for our life; it is a great entail. It belongs as much to those who are to come after us, and whose names are already written in the book of creation, as to us; and we have no right, by any thing that we do or neglect, to involve them in unnecessary penalties, or deprive them of benefits which it was in our power to bequeath.[12]

12 Ruskin, Ch. VI, X, p. 180.

13 Ross, p. 244.

Weather has become increasingly politicized precisely because it is an effective medium to link the particular and everyday to large-scale forces in the social and physical world.[13] The weather, and its relationship to architecture, has assumed added significance since the mid-twentieth century because of changing attitudes to the environment, informed by publicity given to varied events such as military campaigns and climate change by human action.

The principle that weather is a resource to be exploited led to its deployment as a military weapon in the second half of the twentieth century. For example, the 1940s discovery that pure silver iodine sprinkled into clouds stimulates precipitation encouraged the US military to employ 'cloud seeding', as in a CIA plan to destabilize the Cuban economy by seeding clouds before they reached the Cuban sugar crop. In response to such tactics, the UN General Assembly passed Resolution 3264 in December 1974, which led to the 'Prohibition of action to influence the environment and climate for military and other purposes compatible with the maintenance of international security, human well-being and health'.

Climate change research takes account of temperature fluctuations up as well as down. Global warming may occur when carbon dioxide and other gases such as nitrous oxide and methane concentrate in the atmosphere to prevent long-range radiation escaping into space, creating a greenhouse effect. A means to focus criticism on the

free-market economy and question the isolationist policies of countries and corporations, global warming can also be understood as a modern-day manifestation of a metaphorical tradition that includes the biblical flood, in which human failings are threatened by environmental catastrophe.

Rather than weather as a threat to be resisted or a resource to be exploited, critics of cloud seeding and global warming recognize the coexistence of the environment and its inhabitants, so that weather and architecture are opposed terms no longer. For example, weathering is not just equivalent to decay. It can be protective, as in the rust coating on Cor-ten steel, and positive, drawing attention to the transience of life and the possibility and potential of change.[14] As architecture and weather are seen to blur, qualities assumed to be particular to one are found in the other. Rather than opposed, the history of architecture is a history of weather. Knowledge of the weather, its causes and effects, is a valuable basis for architecture because, at all stages of building, it connects architecture to its immediate and wider environments, from the experience of an ambiguous object to awareness of climate change.

[14] Developed in the 1950s by the US Steel Corporation, Cor-ten is also known as 'weathering steel'.

A Window for the Wind

Each a response to the tradition in which architecture and weather are compatible not contradictory, Anton Ambrose and Matthew Butcher design houses that accommodate a public and a private life, questioning the long isolation of the home. Home to a research institute and its researchers, nature and weather fuse with familiar architectural elements in Ambrose's building for the (Un)Natural History Society on a central London site adjacent to the Thames. But rather than people, this home is designed for, and inhabited by, the weather. There is a window for the wind, for example. Using the site's natural weather as a fertilizer, the (Un)Natural History Society cultivates man-made weather to consider our perception of the natural and the artificial. The seasonal relations between varying weather conditions are the principal tool of building, which is endless and evolving rather than finite and fixed. As the building grows it drifts further from the needs of people, blurring the boundaries between home and garden, work and rest, inside and outside, the natural and the artificial. But Ambrose suggests that diminishing the home's association with utility and security may itself be liberating and encourage other, pleasurable and *ad hoc* forms of inhabitation. So that we may inhabit a weathered home the way we do a weathered landscape.[15]

[15] Jonathan Hill and Elizabeth Dow, tutors, Diploma Unit 12, Bartlett School of Architecture, University College London.

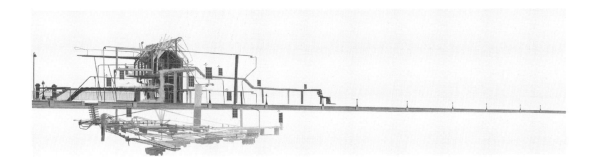

Anton Ambrose, (Un)Natural
History Society, London,
2005. Elevational
perspective from the river
with the outgoing tide at
midday during summer.
Courtesy of Anton Ambrose.
'Seen here from the Peace
Pavilion in Battersea Park,
the (Un)Natural History
Society is an item of intrigue
along the river, familiar yet
uncanny. A low mist forms
on the edge of the Thames,
carpeting the floors.'[16]

Anton Ambrose, (Un)Natural
History Society, London,
2005. The basement living
room at midnight on a cold
winter's night. Courtesy
of Anton Ambrose.

Anton Ambrose, (Un)Natural History Society, London, 2005. The caretaker's study. Courtesy of Anton Ambrose.

'A writing desk for the tide, a mist carpet and window for the wind come together at low tide and only during summer months when the temperature on site exceeds 24°C. Different rooms form at different times of the day and year depending upon the weather and other conditions on site, so that the (Un)Natural History Society is never experienced in its entirety.'[17]

16 Anton Ambrose, (Un)Natural History Society, 2005.

17 Anton Ambrose, (Un)Natural History Society, 2005.

The Flood House

Since the formation of the Netherlands the relationship of the land to the sea has informed the Dutch psyche. For centuries the Dutch government constructed dams and dykes, instigating an extensive programme of land reclamation. Today two-thirds of the Dutch population live below sea-level. But, as the sea continues to rise, attitudes change. Responding to the Dutch environment ministry's decision to counter tradition and return land to the sea, Matthew Butcher proposes The Flood House.[18] Set within the Rhine delta, The Flood House is a prototype for the inhabitation of a seasonally flooded landscape. In contrast to the seventeenth-century Dutch house – the model

18 Jonathan Hill and Elizabeth Dow, tutors, Diploma Unit 12, and Mark Smout, technical tutor, Bartlett School of Architecture, University College London.

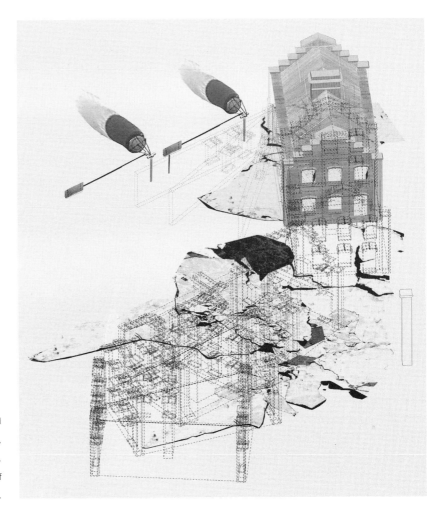

Matthew Butcher, The Flood House, Rhine Delta, The Netherlands, 2004. Axonometric. Courtesy of Matthew Butcher.

for so many houses since – The Flood House does not oppose fluid forces with inflexible barriers. Immersed in a constantly evolving system, as boundaries shift and blur, fluctuations in climate, matter and use are its subject and fabric. Analogous to the environment it inhabits, The Flood House records and responds, expands and contracts, reconfigures and adapts according to the tides, seasons and users. What is inside one moment may be outside the next.

Housing a public and a private life, The Flood House is home to the environment minister and ministry and a vehicle to test and transform environmental policy: 'As the landscape returns to a wilderness the changing form of the house starts to determine the political calendar.'[19] The environment minister's first decision is to change the Dutch national flower from the tulip to the bur reed, a wetland plant. Harvesting the bur reed, The Flood House introduces a new agricultural model to the flooded landscape. A home and an office, The Flood House is also a farm.

The Flood House has three typologies, each at a different scale: an infrastructure of protective sediment banks, a collection of building fragments, and a series of locks that control the seasonal disposition of the banks and fragments. Historically, the Dutch 'lock the land from the sea' and the inside from the outside.[20] The Flood House subverts this tradition. Each lock is a barometer, measuring climatic changes and triggering an appropriate response. Chalk and wood locks cause nets to tighten and sediment banks to form, adjusting their size, location and configuration in response to seasonal variations. The chalk lock registers the winter flood. As it disappears beneath the sea its core dissolves, activating the lock. The wood lock registers the onset of summer. A section of oak emerges as the flood recedes, activating the lock as it dries and shrinks. Bur reeds slow the current and increase sediment deposits. Once they are harvested the sediment banks wash away. Building fragments float or slide together and apart according to the winds, tides and seasons, forming different spaces. An archetypal wooden house with a pitched roof and unglazed openings slides over a glasshouse to create a complete enclosure. In the summer sun algae collect on the south-facing glass, shading the interior.

As immaterial architecture is a product of perception and an instrument of self-reflection, one of The Flood House's concerns is the 'capacity to just perceive one perceiving'.[21] The building that is most open to appropriation is the one we do not know immediately how to occupy, remaining particularly susceptible to numerous appropriations because it is never quite the same each time it is experienced. Open to change, The Flood House is a matrix of interconnected spaces in which users inhabit alternative routes and varied configurations of open and closed spaces. The Flood House questions the assumption that it is possible and useful to predict the user's needs. Instead, it suggests that a feisty dialogue between the user, building and

19 Butcher, p. 1.

20 Butcher, p. 1.

21 Turrell, in Andrews and Bruce, '1992 Interview with James Turrell', p. 48.

Matthew Butcher, The Flood House, Rhine Delta, The Netherlands, 2004. Perspective at low tide. Courtesy of Matthew Butcher.

environment may be more stimulating and rewarding. As a material and a process of architecture, weather – natural, man-made and electromagnetic – and weathering are a means to guarantee a changeable and unpredictable montage available to all the senses.

The history of the Netherlands typifies the attempt to resist nature and weather. The Flood House proposes an alternative model in which inside and outside coexist to the mutual benefit of the environment and its occupants. House and flood are not opposed terms. The house floods and the flood houses. The Flood House is Weather Architecture.

Matthew Butcher, The Flood House, Rhine Delta, The Netherlands, 2004. Perspective at high tide. Courtesy of Matthew Butcher.

bibliography

Ackerman, James S. *Palladio*. Harmondsworth: Penguin, 1966.

Ai, Xiaochun. 'White Shadow, Black Island'. Trans. Jonathan Hill and Zheng Yu Wang. *Artifice*, no. 3, 1995, pp. 80–89.

Alberti, Leon Battista. *On the Art of Building in Ten Books*. Trans. Joseph Rykwert, Neil Leach and Robert Tavernor. Cambridge, Mass., and London: MIT Press, 1988. First published as *De Re Aedificatoria*, *c.* 1450, trans. J. Leoni, as *Ten Books on Architecture*, 1726.

Alberti, Leon Battista. *On Painting/De Pittura*. Trans. Cecil Grayson. Harmondsworth: Penguin, 1991.

Andrews, Malcolm. *Landscape in Western Art*. Oxford: Oxford University Press, 1999.

Andrews, Richard, ed. *James Turrell: Sensing Space*. Seattle, WA: Henry Gallery, 1992.

Andrews, Richard. 'The Light Passing'. In Andrews, *James Turrell: Sensing Space*, pp. 9–17.

Andrews, Richard and Chris Bruce. '1982 Interview with James Turrell'. In Andrews, *James Turrell: Sensing Space*, pp. 37–41.

Andrews, Richard and Chris Bruce. '1992 Interview with James Turrell'. In Andrews, *James Turrell: Sensing Space*, pp. 47–51.

Aragon, Louis. *Paris Peasant*. Trans. Simon Watson Taylor. London: Cape, 1971.

Aristotle. *The Basic Works of Aristotle*. Ed. Richard McKeon. New York: Random House, 1941.

Aristotle. 'Metaphysics'. In Aristotle, *The Basic Works of Aristotle,* pp. 689–934.

Asman, Carrie. 'Ornament and Motion: Science and Art in Gottfried Semper's Theory of Adornment'. In Ursprung, *Herzog & de Meuron: Natural History*, pp. 385–397.

Baal-Teshuva, Jacob, ed. *Christo: The Reichstag and Urban Projects*. Munich and New York: Prestel, 1993.

Banham, Reyner. *The Architecture of the Well-tempered Environment*. Chicago, IL: University of Chicago Press, 1984.

Barthes, Roland. 'The Death of the Author'. In Barthes, *Image–Music–Text*, pp. 142–148.

Barthes, Roland. *Image–Music–Text*. Trans. Stephen Heath. London: Flamingo, 1977.

Barthes, Roland. *The Pleasure of the Text*. Trans. Richard Miller. New York: Hill and Wang, 1979.

Baudrillard, Jean. 'The Ecstasy of Communication'. Trans. John Johnston. In Foster, pp. 126–134.

Baume, Nicholas, ed., in association with Jeanne-Claude Christo. *Christo*. Sydney: Johan Kaldor Art Project/Art Gallery of New South Wales, 1990.

Baume, Nicholas. 'Critical Themes in Christo's Art, 1958–1990'. In Baume, *Christo*, pp. 33–42.

Baume, Nicholas. 'Wrapped Reichstag, Project for Berlin'. In Baume, *Christo*, pp. 188–197.

Beardsley, John. *Earthworks and Beyond*. New York: Abbeville Press, 1984.

Benjamin, Walter. *The Arcades Project*. Ed. Rolf Tiedemann, trans. Howard Eiland and Kevin McLaughlin. Cambridge, Mass., and London: Belknap Press of Harvard University Press, 1999.

Benjamin, Walter. 'The Author as Producer'. In Benjamin, *Reflections*, pp. 220–238.

Benjamin, Walter. *Illuminations: Essays and Reflections*. Ed. Hannah Arendt, trans. Harry Zohn. New York: Schocken Books, 1969.

Benjamin, Walter. *The Origin of German Tragic Drama*. Trans. John Osborne. London: New Left Books, 1977.

Benjamin, Walter. 'Paris, Capital of the Nineteenth Century'. In Benjamin, *Reflections*, pp. 146–162.

Benjamin, Walter. *Reflections: Essays, Aphorisms, Autobiographical Writings*. Ed. Peter Demetz, trans. Edmund Jephcott. New York: Schocken Books, 1978.

Benjamin, Walter. 'What is Epic Theater?'. In Benjamin, *Illuminations*, pp. 147–154.

Benjamin, Walter. 'The Work of Art in the Age of Mechanical Production'. In Benjamin, *Illuminations,* pp. 217–252.

Berman, Marshall. *All That is Solid Melts Into Air: The Experience of Modernity*. London and New York: Verso, 1982.

Birksted, Jan, ed. *Landscapes of Memory and Experience*. London: Spon, 2000.

Blau, Eve and Edward Kaufman, eds. *Architecture and Its Image: Four Centuries of Architectural Representation*. Cambridge, Mass., and London: MIT Press, 1989.

Bloomfield, Ruth. 'He's Under 44, Runs His Own Business, Does Not Own a Car and Leads a Happy Single Life'. *Evening Standard*, 25 June 2003, p. 9.

Bohigas, Oriol, Peter Buchanan and Vittorio Magnago Lampugnani. *Barcelona, City and Architecture, 1980–1992*. New York: Rizzoli, 1990.

Boia, Lucian. *The Weather in the Imagination*. London: Reaktion, 2005.

Bois, Yves-Alain. 'A Picturesque Stroll around Clara-Clara'. Trans. John Shepley. *October*, no. 29, Summer 1984, pp. 33–62.

Bourdieu, Pierre. *Outline of a Theory of Practice*. Trans. Richard Nice. Cambridge: Cambridge University Press, 1977.

Brett, Guy. 'The Century of Kinesthesia'. In Brett, Cotter and Douglas, *Force Fields*, pp. 9–68.

Brett, Guy, Suzanne Cotter and Cathy Douglas, eds. *Force Fields: Phases of the Kinetic*, Barcelona: MACBA/ACTAR, 2000. Catalogue to the exhibition at the Hayward Gallery, London, 2000, pp. 9–68.

Buchloh, Benjamin. 'The Primary Colors for the Second Time: A Paradigm Repetition of the Neo-Avant-Garde'. *October*, no. 37, Summer 1986, pp. 41–52.

Bürger, Peter. *Theory of the Avant-Garde*. Trans. Michael Shaw. Manchester: Manchester University Press, 1985.

Burke, Edmund. *Philosophical Enquiry into the Origin of our Ideas of the Sublime and Beautiful*. Oxford: Oxford University Press, 1998.

Burnham, Jack. 'Hans Haacke – Wind and Water Sculpture'. In Sonfist, pp. 105–124.

Butcher, Matthew. 'The Flood House'. Diploma Technical Dissertation, Bartlett School of Architecture, University College London, 2004.

Carpo, Mario. *Architecture in the Age of Printing: Orality, Typography and Printed Images in the History of Architectural Theory*. Trans. Sarah Benson. Cambridge, Mass., and London: MIT Press, 2001.

Coles, Alex and Alexia Defert, eds. *The Anxiety of Interdisciplinarity*, De-, Dis-, Ex-, vol. 2. London: Backless Books, 1998.

Collins, Peter. *Changing Ideals of Modern Architecture, 1750–1950*. London: Faber and Faber, 1965.

Colomina, Beatriz, ed. *Architectureproduction*. New York, Princeton Architectural Press, 1988.

Colomina, Beatriz. 'More About Reproduction: In Response to Ockman and McLeod'. In Colomina, *Architectureproduction*, pp. 232–239.

Colomina, Beatriz. *Privacy and Publicity: Modern Architecture as Mass Media*. Cambridge, Mass., and London: MIT Press, 1994.

Constant, Caroline. 'The Barcelona Pavilion as Landscape Garden: Modernity and the Picturesque'. *AA Files*, no. 20, Autumn 1990, pp. 46–54.

Cook, Peter, ed. *Archigram*, no. 2, 1962.

Cooke, Lynne. 'The Prevarication of Meaning'. In Craig-Martin, pp. 11–36.

Corrin, Lisa G. 'The Perfect Home: A Conversation with Do-Ho Suh'. In Corrin and Kwon, pp. 27–39.

Corrin, Lisa G. and Miwon Kwon, eds. *Do-Ho Suh*. London/Seattle, WA: Serpentine Gallery/Seattle Art Museum, 2002.

Cousins, Mark. 'Building an Architect'. In Hill, *Occupying Architecture*, pp. 13–22.

Cousins, Mark. 'The First House'. *Arch-Text*, no. 1, 1993, pp. 35–38.

Craig-Martin, Michael. *Michael Craig-Martin: A Retrospective 1968–1989*. Ed. Joanna Skipwith. London: Whitechapel Art Gallery, 1989.

Da Vinci, Leonardo. *Leonardo on Painting: An Anthology of Writings by Leonardo da Vinci*. Ed. Martin Kemp, trans. Martin Kemp and Margaret Walker. New Haven and London: Yale University Press, 1989.

Davies, Norman. *A History of Europe*. Oxford: Oxford University Press, 1996.

De Maria, Walter. 'The Lightning Field'. *Artforum*, 18, April 1980, pp. 51–59.

De Zegher, Catherine and Mark Wigley, eds. *The Activist Drawing: Retracing Situationist Architecture from Constant's New Babylon to Beyond*. New York: The Drawing Center/Cambridge, Mass., and London: MIT Press, 2001.

De Zurko, Edward. *Origins of Functionalist Theory*. New York: Columbia University Press, 1957.

Deitch, Jeffrey. 'The New Economics of Environmental Art'. In Sonfist, pp. 85–91

Derrida, Jacques. *Of Grammatology*. Trans. Gayatri Chakravorty Spivak. Baltimore, MD: Johns Hopkins University Press, 1976.

Derrida, Jacques and Peter Eisenman. *Chora L Works: Jacques Derrida and Peter Eisenman*. Ed. Jeffrey Kipnis and Thomas Leeser. New York: Monacelli, 1997.

Descartes, René. *Meditations on First Philosophy*. Ed. Stanley Tweyman, trans. Elizabeth S. Haldane and G.R.T. Ross. London and New York: Routledge, 1993. First published as *Meditationes de Prima Philosophia* in 1641.

Diamonstein, B. *American Architecture Now*. New York: Rizzoli, 1985.

Diller, Elizabeth. 'Autobiographical Notes'. In de Zegher and Wigley, pp. 131–133.

Diller, Elizabeth. 'Defining Atmosphere: The Blur Building'. *Doors of Perception 6: Lightness*, 2000, www.doorsofperception.com.

Dingwall, Robert. 'Introduction'. In Dingwall and Lewis, pp. 1–13.

Dingwall, Robert and Philip Lewis, eds. *The Sociology of the Professions: Lawyers, Doctors and Others*. London: Macmillan, 1983.

Douglas, Mary. *Purity and Danger*. London: Routledge & Kegan Paul, 1966.

Drexler, Arthur. *The Architecture of Japan*. New York: Museum of Modern Art, 1966.

Dunne, Anthony. *Hertzian Tales: Electronic Products, Aesthetic Experience and Critical Design*. London: Royal College of Art, 1999.

Dunne, Anthony and Fiona Raby. *Design Noir: The Secret Life of Electronic Objects*. London/Basel: August/Birkäuser, 2001.

Dunne, Anthony and Fiona Raby. 'Notopia: Leaky Products/Urban Interfaces'. In Hill, *Architecture – the Subject is Matter*, pp. 91–106.

Einstein, Albert. *Relativity: The Special and the General Theory*. Trans. Robert W. Lawson. London: Methuen, 1960. First published in 1920.

Eisenman, Peter. 'Afterword'. In Frank, pp. 109–111.

Eisenman, Peter. 'The End of the Classical'. *Perspecta*, no. 21, 1984, pp. 154–173.

Eisenman, Peter. 'Post-Functionalism'. *Oppositions*, no. 6, Fall 1976, unpaginated.

Evans, Barrie. 'Snow Business'. *The Architects' Journal*, 19–26 December 2002, vol. 216, no. 22, pp. 20–27.

Evans, Robin. 'Architectural Projection'. In Blau and Kaufman, pp. 19–34.

Evans, Robin. 'Figures, Doors and Passages'. In Evans, *Translations*, pp. 55–92.

Evans, Robin. 'Mies van der Rohe's Paradoxical Symmetries'. In Evans, *Translations*, pp. 233–277.

Evans, Robin. *The Projective Cast: Architecture and its Three Geometries*. Cambridge, Mass.: MIT Press, 1995.

Evans, Robin. 'Rookeries and Model Dwellings: English Housing and the Moralities of Private Space'. In Evans, *Translations*, pp. 93–117.

Evans, Robin. 'Translations from Drawing to Building'. In Evans, *Translations*, pp. 153–194.

Evans, Robin. *Translations from Drawing to Building and Other Essays*. London: Architectural Association, 1997.

Farmer, John. *Green Shift: Towards a Green Sensibility in Architecture*. Ed. Kenneth Richardson. Oxford and Boston, Mass.: Butterworth-Heinemann, 1996.

Filarete, Antonio di Piero Averlino. *Treatise on Architecture*. 2 vols. Trans John R. Spencer, New Haven and London: Yale University Press, 1965. First published before 1465.

Fletcher, Banister. *A History of Architecture on the Comparative Method*. 7th edition, London: B.T. Batsford, 1924.

Flusser, Vilém. *The Shape of Things: A Philosophy of Design*. London: Reaktion, 1999.

Forty, Adrian. 'Flexibility', 1998. Draft chapter for *Words and Buildings: A Vocabulary of Modern Architecture*.

Forty, Adrian. *Words and Buildings: A Vocabulary of Modern Architecture*. London: Thames and Hudson, 2000.

Foster, Hal, ed. *Postmodern Culture*. London: Pluto, 1985.

Foucault, Michel. 'Space, Knowledge and Power (Interview Conducted with Paul Rabinow)'. Trans. Christian Hubert. In Leach, pp. 367–380.

Frank, Suzanne. *Peter Eisenman's House VI: A Client's Response*. New York: Whitney, 1994.

Frazer, John. *An Evolutionary Architecture*. London: Architectural Association, 1995.

Freidson, Eliot. 'The Theory of Professions: State of the Art'. In Dingwall and Lewis, pp. 19–37.

Freud, Sigmund. *The Standard Edition of the Complete Psychological Works of Sigmund Freud, Vol. 17*. Ed. James Strachey. Toronto: Clarke Irwin, 1955.

Freud, Sigmund. 'The "Uncanny"'. Trans. Alix Strachey. In Freud, *The Standard Edition*, pp. 217–252. First published in 1919.

Giedion, Sigfried. *Befreites Wohnen*. Frankfurt: Syndikat, 1985.

Giedion, Sigfried. *Building in France, Building in Iron, Building in Ferroconcrete*. Trans. J. Duncan Berry. Santa Monica, CA: Getty Center, 1995.

Giedion, Sigfried. *Space, Time and Architecture: The Growth of a New Tradition*. Cambridge, Mass.: Harvard University Press, 1956.

Govan, Michael. 'Minimal?' In Markopoulos, pp. 5–26.

Graham, Dan. *Architecture*. London: Architectural Association, 1997.

Graham, Dan. 'Art in Relation to Architecture/Architecture in Relation to Art'. In Graham, *Rock My Religion*, pp. 224–241.

Graham, Dan. *Rock My Religion: Writings and Art Projects*, 1965–90. Ed. Brian Wallis. Cambridge, Mass.: MIT Press, 1993.

Graham, Dan and Brian Hatton. 'Feedback: An Exchange of Faxes'. In Graham, *Architecture,* pp. 6–19.

Gregory, Richard. *Eye and Brain: The Psychology of Seeing*. Oxford: Oxford University Press, 1998.

Gropius, Walter. *Apollo in the Democracy: The Cultural Obligation of the Architect*. New York: McGraw Hill, 1968.

Gropius, Walter. 'Preface'. In Moholy-Nagy, *The New Vision*, pp. 5–6.

Hale, Jonathan A. *Building Ideas: An Introduction to Architectural Theory*. Chichester: Wiley, 2000.

Harper, Thomas J. 'Afterword'. In Tanizaki, pp. 43–48.

Harries, Karsten. *The Ethical Function of Architecture*. Cambridge, Mass., and London: MIT Press, 1997.

Harries, Karsten. *Infinity and Perspective*. Cambridge, Mass., and London: MIT Press, 2001.

Herzog, Jacques and Pierre de Meuron. 'Just Waste'. In Ursprung, *Herzog & de Meuron: Natural History*, pp. 74–75.

Heynen, Hilde. *Architecture and Modernity: A Critique*. Cambridge, Mass., and London: MIT Press, 1999.

Hill, Jonathan. *Actions of Architecture: Architects and Creative Users*. London and New York: Routledge, 2003.

Hill, Jonathan, ed. *Architecture – the Subject is Matter*. London and New York: Routledge, 2001.

Hill, Jonathan, ed. *Occupying Architecture: Between the Architect and the User*. London and New York: Routledge, 1998.

Hill, Jonathan. 'Weather Architecture (Berlin 1929–30, Barcelona 1986–, Barcelona 1999–)'. In Hill, *Actions of Architecture*, pp. 159–173.

Hofstadter, Albert and Richard Kuhns, eds. *Philosophies of Art and Beauty*. Chicago: University of Chicago Press, 1964.

Holmes, Hannah. *The Secret Life of Dust: From the Cosmos to the Kitchen Counter, The Big Consequences of Small Things*. Hoboken, NJ: Wiley, 2001.

Hume, David. 'Of the Standard of Taste'. In Hume, *Selected Essays*, pp. 133–154. First published in 1757.

Hume, David. *Selected Essays*. Oxford: Oxford University Press, 1993.

Hume, David. *Treatise on Human Nature*. Ed. Ernest C. Mossner. Harmondsworth: Penguin, 1969. First published in 1739–40.

Hunt, John Dixon. *Gardens and the Picturesque: Studies in the History of Landscape Architecture*. Cambridge, Mass., and London: MIT Press, 1992.

Hunt, John Dixon. *The Picturesque Garden in Europe*. London: Thames and Hudson, 2002.

Hunt, John Dixon. *William Kent: Landscape Garden Designer*. London: Zwemmer, 1987.

Hunt, John Dixon and Peter Willis, eds. *The Genius of the Place: The English Landscape Garden 1620–1820*. London: Elek, 1975.

Hunt, John Dixon and Peter Willis. 'Introduction'. In Hunt and Willis, *The Genius of the Place*, pp. 1–46.

Imrie, Rob. 'Architects' Conceptions of the Human Body', 2001. Draft text for *Society and Space*.

Jacques, Alison Sarah. 'There is No Light . . . Even When All the Light is Gone, You Can Still Sense Light: Interview with James Turrell'. In Svestka, pp. 56–71.

Jenkins, Janet, ed. *In the Spirit of Fluxus*. Minneapolis, MN: Walker Art Center, 1993.

Jones, Peter Blundell. *Modern Architecture Through Case Studies*. Oxford: Architectural Press, 2002.

Joseph, Leo. *Caspar David Friedrich and the Subject of Landscape*. London: Reaktion, 1990.

Judd, Donald. *Donald Judd. In Context*. Oxford: Oxford Museum of Modern Art, 1995.

Jury, Louise. 'British Museum's Long-hidden Treasures Find a New Home after Library's £8m Restoration'. *The Independent*, 11 December 2003, p. 23.

Kafka, Franz. *The Castle*. Trans. Willa and Edwin Muir. Harmondsworth: Penguin, 1957.

Kahn, Douglas. 'The Latest: Fluxus and Music'. In Jenkins, pp. 100–121.

Kant, Immanuel. *Critique of Judgement*. Trans. J.C. Meredith. Oxford: Clarendon Press, 1952. First published in 1790.

Klein, Yves. 'The Evolution of Art Towards the Immaterial'. In Noever and Perrin, pp. 35–45. From a 3 June 1959 lecture at the Sorbonne, Paris.

Koolhaas, Rem. *Delirious New York: A Retroactive Manifesto for Manhattan*. Rotterdam: 010, 1994. First published in 1978.

Kostof, Spiro, ed. *The Architect: Chapters in the History of the Profession*. New York and Oxford: Oxford University Press, 1977.

Kostof, Spiro. 'The Architect in the Middle Ages, East and West'. In Kostof, *The Architect*, pp. 59–95.

Kostof, Spiro. 'The Practice of Architecture in the Ancient World: Egypt and Greece'. In Kostof, *The Architect*, pp. 3–27.

Kristeller, Paul Oskar. 'The Modern System of the Arts'. In Kristeller, *Renaissance Thought and the Arts*, pp. 163–227.

Kristeller, Paul Oskar. *Renaissance Thought and the Arts: Collected Essays*. Princeton, NJ: Princeton University Press, 1990.

Laugier, Marc-Antoine. *An Essay on Architecture*. Trans. Wolfgang and Anni Herrmann. Los Angeles: Hennessey and Ingalls, 1977. First published as *Essai sur l'Architecture* in 1753.

Le Camus de Mèzieres, Nicolas. *The Genius of Architecture – or the Anatomy of that Art with our Sensations*. Trans. David Britt. Santa Monica, CA: Getty Center, 1992. First published in 1780.

Le Corbusier. 'A Coat of Whitewash: The Law of Ripolin'. In Le Corbusier, *The Decorative Art of Today*, pp. 185–192.

Le Corbusier. *The Decorative Art of Today*. Trans. James Dunnett. London: Architectural Press, 1987.

Le Corbusier. *Towards a New Architecture*. Trans. Frederick Etchells. London: Rodker, 1927.

Leach, Neil, ed. *Rethinking Architecture: A Reader in Cultural Theory*. London: Routledge, 1996.

Lefaivre, Liane and Alexander Tzonis. 'The Question of Autonomy in Architecture'. *The Harvard Architecture Review*, vol. 3, Winter 1984, pp. 27–43.

Lefebvre, Henri. *The Production of Space*. Trans. Donald Nicholson-Smith. Oxford: Blackwell, 1991.

Lévi-Strauss, Claude. *The Origin of Table Manners*. Trans John and Doreen Weightman. New York: Harper and Row, 1978.

Lévi-Strauss, Claude. *The Way of Masks*. Trans. Sylvia Modelski. Seattle, WA: University of Washington Press, 1982.

Libeskind, Daniel. *Traces of the Unborn: 1995 Raoul Wallenberg Lecture*. Ann Arbor, MI: University of Michigan, 1995.

Liebermann, Valeria. '"Reflections on a Photographic Medium", "Memorial to the Unknown Photographer", or "Visual Diary"? Thomas Ruff's Newspaper Photos'. In Mack and Liebermann, pp. 56–64.

Ligo, Larry L. *The Concept of Function in Twentieth-Century Architectural Criticism*. Ann Arbor, MI: UMI Research Press, 1984.

Locke, John. *Essay concerning Human Understanding*. Ed. Peter H. Nidditch. Oxford: Clarendon Press, 1975. First published in 1690.

Loos, Adolf. 'Ornament and Crime'. In Safran and Wang, pp. 100–103.

Loos, Adolf. 'Ornament und Erziehung'. In Loos, *Sämtliche Schriften*, pp. 391–398.

Loos, Adolf. 'The Principle of Cladding'. In Loos, *Spoken into the Void*, pp. 66–69.

Loos, Adolf. *Sämtliche Schriften*. Vienna: Verlag Herold, 1962.

Loos, Adolf. *Spoken into the Void: Collected Essays 1897–1900*. Trans. Jane O. Newman and John. H. Smith. Cambridge, Mass.: MIT Press, 1982.

MacDonald, William L. 'Roman Architects'. In Kostof, *The Architect*, pp. 28–58.

Mack, Gerhard. 'Building with Images: Herzog & de Meuron's Library at Eberswalde'. In Mack and Liebermann, pp. 7–55.

Mack, Gerhard and Valeria Liebermann. *Eberswalde Library: Herzog & de Meuron*. London: Architectural Association, 2000.

McLeod, Mary. 'Architecture or Revolution: Taylorism, Technocracy and Social Change'. *Art Journal*, no. 43: 2, Summer 1983, pp. 132–147.

Mallgrave, Harry Francis. 'Introduction'. In Semper, *The Four Elements of Architecture and Other Writings*, pp. 1–44.

Markopoulos, Leigh, ed. *Dan Flavin*. London: Serpentine Gallery, 2001.

Martin, Louis. 'Interdisciplinary Transpositions: Bernard Tschumi's Architectural Theory'. In Coles and Defert, pp. 59–88.

Marx, Karl. 'Speech at the Anniversary of the *People's Paper*'. In Tucker, pp. 577–578.

Marx, Karl and Friedrich Engels. 'Manifesto of the Communist Party'. In Tucker, pp. 469–500.

Melhuish, Clare. 'Creative Concern in Office City'. *Building Design*, 1144, 1 October 1993, p. 8.

Meyer, Franz. 'Marfa'. In Petzinger and Dannenberger, pp. 24–80.

Meyer, James, ed. *Minimalism: Themes and Movements*. London: Phaidon, 2000.

Meyer, James. 'Survey'. In Meyer, *Minimalism*, pp. 12–45.

Meyrowitz, Joshua. *No Sense of Place: The Impact of Electronic Media on Social Behaviour*. New York and Oxford: Oxford University Press, 1986.

Mies van der Rohe, Ludwig. 'Build Beautifully and Practically! Stop this Cold Functionality'. In Neumeyer, p. 307.

Minuchin, Salvador. *Families and Family Therapy*. London: Tavistock, 1974.

Moggridge, Hal. 'Notes on Kent's Garden at Rousham'. *Journal of Garden History*, vol. 6, no. 3, July–September 1986, pp. 187–226.

Moholy-Nagy, László. *The New Vision 1928 fourth revised edition 1947 and Abstract of an Artist*. Trans. Daphne M. Hoffmann. New York: George Wittenborn, 1947.

Mowl, Timothy. *Gentlemen and Players: Gardeners of the English Landscape*. Stroud: Sutton, 2000.

Neuhaus, Max. 'Sound Design'. *Zeitgleich*. Vienna: Triton, 1994.

Neumeyer, Fritz. *The Artless Word: Mies van der Rohe on the Building Art*. Cambridge, Mass., and London: MIT Press, 1991.

Newman, Michael. 'Revising Modernism, Representing Post-Modernism: Critical Discourses of the Visual Arts'. *ICA Documents*, nos. 4–5, 1986, pp. 32–51.

Noever, Peter and François Perrin, eds. *Air Architecture: Yves Klein*. Ostfildern-Ruit: Hatje Cantz, 2004.

Norberg-Schulz, Christian. *Late Baroque and Rococo Architecture*. New York: Harry N. Abrams, 1974.

Norberg-Schulz, Christian. 'A Talk with Mies van der Rohe'. In Neumeyer, pp. 338–339. First published in *Baukunst und Werkform*, 11, no. 11, 1958, pp. 615–618.

Palladio, Andrea. *The Four Books on Architecture*. Trans. Robert Tavernor and Richard Schofield. Cambridge, Mass.: MIT Press, 1997. First published as *Quattro Libri dell' Archittetura* in 1570.

Pallasmaa, Juhani. *The Eyes of the Skin: Architecture and the Senses*. London: Academy Editions, 1996.

Panofsky, Erwin. *Idea: A Concept in Art Theory*. Trans. Joseph J.S. Peake. Columbia, SC: University of Southern Carolina Press, 1968. First published in 1924.

Pask, Gordon. 'The Architectural Relevance of Cybernetics'. In Spiller, pp. 78–82. First published in 1969.

Pérez-Gómez, Alberto. *Architecture and the Crisis of Modern Science*. Cambridge, Mass.: MIT Press, 1983.

Perlein, Gilbert and Bruno Corà, eds. *Yves Klein: Long Live the Immaterial*. New York: Delano Greenidge, 2000.

Petzinger, Renate and Hanne Dannenberger, eds. *Donald Judd*. Stuttgart: Cantz, 1993.

Plato. *Philebus*. Trans. J.C.B. Gosling. Oxford: Clarendon Press, 1975.

Plato. *The Republic*. Ed. Terence Irwin, trans. A.D. Lindsay. London: Everyman, 1992.

Plato. *Timaeus, Critias, Cleitophon, Menexenus, Epistles*. Trans. R.G. Bury. Cambridge, Mass.: Harvard University Press, 1929.

Porter, Roy. *Enlightenment: Britain and the Creation of the Modern World*. London: Penguin, 2001.

Porter, Roy. *Flesh in the Age of Reason: How the Enlightenment Transformed the Way We See Our Bodies and Souls*. London: Penguin, 2004.

Porter, Tom. *The Architect's Eye: Visualization and Depiction of Space in Architecture*. London: E & FN Spon, 1997.

Price, Cedric. 'Activity and Change'. In Cook, *Archigram*, unpaginated.

Price, Cedric. 'Generator Project'. In Spiller, pp. 86–89.

Price, Uvedale. 'From *An Essay on the Picturesque*'. In Hunt and Willis, *The Genius of the Place*, pp. 351–357. First published in 1794.

Pugh, Simon. *Garden – Nature – Landscape*. Manchester: Manchester University Press, 1988.

Quick, Zoë. 'Wool, Wing Chairs and Thermal Delight'. Diploma Technical Dissertation, Bartlett School of Architecture, University College London, 2003.

Rabeneck, Andrew, David Sheppard and Peter Town. 'Housing – Flexibility/ Adaptability?' *Architectural Design*, vol. 44, February 1974, pp. 76–91.

Reichardt, Jasia. *Yves Klein Now*. London: Hayward Gallery, 1995.

Riegl, Alois. *Problems of Style: Foundations for a History of Ornament*. Trans. Evelyn Kain. Princeton, NJ: Princeton University Press, 1992.

Riley, Terence. *The Un-Private House*. New York: Museum of Modern Art, 1999.

Robbins, Edward. *Why Architects Draw*. Cambridge, Mass., and London: MIT Press: 1997.

Robinson, John Martin. *Temples of Delight: Stowe Landscape Gardens*. Norwich: Jarrold, 1990.

Ross, Andrew. *Strange Weather: Climate, Science and Technology in the Age of Limits*. London and New York: Verso, 1991.

Rowe, Colin. 'The Mathematics of the Ideal Villa'. In Rowe, *The Mathematics of the Ideal Villa and Other Essays*, pp 1–27.

Rowe, Colin. *The Mathematics of the Ideal Villa and Other Essays*. Cambridge, Mass., and London: MIT Press, 1982.

Rüedi, Katerina. 'Curriculum Vitae. The Architect's Cultural Capital: Educational Practices and Financial Investments'. In Hill, *Occupying Architecture*, pp. 23–38.

Rueschemeyer, Dietrich. 'Professional Autonomy and the Social Control of Expertise'. In Dingwall and Lewis, pp. 38–58.

Ruskin, John. *The Seven Lamps of Architecture*. New York: Farrar, Straus and Giroux, 1984. First published in 1849.

Rybczynski, Witold. *Home: A Short History of an Idea.* London: Penguin, 1986.

Rykwert, Joseph. *On Adam's House in Paradise: The Idea of the Primitive Hut in Architectural History*. New York: Museum of Modern Art, 1972.

Safran, Yehuda and Wilfred Wang, eds. *The Architecture of Adolf Loos*. London: Arts Council, 1985.

Sarti, Raffaella. *Europe at Home: Family and Material Culture: 1500–1800*. Trans. Allan Cameron. New Haven, CT and London: Yale University Press, 2002.

Savi, Vittorio E. and Josep M. Montaner. *Less is More: Minimalism in Architecture and the Other Arts*. Barcelona: Colegio de Arquitectos de Cataluña y Actar, 1996.

Scalbert, Irénée. 'A Real Living Contact with the Things Themselves: Landscape Painters and Architects, 1600–1850'. *AA Files*, 50, 2004, pp. 20–35.

Schama, Simon. *The Embarrassment of Riches: An Interpretation of Dutch Culture in the Golden Age*. London: Fontana, 1991.

Schmied, Wieland. 'Eight Aspects and a Summary'. In Baal-Teshuva, pp. 11–12.

Schnaidt, Claude. *Hannes Meyer: Buildings, Projects and Writings*. Teufen: Arthur Niggli, 1965.

Scully, Vincent. *Architecture: The Natural and the Manmade*. New York: St Martin's Press, 1991.

Scully, Vincent. *Modern Architecture.* New York: Braziller, 1965.

Sedlmayr, Hans and Hermann Bauer. 'Rococo'. *Encyclopedia of World Art, Vol. XII, Renaissance–Shahn*. London: McGraw Hill, 1966, pp. 230–274.

Semper, Gottfried. *Der Stil in den technischen und tektonischen Künsten oder praktische Ästhetik*. Frankfurt, 1860 and 1863.

Semper, Gottfried. 'The Four Elements of Architecture'. In Semper, *The Four Elements of Architecture and Other Writings*, pp. 74–129.

Semper, Gottfried. *The Four Elements of Architecture and Other Writings*. Trans. Harry Francis Mallgrave and Wolfgang Herrmann. Cambridge: Cambridge University Press, 1989.

Semper, Gottfried. 'On Architectural Styles'. In Semper, *The Four Elements of Architecture and Other Writings*, pp. 264–284.

Semper, Gottfried. 'Style in the Technical and Tectonic Arts or Practical Aesthetics'. In Semper, *The Four Elements of Architecture and Other Writings*, pp. 181–263.

Serlio, Sebastiano. *Sebastiano Serlio on Architecture*, vol. 1, books I–V of *Tutte l'opere d' architettura et prospectiva, 1537–1551*. Trans. V. Hart and P. Hicks. New Haven, CT and London: Yale University Press, 1996.

Sibley, David. 'Comfort, Anxiety and Space'. In Hill, *Architecture – the Subject is Matter*, pp. 107–118.

Sibley, David. *Geographies of Exclusion: Society and Difference in the West*. London: Routledge, 1995.

Skirbekk, Gunnar and Nils Gilje. *A History of Western Thought: From Ancient Greece to the Twentieth Century*. London and New York: Routledge, 2001.

Solà Morales, Ignasi de, Christian Cirici and Fernando Ramos. *Mies van der Rohe: Barcelona Pavilion*. Trans. Graham Thomson. Barcelona: Editorial Gustavo Gili, 1993.

Sonfist, Alan, ed. *Art in the Land: A Critical Anthology of Environmental Art*. New York: E.P. Dutton, 1983.

Spiller, Neil, ed. *Cyber_Reader: Critical Writings for the Digital Era*. London: Phaidon, 2002.

Steadman, Philip. *Vermeer's Camera: Uncovering the Truth Behind the Masterpieces*. Oxford: Oxford University Press, 2001.

Stich, Sidra. *Yves Klein*. Stuttgart: Cantz, 1994.

Stoichita, Victor I. *A Short History of the Shadow*. London: Reaktion, 1997.

Svestka, Jiri, ed. *James Turrell: Perceptual Cells*. Stuttgart: Edition Cantz, 1992.

Tabor, Philip. 'Striking Home: The Telematic Assault on Identity'. In Hill, *Occupying Architecture*, pp. 217–228.

Tafuri, Manfredo. *Architecture and Utopia: Design and Capitalist Development*. Trans. Barbara Luigia La Penta. Cambridge, Mass.: MIT Press, 1976.

Tafuri, Manfredo. *Theories and History of Architecture*. Trans. Giorgio Verrecchia. London: Granada, 1980.

Tafuri, Manfredo and Francesco Dal Co. *Modern Architecture: Vol. 1*. Trans. Robert Erich Wolf. London: Faber and Faber, 1986.

Tanizaki, Jun´ichiró. *In Praise of Shadows*. Trans. Thomas J. Harper and Edward G. Seidensticker. Stony Creek: Leete's Island Books, 1977.

Tarnas, Richard. *The Passion of the Western Mind: Understanding the Ideas That Have Shaped Our World View*. London: Pimlico, 1996.

Tatarkiewicz, W. 'Classification of the Arts'. In Wiener, vol. 4, pp. 456–462.

Tiberghien, Gilles A. *Land Art*. London: Art Data, 1995.

Tschumi, Bernard. 'The Architectural Paradox: The Pyramid and the Labyrinth'. In Tschumi, *Questions of Space*, pp. 11–30.

Tschumi, Bernard. 'Architecture and its Double'. In Tschumi, *Questions of Space*, pp. 61–78.

Tschumi, Bernard. *Cinégramme Folie: Le Parc de la Villette*. Princeton: Princeton Architectural Press, 1987.

Tschumi, Bernard. *Event-Cities (Praxis)*. Cambridge, Mass.: MIT Press, 1994.

Tschumi, Bernard. 'Illustrated Index – Themes from The Manhattan Transcripts'. *AA Files*, no. 4, 1983, pp. 65–75.

Tschumi, Bernard. 'Index of Architecture: Themes from The Manhattan Transcripts'. In Tschumi, *Questions of Space*, pp. 97–110.

Tschumi, Bernard. 'The Pleasure of Architecture'. In Tschumi, *Questions of Space*, pp. 47–60.

Tschumi, Bernard. *Questions of Space: Lectures on Architecture*. London: Architectural Association, 1990.

Tschumi, Bernard. 'Spaces and Events'. In Tschumi, *Questions of Space*, pp. 87–96.

Tucker, Robert C., ed. *The Marx–Engels Reader*. London: Norton, 1978.

Tuveson, Ernest Lee. *The Imagination as a Means of Grace: Locke and the Aesthetics of Romanticism*. Berkeley and Los Angeles: University of California Press, 1960.

Ursprung, Philip, ed. *Herzog & de Meuron: Natural History*. Montreal/Baden: CCA/Lars Müller, 2002.

Ursprung, Philip. 'I Make My Picture on the Surface: Visiting Thomas Ruff in Düsseldorf'. In Ursprung, *Herzog & de Meuron: Natural History*, pp. 157–165.

Ursprung, Philip, Jacques Herzog and Pierre de Meuron. 'Portfolio'. In Ursprung, *Herzog & de Meuron: Natural History*, pp. 78–108.

Van de Ven, Cornelius. *Space in Architecture*. Assen, Netherlands: Van Gorcum, 1978.

Van Eck, Caroline. '"The Splendid Effects of Architecture, and its Power to Affect the Mind": the Workings of Picturesque Association'. In Birksted, pp. 245–258.

Vasari, Giorgio. *Vasari on Technique*. Trans. Louisa S. Maclehose. New York: Dover, 1960. First published as *Le vite de' più eccelenti pittori, scultori e architettori* (The Lives of the Most Eminent Painters, Sculptors and Architects), 2nd edition, 1568.

Vidler, Anthony. *The Architectural Uncanny: Essays in the Modern Unhomely*. Cambridge, Mass.: MIT Press, 1996.

Vidler, Anthony. 'A Dark Space'. In Whiteread, pp. 62–72.

Vigarello, Georges. *Concepts of Cleanliness: Changing Attitudes in France since the Middle Ages*. Trans. Jean Birrell. Cambridge: Cambridge University Press, 1988.

Vitruvius. *The Ten Books on Architecture*. Trans. Morris Hicky Morgan. New York: Dover, 1960. First published as *De Architectura* in the first century BC.

Walpole, Horace. 'From *The History of the Modern Taste in Gardening*'. In Hunt and Willis, *The Genius of the Place*, pp. 313–317. First printed in 1771 and published in 1780.

Watson, Victoria. 'The Atmospheric Signifier – Miesian *Form-Giving*, Lefebvrian *Space* and *Cotton Grid*'. PhD Thesis, Bartlett School of Architecture, University College London, 2004.

Webb, Michael. *Temple Island: A Study by Michael Webb*. London: Architectural Association, 1987.

Weston, Richard. *Materials, Form and Architecture*. London: Laurence King, 2003.

Whately, Thomas. 'From *Observations on Modern Gardening*'. In Hunt and Willis, *The Genius of the Place*, pp. 38, 301–307. First published in 1770.

White, Iain Boyd, ed. and trans. *The Crystal Chain Letters*. Cambridge, Mass.: MIT Press, 1985.

Whiteread, Rachel. *House*. Ed. James Lingwood. London: Phaidon, 1995.

Whyte, Ian D. *Landscape and History Since 1500*. London: Reaktion, 2002.

Wiener, Philip P., ed. *Dictionary of the History of Ideas.* New York: Charles Scribner's Sons, 1973.

Wigley, Mark. *The Architecture of Deconstruction: Derrida's Haunt.* Cambridge, Mass., and London: MIT Press, 1995.

Wigley, Mark. 'Paper, Scissors, Blur'. *Another City for Another Life: Constant's New Babylon.* New York: The Drawing Center, 1999, pp. 9–34.

Wigley, Mark. *White Walls, Designer Dresses: The Fashioning of Modern Architecture.* Cambridge, Mass., and London: MIT Press, 1993.

Wilkinson, Catherine. 'The New Professionalism in the Renaissance'. In Kostof, *The Architect,* pp. 124–160.

Wilson, Peter. *Western Objects, Eastern Fields*, London: Architectural Association, 1989.

Woods, Lebbeus. 'Henley and the Enigma of Michael Webb'. In Webb, pp. 53–56.

Woodward, Christopher. *In Ruins.* London: Chatto and Windus, 2001.

Wurman, Richard Saul. *What Will Be Has Always Been. The Words of Louis I. Kahn.* New York: Rizzoli, 1986.

Yanagi, Masahiko. 'Interview with Christo'. In Baal-Teshuva, pp. 21–29.

Zabalbeacscoa, Anatxu. *Igualada Cemetery: Enric Miralles and Carme Pinós.* London: Phaidon, 1996.

Zumthor, Paul. *Daily Life in Rembrandt's Holland.* Trans. Simon Watson Taylor. New York: Macmillan, 1963.

INDEX

Page numbers in *italics* denotes an illustration